EUROPEAN PRODUCTS

European Products

Making and Unmaking Heritage in Cyprus

Gisela Welz

berghahn
NEW YORK • OXFORD
www.berghahnbooks.com

First published in 2015 by
Berghahn Books
www.berghahnbooks.com

Library of Congress Cataloging-in-Publication Data

Welz, Gisela.
 European products : making and unmaking heritage in Cyprus / Gisela Welz.
 pages cm
 Includes bibliographical references and index.
 ISBN 978-1-78238-822-7 (hardback : alk. paper) — ISBN 978-1-78533-517-4
 (paperback) — ISBN 978-1-78238-823-4 (ebook)
 1. Cultural property—Social aspects—Cyprus. 2. Historic preservation—Social
aspects. 3. National characteristics, Cypriot. 4. Cyprus—Cultural policy. I. Title.
 DS54.35.W45 2015
 306.095693—dc23

 2015003127

British Library Cataloguing in Publication Data

A catalogue record for this book is available from the British Library

ISBN 978-1-78238-822-7 (hardback)
ISBN 978-1-78533-517-4 (paperback)
ISBN 978-1-78238-823-4 (ebook)

TO THE MEMORY OF

STEFAN BECK

1960 – 2015

Contents

Acknowledgements viii

List of Abbreviations xi

Map of Cyprus xiii

Introduction 1

Part I. Heritage Regimes 19

Chapter 1. Preserving Vernacular Architecture 21

Chapter 2. Packaging Hospitality 38

Chapter 3. Inventing the Rural 57

Part II. Food, Culture and Heritagization 75

Chapter 4. 'Full *Meze*': Tourism, Modernity, Crisis 77

Chapter 5. 'Origin Food': The Struggle over Halloumi 93

Part III. Ambient Heritage 113

Chapter 6. The Nature of Heritage Making: Environmental
Governance 115

Chapter 7. The Divided City: Europe and the Politics of Culture 131

Conclusion 150

Bibliography 170

Index 187

Acknowledgements

This book has been a long time in the making, and I have incurred many debts. When my late husband Stefan Beck and I started travelling together to Cyprus more than twenty years ago, we were fortunate to meet people who took it upon themselves to open our eyes and hearts to the grace and warmth of the island and its inhabitants, who made us aware of the disastrous effects of war, division and displacement and kindled hopes for peace and reconciliation: Violetta Christophidou-Anastasiadou, Vassos Argyrou, Christiane Chimarrides, Michalis Chimarrides, Panicos Chrysanthou, Traude Chrysanthou, Katherine Clerides, Olga Demetriou, Lisa Dikomitis, Murat Erdal, Sylvaine Gautier, Brigitte Ioannou, Niyazi Kizilyurek, Stavros Marangos, Savvas Tamamounas. Thank you to all of you, as your conviviality, generosity, support, frankness and willingness to engage in debate have shaped my perspective on Cyprus and sustained me over this long period of research and writing.

Many other people have also contributed significantly to my attempts to achieve some kind of understanding of Cyprus, its people, its past and present. Over the years, academic colleagues became friends, and nonacademic friends became collaborators in research. None of them can be held responsible for any errors I commit or for opinions that I express, and all of them have my gratitude.

The people I interviewed, often repeatedly in the course of many years, for the case studies assembled in this book are too numerous to mention here and are credited individually in the endnotes appended to the chapters. Except, of course, for those who chose to remain anonymous: to them, special thanks is due, as it was often the information that they shared with me that allowed a more nuanced assessment as to some of the political controversies and economic interests involved. At various times during the intermittent research spanning more than fifteen years, some people have been very helpful as door openers and have facilitated fieldwork in a number of ways. I am particularly grateful to Nicholas Andilios, Phaedon Enotiades, Frances Higgins, Bernard Musyck, Maria Neocleous, Photis Papademas, Costas Kattamis, Nicholas Symons and Artemis Yiordamli.

I would also like to mention that when I first embarked on fieldwork in Cyprus in the 1990s, the late Peter Loizos was generous with advice and encouragement. Also, the University of Nicosia – known as Intercollege previously

– and the colleagues teaching there provided me and some of my students with an academic home away from home by inviting us to numerous conferences and workshops to present our work. I am especially grateful to Nicos Peristianis, whose personal friendship and professional support made this possible. At the University of Cyprus in Nicosia, the Department of Political and Social Sciences repeatedly hosted me and my students, as well as developing an ERASMUS exchange link with the Goethe University Frankfurt. Special thanks for keeping the Frankfurt-Nicosia connection alive is due to Yiannis Papadakis. Last but not least, I would like to thank the Goethe University Frankfurt graduate students I had the privilege to work with during these more than twenty years of engagement with the anthropology of Cyprus, in particular Ramona Lenz, Petra Ilyes and Enikö Baga.

My understanding of Europeanization and the role of heritage making in Europe also benefitted much from colleagues whose anthropological concerns and regional specializations have nothing to do with Cyprus. Of the many exchanges and associations that were helpful, I particularly would like to mention the Binghamton/Cornell Consortium Anthropology of Europe, with whom I met at the State University of New York at Binghamton, and CHIMERA, an interdisciplinary heritage studies consortium at the University of Manchester, where Stefan and I were fortunate to stay as Simon Visiting Professors in Social Anthropology for a brief but productive visit in 2009. Earlier versions of the book manuscript or of individual chapters have been read by Nir Avieli, Vassos Argyrou, Olga Demetriou, Andreas Demetropoulos, Hubert Faustmann, Rafi Grosglik, Sharon Macdonald, Christina McRoy, Kerem Öktem and Kiran Klaus Patel, and I am grateful for their comments, criticism and suggestions.

Funding for my fieldwork in 1997 was made possible as part of a Heisenberg Fellowship grant by the German Research Foundation (DFG), and the excursion with students in 1999 was partly funded by the German Academic Exchange Service and the Goethe University Frankfurt, as was another excursion in 2005. Semester-length sabbaticals granted by the Goethe University Frankfurt in the winter terms of 2004–5, 2008–9 and 2012–13 were extremely helpful in pushing ahead with work on the case studies.

I would never have come to Cyprus if Stefan had not taken me there on a holiday in 1991 when we first met and fell in love. After that, we returned every year. Both of us started to work as anthropologists in and about Cyprus. While he pursued topics at the interface of biomedical science and ethnography, my own research would eventually result in the case studies that make up this book. In many respects, the book would not have happened without him: His constant and steady encouragement to keep on with it, his vibrant interest in the politics of theory, and his strong impetus to make anthropology speak about contemporary forms of life have left an unmistakable mark on every page. One year after my work on the manuscript was completed, Stefan

died suddenly and unexpectedly in March 2015, while we were visiting friends and family in Australia. It is to his memory that I dedicate this book.

* * *

Chapter 5 is an updated and revised version of an article that appeared in 2013 as 'Halloumi/Hellim: Global Markets, European Union Regulation, and Ethnicized Cultural Property', in O. Demetriou (ed.), 'Dedicated to the Memory of Peter Loizos', special issue, *The Cyprus Review* 51(1): 37–54. Reprinted with permission by the University of Nicosia.

Chapter 6 was first published in 2012 as 'Regimes of Environmental Governance: A Case Study from Cyprus', in G. Welz, F. Sperling and E. M. Blum (eds), *Negotiating Environmental Conflicts: Local Communities, Global Policies*. Frankfurt: Kulturanthropologie Notizen, pp. 179–202. Reprinted with permission.

Abbreviations

CAC	Cyprus Agrotourism Company
CAP	Common Agricultural Policy
CTO	Cyprus Tourism Organisation
CYTA	Cyprus Telecommunications Authority
EAGGF	European Agricultural Guidance and Guarantee Fund
ECOC	European Capital of Culture
EHD	European Heritage Day(s)
EOKA	Ethnikí Orgánosis Kipriakoú Agónos (Greek-Cypriot underground organisation)
ERDF	European Regional Development Fund
ESF	European Social Fund
EU	European Union
FAO	Food and Agriculture Organization (United Nations)
HACCP	Hazard Analysis and Critical Control Points (food hygiene protocol)
IBRD	International Bank for Reconstruction and Development
NGO	non-governmental organization
OECD	Organisation for Economic Co-operation and Development
OHIM	Office of Harmonization in the Internal Market (European Union)
PDO	protected designation of origin
PGI	protected geographical indication
PRIO	Peace Research Institute of Oslo
RDP	Rural Development Programme

TRIPS	Agreement on Trade-Related Aspects of Intellectual Property Rights
UN	United Nations
UNDP	United Nations Development Programme
UNDP-ACT	United Nations Development Programme's Action for Cooperation and Trust
UNESCO	United Nations Educational, Scientific and Cultural Organization
USAID	United States Agency for International Development
WIPO	World Intellectual Property Organization
WTO	World Trade Organization

Map of Cyprus

❦

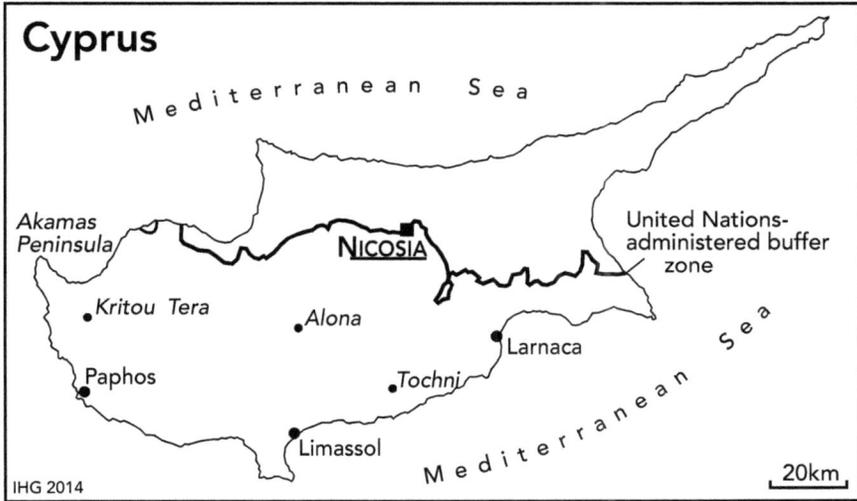

Cyprus

Mediterranean Sea

Akamas Peninsula

NICOSIA

United Nations-administered buffer zone

Kritou Tera

Alona

Larnaca

Paphos

Tochni

Mediterranean Sea

Limassol

IHG 2014

20km

In addition to the major cities of Nicosia, Paphos, Limassol and Larnaca, the village communities of Kritou Tera, Alona and Tochni that figure prominently in this book are indicated on this map, as is the Akamas Peninsula. The United Nations–administered buffer zone divides the areas of the Republic of Cyprus between those in the north where, since the 1974 Turkish invasion, the government does not exercise effective control, and those areas in the south where it does. Since the 2004 European Union accession, the European Union's community accord has been implemented south of the buffer zone, but remains suspended to the north of it as long as the political problem of the division is not solved. *Map designed by Elke Alban, Cartography Section, Institute of Human Geography (IHG), Goethe University Frankfurt.*

Introduction

❧

Fieldstone walls, vineyards, old farmhouses, olive trees, pebble-strewn beaches and brush-covered hills figure in this book. It introduces its readers to rural villages, historic city quarters, taverns that serve simple but tasty food and family-run enterprises that make cheese from goat and sheep milk. These settings epitomize what we consider old, genuine, untouched by modernization. Unadulterated culture, as well as unspoiled nature, are master tropes in the cosmology of Western modernity, which locates authenticity, as the antithesis of technology-driven progress, in the absence of calculated intervention. Indeed, these places appear as if they were relics of an earlier time, bypassed by change and spared from modernization. Yet, they would not exist if they had not been intentionally preserved, or even materially reconstructed, if they had not been identified by experts, discursively marked as heritage and strictly regulated under national law and transnational conventions. Also, we would not be able to visit them – or, indeed, be interested in doing so – if these places were not also advertised as sightseeing attractions in tourist destination areas, and if their official entry into heritage registers or lists of protected sites did not guarantee their genuineness. Heritage is not something that exists prior to preservation efforts, but is the very result of purposive action, guided by standards that are decidedly nonlocal and that obey a 'global hierarchy of value' (Herzfeld 2004).

Anthropology has a long history of critically engaging with the making of heritage, both cultural and natural, attacking it under various guises as the commodification of culture, the invention of tradition, the rise of the heritage industry and the social construction of nature. Early on, anthropologists suggested that commercialization is inherently evil, polluting culture and dispossessing local populations of their birthright. However, to lament the loss of identity and the disenfranchising of local populations that occur once their patrimony is reinvented as an object to be bought and sold, even though often morally justified, does not afford any insights into what is happening, how and why. More recently, however, anthropology started to scrutinize closely the mechanisms of how these conversions operate, how culture – and nature! – are constructed as items that presumably are exempt from modern commodity circulation, and how this exemption then constitutes their unique selling point in the market. Indeed, knowledge-based and technologically enhanced regimes of valuation and valorization (Kirshenblatt-Gimblett 2006) remake things, peo-

ple and places once they come into the purview of heritage making and become
constituted anew as objects of exhibition and trade (Herzfeld 2004). Heritage,
then, is a product that is fashioned according to historically generated specifica-
tions. Heritage production is based on and propagates normative assessments
of what is fit to 'embody the uniquely characterized and enduring presence of a
collectivity' (Filippucci 2004: 72). More often than not, the designation of an
object or a practice as an exemplar of authentic heritage rests on hegemonic
definitions by cultural elites or state bureaucracies. They may, in turn, enlist
academic research and scholarly knowledge as authoritative sources on how to
distinguish the authentic from the inauthentic. The anthropological and ethno-
logical disciplines have from their inception been complicit in the construction
of the divide between tradition and modernity that continues to underlie much
heritage production. Heritage production, then, is itself a modern phenome-
non, deeply rooted in both the political economy of capitalism and the emer-
gence of the modern nation-state, as 'stable national identities presuppose the
standardization of cultural expression' (Eriksen 2004: 20).

This book is about a small country on the margins of Europe, the Repub-
lic of Cyprus. On the island of Cyprus, accidents of history as well as unique
biogeographical conditions have created a particularly rich and intensely di-
verse cultural and natural landscape on a relatively small-scale territory. Cyprus
has often been called a cultural catalyst and a bridge between Occident and
Orient. Since Neolithic times, the island has served as an easily exploitable
resource for successive waves of conquerors and emperors, as a mere stopover
for seafarers and traders and as a new home for various groups of invaders
and colonizers through the ages. Its landscape today is littered with the relics
of prehistoric settlements, Hellenic temples, and Roman villas. It is studded
with crusader's castles and Byzantine chapels; its cities boast Gothic cathe-
drals, Venetian fortifications and Ottoman mosques, with many an ancient ed-
ifice having undergone multiple transformations and receiving new functions
whenever it came within the purview of yet another ruler or religion. Cyprus
also contains many landscapes of spectacular beauty. Its coastal areas as well as
the mountain regions are known for their biodiversity. While some plants and
a few animals are endemic to the island, the fauna and flora exhibits a unique
overlap of the Mediterranean and the Near Eastern regions. What interests
me primarily about the legislation and regulation of the cultural and natural
heritage of the country, and the social actors, institutions and practices that
implement them, is how they are related to the process of Europeanization
that Cyprus is currently undergoing. The Republic of Cyprus, the state that
represents the entirety of the island but whose de facto sovereignty extends
only over the Greek Cypriot southern portion of the island, acceded to the
European Union (EU) in 2004. European supranational institutions started
to exert influence even earlier. Indeed, as Cyprus was a British colony prior to

1960, both nature conservation and cultural heritage regulation on the island had been subject to principles prevalent in Western Europe for more than one hundred years before EU accession.

'Past Presencing' on the European Periphery

The focus of this book is on the social practices and discursive operations that make – and sometimes, also unmake – heritage. Instead of reifying objects or practices of the past as 'patrimony' or cultural 'legacy', the notion of heritage being made highlights the practical, even technical side of conservation, preservation and safeguarding, and their processual character. The constructivist turn in anthropology made it possible to conceptualize 'tradition' and other forms of 'authentic' culture as discursively produced, to chart how these are deployed, and to enquire into the ways in which these play into the self-representations of modern societies, and into perceptions of Europe more generally (Macdonald 2012: 237). Social anthropologist Sharon Macdonald, whose conceptualizations of heritage provide one of the theoretical moorings for my enquiry, argues that heritage is an important element of 'the European memory complex' (Macdonald 2013: 5), referring to specifically European modes of engaging with 'the past', 'capable of reorganising land- and cityscapes and validating certain social groups (and not others).... Heritage invariably implies ownership' (Macdonald 2013: 18). In her work on museums as well as on memorials and historic sites, she has consistently posed the question of 'why and how some things come to count as "heritage" and the consequences that flow from this' (Macdonald 2013: 17). The selectivity that is inherent in heritage making, valuating certain artefacts as worthy of preservation and letting others fall into oblivion, is understood to be also a politicized process, catering to and engineered by the interests of elites, but sometimes also of minorities and marginal groups. Heritage making creates references to 'multiple pasts', and the same site or artefact may indeed evoke radically different interpretations and meanings for different audiences. 'Difficult' or dissonant heritage confronts societies with uncomfortable truths about historical responsibility and offers particular insights into how contemporary social actors deal with the legacies of the past. In contrast to much of the earlier anthropological critiques of cultural commodification and the heritage 'industry', Macdonald does not consider the outcome of heritage making wholly explicable by retracing how it originates in a particular political ideology or specific social actors' economic interests. Rather, her perspective allows for unexpected, even paradoxical effects of heritage making, effects that, however, have much to do with the materiality of heritage objects or sites and how they allow for specific forms of embodiment or emplacement, and also afford specific affective and sensorial responses. Macdonald suggests

that anthropologists abandon the notion of 'heritage' in favour of paying attention to practices of 'past presencing' in modern European societies. According to her, 'past presencing' encompasses all technologies, materializations and objects that societies have created in order to make the past present, which should all constitute the object of anthropological enquiry, with a special focus on 'how they allow access to distant pasts and places' (Macdonald 2012: 246).

When studying heritage, anthropologists usually have in mind museums, archives, monuments and sites of commemoration as well as architectural heritage, food traditions and other manifestations of the man-made. In this book, however, I extend this analytical framework to include constructions of nature as well, following along the lines of sociologists Phil Macnaghten and John Urry (1998), who insisted that nature, as it is embodied in Western European notions of landscape, countryside and – more recently – environment, is also historically generated and invested with cultural meanings and collective memories. So nature reserves, national parks and other forms of protected areas will also be considered, for the purposes of this study, examples of 'presenced pasts'. I submit them to the same types of anthropological enquiries as ensembles of old village houses placed under preservation orders. I am particularly interested in the role of expert knowledge that goes into 'past presencing', and what kinds of material-discursive practices constitute the making of heritage. Experts – scholars, administrators, entrepreneurs and cultural brokers – take centre stage for my research into what I consider a technology of governance at the beginning of the twenty-first century.

European Products

In Cyprus, heritage is a European product. 'European products' stand for a rather broadly conceived category of things, practices and ideas that are infused with European Union regulatory mechanisms. As I have argued elsewhere (Welz 2005; Welz and Lottermann 2009), European products have emerged as a result of the implementation of EU directives and laws. Indeed, they would not exist without them. They are effects – some by design, some unintentional – of EU governance practices. As the application to heritage artefacts and sites suggests, 'European products' need not be commodities in the conventional sense, or goods that European economies are exporting abroad. They are as diverse as children's toys that are guaranteed to be free of harmful toxic substances, food products labelled to warn people who suffer from allergies that they may contain traces of peanuts or, as in this book, nature conservation areas legislated under the EU's Habitats Directive and managed as so-called Natura 2000 sites. Quite a few are material, others are intangible and still others take the form of standards. Not all of them are mandated by

the European Union, as some are also based on other intergovernmental accords between European states. Nevertheless, it is the rules that regulate these European products, as well as their development, implementation, monitoring and subsequent modification which make up a large part of the work that is being done in the European Commission and in the General Directorates of its services, keep the members of the European Parliament busy, and fill countless pages of documents.

Since the 1990s, anthropologists have been enquiring into the modalities and effects of the European integration process. The new research focus on the European unification process entailed moving in an epistemological landscape quite different from that of an earlier anthropology of Europe, which conducted ethnographic studies of village communities and peasant societies and looked for relics of tradition and the residues of premodern social order. Europeanists in anthropology were now entering into lively debates on modernity, subjectivity, power and the state. (Borneman and Fowler 1998) They also insisted that Europe was no stable object or predefined geopolitical unit, but the result of ongoing negotiations and even contestations, and that 'an anthropology of Europe needed to focus on the interrelationship between local events and macro social processes of "state formation, national integration, industrialization, urbanization, bureaucratization, class conflict and commercialization"' (Goddard, Llobera and Shore 1994: 14). Instead of aligning itself with the anthropology of Europe,[1] this book argues for an anthropology of Europeanization. Europeanization foregrounds becoming rather than being European, paying special attention to the unevenness and discontinuity of the process, instead of expecting convergence and increasing cohesion. More precisely, for anthropologists, being interested in Europeanization means to focus on social actors and practices in those countries that belong to the EU, have recently joined or aspire to do so in the future. Rather than assuming that the balance of power is irrevocably tipping from the member states to supranational institutions and that national sovereignty is being evacuated by governance shifting to actors both above and below the nation-state, the Europeanization approach is 'grounded in an understanding of Europeanization as interactive process' rather than 'a narrow, linear, top-down notion' (Radaelli 2004: 4) of the impact of European Union institutions on politics in the member states. Each country adapts to the challenges that alignment with the EU poses in its own way, thereby recontextualizing EU regulatory frameworks and making them work 'on the ground' (Börzel and Panke 2010). This ultimately results in a two-way transfer of policy blueprints and problem-solving strategies. 'Europeanization deals with how domestic change is processed, and the patterns of adaptation can be more complex than simple reactions to "Brussels"' (Radaelli 2004: 4).

Research addressing Europeanization from an anthropological point of view does not only look at national-level bureaucracies and domestic deci-

sion makers in relation to their counterparts in the EU, but also engages with nongovernmental organizations (NGOs), social movements, regional governments, municipal administrations and local initiatives. Many analysts of the way the European Union implements the policies that it develops argue that the EU works by way of engaging other actors beyond the narrowly conceived political institutions, and that it often 'functions without any direct imposition of order but through a steady process of ordering' (Barry 2002: 147). Indeed, the institutionalizing of so-called multistakeholder deliberation and the involvement of nonstate actors, such as business people, experts and civil society organizations, in so-called new governance procedures is quite typical for the way the EU manages to implement its policies in the member states. Many analysts point out that this makes the EU an outstanding example of neoliberal state practices.

Anthropological enquiries into Europeanization benefit from anthropological work on transnational governance and neoliberal governmentality. Following Foucauldian theoretical inclinations towards identifying technologies of power, 'governmentality offers a way of approaching how rule is consolidated and power is exercised in society through social relations, institutions, and bodies that do not automatically fit under the rubric of "the state"' (Gupta and Sharma 2006: 277). Europeanization poses new challenges, both to the state's practices of spatialization and to anthropology's attempts to conceptualize statehood.

The EU manages 'to intensify the regulatory and technical interconnections between its member states' (Dunn 2004: 163) by introducing new procedures of management and quality control. Hailed as helping to increase productivity and the competitiveness of the economy as well as facilitating transnational commerce, these herald much more fundamental transformations of society and everyday life. Much of this is happening not through the implementation of laws, state controls and sanctions, but rather informally, by introducing so-called best practices and soft law. In this book, I contend that the designation of heritage provides inroads for the Europeanization of social life, institutions and individual agency. Indeed, the presenced past in Cyprus today is a European product, a social construction infused with EU values, standards and regulatory power.

Cyprus: Postcoloniality, Division and EU Accession

For almost three hundred years, Cyprus had been part of the Ottoman Empire before it came under British colonial rule in 1878 (Faustmann and Peristianis 2006). Greek-speaking Christian inhabitants of Cyprus were encouraged, not only by the British colonial elites but also by travellers from other countries of

the European north, to consider themselves heirs to the Hellenism of antiquity that in turn was considered to be the patrimony of the entire Occident. When the Crown released Cyprus into independence in 1960 and the Republic of Cyprus came into being, the two main communities on the island, Greek Cypriots and Turkish Cypriots, were forced by the departing colonial power to become reluctant partners in a shared sovereign state. (Kizilyürek 2002) Their mutual antagonism that had been catalyzed by the divide-and-rule politics of the British and fuelled by the nationalisms of their 'mother countries', Greece and Turkey, erupted into civil war in the winter of 1963/64. Intermittent intergroup violence had already in the 1950s resulted in the division of the capital city of Nicosia, and a United Nations (UN) peace mission was installed on the island. In 1974, the Turkish military invasion of the island, ostensibly to protect the Turkish Cypriot minority, caused numerous deaths among Greek and Turkish Cypriots. Greek Cypriots were expelled from the north of the island by force, and Turkish Cypriots fled from the south. Since then, about one-third of the island has been occupied by the Turkish army. The de facto partition of the island remains in place today in spite of numerous attempts by domestic and international political actors to affect a resolution and reunification. In 2003, the strict prohibition against crossing the 'Green Line' that applied to Cypriots of both communities was lifted unilaterally by the authorities in the north, thereby making travel back and forth possible across designated checkpoints. This gave displaced persons the opportunity to visit their lost homes, although a resettlement of refugees has not been possible as yet and continues to be one of the bones of contention in negotiations between both sides.

On 1 May 2004, the Republic of Cyprus, along with nine other countries, became a member of the European Union. Accession negotiations between the EU and Cyprus had started in 1998. Throughout the accession process, much hope had been invested in the ability of the EU to bring an end to the division between the Republic of Cyprus in the south and the Turkish-occupied north of the island. However, in a referendum in 2004, a majority of Greek Cypriots voted against a United Nations peace plan that was supported by the EU and had offered a comprehensive framework for the reunification of the island. This was only one week before the Republic of Cyprus became a new member of the EU. As a consequence, the European Union's community contract, the Acquis Communautaire, was suspended for the internationally nonrecognized Turkish Cypriot polity in the north of the island. Even though talks were reopened under the aegis of the United Nations in 2008, the political process has remained stalled until recently. In the springtime of 2014, a new round of talks generated hope that the Cyprus problem might be solved within the foreseeable future.

So far, however, the so-called Cyprus problem remains an unresolved issue. After 1974, Greek Cypriot society bonded around the trauma of the invasion and the prevailing political insecurity, with all social groups striving for a so-

cietal consensus. This also restricted opportunities for dissent and pluralism and cemented conservative attitudes that preclude risk taking. The Turkish invasion of 1974 is often cited as a cause for a delayed modernization process. Economically, however, the Republic of Cyprus experienced an unprecedented economic comeback, dubbed 'the Cyprus miracle' (Christodoulou 1992).[2] Since then, the economy showed impressive growth rates, and incomes were steadily on the rise. Cyprus transformed itself from a developing country into a rapidly expanding services-based economy that thrived on its position as a bridge between Europe and the Middle East. For many years, the workforce enjoyed full employment, and the labour market also attracted many temporary immigrants from non-European countries. In the 1980s and 1990s, the fast-growing tourism economy was a major factor in this, also contributing to marked population growth in the urban centres and the coastal agglomerations.

Billed under the heading of 'construction', another booming economic sector since the late 1990s has been real estate development, increasingly targeting buyers as well as investors from abroad. In many of the environmentally sensitive coastal areas, the mushrooming of resorts and villa developments that are advertised abroad as second homes or tax havens represents an especially problematic effect of these developments.

While the image of a sun-and-sea tourism destination with a rich cultural heritage is still being deployed, other economic sectors have been on the ascendancy since the 1990s, most markedly the financial sector and corporate services. In 2011, services accounted for 80 per cent of the economy, with tourism making up only one-quarter of the service sector. Instead, the Republic of Cyprus has emerged as an important centre for so-called offshore financial sector operations, able to use low taxation as well as a well-developed banking sector, an efficient state administration, a transparent legal system, a high level of education in its workforce and the prevalence of the English language in its business sector to its competitive advantage. Even though EU accession introduced stricter regulations in the banking sector, Cyprus continued to enjoy the reputation of being a financial 'asset-protection location' (Kaufmann, Christou and Christophorou 2010), which in turn incited European officials and especially German politicians to denigrate the Cyprus economy as a tax haven.[3]

In retrospect one can say that the EU accession process 'proved to be the single most important driving force for Cyprus's socio-political, economic and institutional modernization' (Agapiou-Josephides 2005: 157) since independence. During the accession process, Cyprus speedily transposed EU rules and standards into national legislation. In the 1990s, there was broad support and even enthusiasm for attaining EU membership among Greek Cypriots. This was motivated most of all by the promise of security and the hopes for a solution to the political problem of the island that the EU appeared to offer. The extent of the ongoing social and economic transformation of the Republic of

Cyprus was most likely unintended by the political architects of Cyprus's accession to the EU, while the rewards that were anticipated with accession in terms of the solution of the Cyprus problem have not materialized. However, the experience of Europeanization exacerbated a widespread conviction that Greek Cypriot society is experiencing discontinuities and disjunctures in a process of rapid social change, summarized by a member of Parliament I interviewed in 1999, one year after EU accession was incepted: 'Superficially, we behave like the Europeans behave. The odd thing about Cyprus is that in economic terms, we developed very rapidly in the last forty years. But at the same time, in terms of social concepts and values, there is a lot of confusion.'[4] Social anthropologist Vassos Argyrou, in a contribution to a volume that looked back on fifty years of Cyprus as a sovereign state, argues that Cyprus remains a 'post colony, a society formed during the colonial period and hence a society also that cannot not reproduce the colonial power that formed it' (2010: 41). This postcolonial condition, according to him, explains the readiness of Cypriots to submit to the hegemony of European Union regulation. The aspiration to European Union membership, as Argyrou and other critics contend, and the desire to be recognized as a full-scale European society 'inadvertently reproduce(s) a historical experience of symbolic domination − the recognition that their cultural identity is inferior to that of the countries of Western Europe and North America' (Argyrou 1996: 3). Ultimately, Europeanization has set in motion a series of fundamental changes. Some of them are clearly positive, as are the increased opportunities for transnational exchange and cooperation, the strengthening of civil society and a more liberal cultural climate. However, the increasing reliance of the economy on business sectors especially vulnerable to the global financial crisis, and heavily implicated with the economic fate of Greece, has compounded the negative effects of European integration. These came to a head in the dramatic weeks of the March 2013 crisis when the so-called Troika of the European Central Bank, the European Commission and the International Monetary Fund imposed harsh measures on the government, banks and unsuspecting citizens alike in return for keeping the Cypriot state from bankruptcy. Since then, the economy of the Republic of Cyprus has been shrinking significantly, and unemployment is dramatically on the rise. Political actors in Cyprus engage in a discourse of crisis 'that is increasingly framing political conduct within the parameters of emergency, whereby the deterioration of social welfare and rights is considered inevitable and thus naturalized' (Demetriou 2013a).

Fieldwork in Cyprus: Ethnographic Modalities

Mediterraneanist anthropologists were slow to abandon the community study approach and held on to a focus on rural, often marginal village communities.

(Welz 2002) In recent decades, they exchanged the focus on traditional culture for a lively interest in how villagers respond to the exposure to modernization and social change. Coincidentally, the way for this paradigm shift was paved by an ethnography that Peter Loizos (1975) conducted in the 1960s in Cyprus, in a village of the Morphou district. However, even when single-sited community studies were still the norm in many of the southern European research areas frequented by Mediterraneanist anthropology, studies in Cyprus seem to have involved some degree of multisitedness almost from the very beginning, as fieldworkers would often be moving back and forth between the capital city of Cyprus, Nicosia, and a village setting.[5] Since 1974, the armistice line between the Republic of Cyprus in the south of the island and the Turkish-occupied north, the Green Line, was an almost insurmountable obstacle to mobility between the two parts of the island. However, some anthropologists managed to conduct fieldwork bicommunally,[6] both among Turkish Cypriots in the north and in Greek Cypriot society, even before the Green Line became passable in 2003.

This book, however, differs from most of the work done in Cyprus by anthropologists. For one thing, it is not strictly ethnographic, if one takes ethnography to mean a fieldwork approach that relies primarily on participant observation and is predicated on the fieldworker's ability to communicate in the native language. Conversely, I take ethnography to mean an epistemological stance based on the assumption that cultural realities are coproductions between the researcher and those he or she does fieldwork with and among. This book is based on a series of small-scale case studies that span the better part of two decades. The case studies coalesce around the issue of heritage making in the Republic of Cyprus, but they were not initially intended to form a unified monograph. The material for them was collected at different sites over periods of time of varying length, some over many years, within the framework of a protracted research engagement. Beginning in 1991, I started coming to Cyprus with my late husband, Stefan Beck, often for two, sometimes three, times a year. Visits would last from a minimum of two weeks to extended stays of up to three months, dividing time and alternating between the region most intensively and best represented in the case studies, the northern part of the Paphos district in the west of the island, and the capital city of Nicosia. We often did fieldwork together but pursued separate research interests. Stefan Beck was a medical anthropologist and addressed the interface between biomedical science and social change. Over the years, his research ranged from thalassemia prevention and cystic fibrosis screening to reproductive medicine, organ transplantation and bio-banks.[7] In Cyprus, he discovered 'novel entities, facts, and relationships brought into being through the application of biomedical technologies' (Beck 2007: 17). He also used ethnographic accounts generated by his fieldwork, to develop and sharpen arguments extending far

beyond the implementation of biomedicine, in order to enquire into Cyprus as production-site of modernity. The collection of research materials for this book spans a period of fifteen years, from 1997 to 2012, with some earlier work done in 1995 also integrated into the analysis. In sum, the duration of these short-term visits adds up to more than eighteen months. Clearly, this kind of intermittent, piecemeal research does not comply with requirements of conventional ethnographic fieldwork as an intensely sedentary, continuous activity by a fieldworker who immerses him- or herself in the daily life of the community under study. Nor does my research in any simple way mirror the new modes of 'multisited research' (Marcus 1995) that have been invented in order to make ethnographic fieldwork more compatible with the challenges of globalizing cultures. These abandon the conventional focus on a single site of data collection in favour of much more flexible research designs that might engage a multiplicity of sites spread over a number of countries but connected by links of mobility or communication. As opposed to cross-cultural comparison, there is no juxtaposition of social units, but multisited projects aim to emphasize transnational networks and mobilities. Recently, George Marcus has called our attention to a new 'modality of collaboration' in ethnographic fieldwork:

> As fieldwork has become multisited and mobile in nature, subjects are more 'counterpart' than 'other'. Fieldwork becomes implicated in the organized knowledge of its subjects, in the form of social movements, NGOs, research groups. The basic trope of fieldwork encounter shifts from, say, apprentice, or basic learner of culture in community life, to working with subjects of various situations in mutually interested concerns and projects with issues, ideas, etc. (2009: 7)

Rather than calling my research 'multisited', however, I prefer to apply the label of 'studying sideways', a term that Ulf Hannerz coined some years ago to denote a new type of fieldwork that has been emerging with the growing interest of anthropologists in expertise and knowledge practices (Hannerz 2004). Many of the people I worked with in my research can be considered experts in the sociological sense of the word: they are civil servants, representatives of NGOs, entrepreneurs, university professors, journalists, artists and politicians. The areas in which they were trained and in which they apply their professional expertise cover regional planning, architecture, art history, folklore, anthropology, food science, archaeology, biology, geology, environmental policy, nature conservation, heritage management, agricultural economics and sustainable tourism development. Most of them received their training and acquired their academic degrees abroad. They are working in areas that are increasingly connected transnationally, especially within the European Union, and their command of the English language is generally very good. A few could be interviewed in German which is my native language. Increasingly, anthro-

pologists find themselves interviewing and working alongside professionals of other disciplines whose work habits and interests are often not so dissimilar from social science research, and with whom the anthropologist often shares standards of professionalism and work ethics. At the same time, cultural differences also become much more apparent when interacting closely with 'counterparts' whose professional universes intersect with mine as fellow academics, teachers, researchers, conference speakers and authors.

Much of my work was with these counterparts, many of whom live and work in Nicosia, the divided city that is capital to both polities, south and north. In addition, the area of and around the municipality of Polis Chrysochous in the north of the Paphos district became a permanent field site for me and my husband over many years, affording a long-term association with places and people, refreshed every year by one or more 'revisits'. Sociologist Michael Burawoy, whose epistemological as well as political enquiries into the history of ethnography in the social sciences are particularly insightful, uses the term 'revisit' to denote sequential fieldwork spread over a number of years, often decades, during which the researcher keeps returning to the same place or area. Burawoy argues that there is a special reflexivity afforded by the fieldwork modality of the revisit, as 'every entry into the field is followed not just by writing about what happened but also by an analysis in which questions are posed, hypotheses are formulated, and theory is elaborated—all to be checked out in successive visits' (2003: 668). The research that this book is based on was conducted as sequential fieldwork of short-term research visits spread over a period of more than fifteen years. The Swedish social anthropologist Helena Wulff claims that 'repeated returns strengthen [the] bonds to the field', and adds that 'immersion … is a process that occurs along a time axis' (2002: 123).

'Temporalized' forms of conducting research today, however, do not only mean travelling back and forth between 'the field' and one's academic home institution, but also entail switching between on-site and off-site fieldwork (Dalsgaard 2013). What counts as fieldwork today may include both face-to-face encounters with social actors 'in the field' and long-distance interaction, such as keeping up with people in the field by phone or email and reading newspapers published in the fieldwork community or country. Because my engagement with this particular permanent field site spanned almost two decades, the development of modalities of research also made me more acutely aware of the 'changes in the technologies of practising ethnography' (Wilk 2011: 15) that have not just extended the scope of ethnography but also, as Richard Wilk convincingly argues, are making boundaries between the professional practices of anthropology – research, writing, teaching – more porous,[8] eventually eroding the separation between work and free time, professional and private life. Indeed, during the fifteen years of research that led to this book, not only has email as a mode of correspondence become ubiquitous, even among officials

of the Cyprus government, but in Cyprus, cell phones have effectively replaced the use of public phone booths as a mobile telephony option and considerably eased the fieldworker's efforts to establish contacts and make appointments. Gone also are the days when the Cyprus newspapers that I subscribed to would be sent by mail, to arrive in Germany a week after the date. Today, the Cypriot press is accessible to a large degree on the Internet; many newspapers have websites, hosting online editions that are updated frequently as well as news services and blogs. Even more importantly, much of the information sources that during the 1990s were only accessible in hard copy, printed on paper and filed away in archives, today are available and easily accessible on the Internet. Increasingly, government documents that used to be published exclusively in Greek are now also available and can be quoted in an English-language version.

This is also an effect of the 2004 European Union accession of the Republic of Cyprus. For one thing, being a EU member state meant that the state bureaucracy but also nongovernmental actors as well as the business world established closer links with transnational networks, both within and without the EU. Also, the new mode of neoliberal governance, operating by way of quality control, documentation and self-checking, generates a huge amount of written texts, both online and offline. The documentary practices of organizations are particularly useful to the anthropologist to 'unpack the work of institutions and bureaucracies' (Escobar 1995: 113). By translating events or objects into textual form, organizational texts[9] bring schemata and structuring processes to bear on local populations (Ferguson and Gupta 2005). For the purposes of my analysis, government documents, EU publications and NGO reports constitute important devices that make Europeanization socially effective.

About This Book

This book explores how heritage as a European product plays out in Cyprus. The book looks at Cyprus as a postcolony and as a recent member to the European Union that is currently undergoing a severe crisis both of its economy and of its self-image as an equal of other European nations. Unlike most social science studies of Cyprus, however, the book does not address the Cyprus problem, the division of the island, and the likelihood of achieving reconciliation of the two main communities and a reunification of the island. While this issue continues to draw much attention from academics, politicians and the media, the effects of European integration on Greek Cypriot society have not been discussed as widely as the Cyprus conflict by social scientists. The small but growing number of studies conducted in Cyprus by anthropologists also, for the most part, address aspects of Greek Cypriot and Turkish Cypriot past or future coexistence on the island. While these studies are particularly valu-

able in contesting mainstream analyses by political scientists and historians, instead highlighting issues of local agency and counter narratives to hegemonic discourses, this 'resulted in the relative neglect of other areas that have traditionally concerned anthropology elsewhere' (Papadakis, Peristianis and Welz 2006: 23). This book is an attempt to address some gaps in a number of understudied research areas pertinent to Cyprus. So far, there have been only a few studies in the anthropology of tourism addressing Cyprus.[10] The production of heritage within frameworks of tourism, rural development, urban and regional planning, and environmental policy in the Republic of Cyprus has rarely been tackled.[11] Nor has the role of the European Union in the current transformations of Greek Cypriot society received as much interest by anthropologists, or members of other social science disciplines, as it deserves. This book deals with case studies in the Republic of Cyprus exclusively and will refer to comparable situations and developments in the so-called Turkish Republic of North Cyprus only in passing. Yet, heritage making in the Republic of Cyprus can only be discussed against the backdrop of the ongoing division of the island. Two polities, south and north, are competing for ownership of cultural heritage sites, often voicing conflicting claims for the same cultural artefact or heritage site. This comes to the fore in some of the case studies assembled in this book.

The first section of the book explores how abandoned buildings in rural areas have been reinvented as vernacular architecture within a framework of state-legislated and state-funded historic preservation. Chapter 1, the first chapter within this section, shows how, even before EU accession, historic preservation was infused with European standards, aesthetic as well as material, and also served as a conduit for Europeanization. The second case study in this section enquires into how vernacular architecture became an asset and a resource to be exploited economically when the new tourism product of 'agrotourism' was introduced in Cyprus. Chapter 2 shows how agrotourism creates an interface between so-called traditional houses and tourist consumption. The last chapter in this section addresses how the inland and mountain regions of Cyprus became aligned with the European Commission's hegemonic ideas of rural economies and agricultural land uses. Chapter 3 looks at rural development policies in Cyprus, and considers them to be a European governing technology that produces new categories of social actors as well as new discourses about 'rurality'.

Anthropologists consider food items and food practices to be important sites for the creation, negotiation and contestation of cultural meanings. The second section of this book engages with the political dimensions of food production and consumption. Chapter 4 addresses the invention of culinary heritage within the framework of mass tourism in Cyprus since the 1960s. The so-called Cyprus *meze*, a plethora of various individual dishes combined in a set meal, embodies many of the tensions and contradictions that accom-

panied the emergence of Cyprus as one of the sun-and-sea destinations of Mediterranean tourism. By symbolizing affluence and even excess, *meze* also reflects social change within postcolonial Greek Cypriot society. As an effect of industrialization and changing consumer habits throughout Europe, many artisanal foods that used to be produced in rural households and small family-run businesses have become almost extinct because they cannot compete against mass production. This has also happened in Cyprus. The EU's origin foods programme is intended to strengthen the economic competitiveness of regional food producers as well as to sustain the diversity of the European food repertoire. Chapter 5 engages with this programme as an instance of neoliberal governmentality, analyzing the conflicts that coalesced around an application to the EU to safeguard halloumi cheese as a Greek Cypriot product.

The third section combines two case studies. One addresses nature conservation in a coastal area encroached upon by real estate development, the other cultural heritage protection in the divided city of Nicosia. At first sight, these topics may not be closely related. However, the European Union and other transnational agencies are operating with economy-driven notions of heritage as a 'resource', which allows them to conceptualize both unspoiled nature and historically generated culture as productive assets. Chapter 6 reports on long-term research into conflicts over the future of the Akamas Peninsula, a wilderness area in the west of the Republic of Cyprus. The second case study addresses the historical heart of the city of Nicosia, the old town encircled by the Venetian walls and dissected by the barbed wire and sandbag fortifications of the Green Line. Chapter 7 explores how cultural politics engages with the division of the city, striving to subvert and ultimately to overcome it. Heritage preservation, cultural projects and artistic production play an increasingly important role in the attempts to position Nicosia, and the whole of Cyprus, well within the European cultural arena.

What about the 'unmaking' of heritage that the title of the book refers to?

Today, because of the risk of state bankruptcy, the demise of the banking sector, the declining economy and the dramatic rise of unemployment, especially among young adults in Cyprus, 'heritage' may appear as a comparatively inconsequential, even banal topic for ethnographic enquiry. Yet, the production of heritage, the commodification of traditions and the construction of tourist destinations bear scrutiny precisely because the so-called Troika and the Cyprus government in their Memorandum of Understanding have earmarked tourism and real estate development as future economic growth sectors for Cyprus. The book's conclusion consolidates the perspective of postcolonial critique and attempts an assessment of the future role of 'heritage making' within the realm of the European Union's hegemonic politics, in Cyprus and elsewhere in Europe.

Heritage is but one example of how 'European products' are being standardized across Europe. However, heritage making emerges as a privileged and

indeed authoritative political tool within the wider framework of Europeanization. The celebration of historic legacies is employed throughout Europe, to instil a sense of European citizenship in the populations of European countries and to establish 'a common cultural basis for a European demos' (J. Scott 2005: 227). For heritage to fulfil its European role, it has to transcend its narrow association with national identities and ally itself with the EU's normative ideal of culture building via 'unity in diversity'. But the cultural logic of all heritage making itself harbours a fundamental tension between the assertion of distinctiveness and the fact that in order to plausibly exhibit its uniqueness, it has to resort to conventional means of heritagization that are becoming increasingly similar not just within Europe, but worldwide.

Notes

1. Today, the anthropology of Europe has become a well-established area of specialization in anthropology, engaging researchers from most European countries (Kockel, Nic Craith and Frykman 2012) as well as non-Europeans, mostly from North America. The impact of European Union policies on European citizens, who may well experience them as interventions from above, their identity projects and how they engage, in affirmation or resistance, with the symbols of inclusionist Europeanness, the representations of a common legacy and shared future, figures prominently in many of these studies. European citizenship as a category of rights and entitlements and also as the effect of exclusionary practices draws the interest of many younger ethnographers who address issues of immigration politics, human rights and the EU's regimes of policing its outer boundaries. Though the voice of anthropology is not heard often enough, and even more rarely listened to in the centres of European integration research and European studies, ethnographic studies rise to challenge the hegemony of historians and political scientists who have the monopoly on explaining how and why a unified Europe came about.
2. Greek Cypriot refugees from the occupied north had effectively been impoverished by the loss of property and land at the hand of the invaders, and had to be integrated at great cost into the south's economy and housing market. However, not only economically, but also in terms of social effects and even health issues, the consequences of the displacement and loss forced on the refugees are complex and not easy to gauge (see Loizos 1981, 2008).
3. In addition to growing into an important centre for 'offshore' financial services, the Republic of Cyprus has also come to prominence for hosting a register for foreign-owned ships. For ship-owners it is advantageous to register a vessel in a country like Cyprus, where labour legislation for many years allowed for low-wage employment and pay continues to be low. This in turn makes Cyprus also a location for maritime services, many of them concentrated in the port city of Limassol.
4. From an interview conducted in 1999 with Katherine Clerides, a politician representing the progressive wing of the centre-right party DISY (Welz 2001: 232). For an acute analysis of social change in Cyprus since the 1930s and the resulting bifurcation of class cultures since the 1960s, see Argyrou (1996).
5. Peter Loizos, in his 1975 study about the fate of his co villagers from Argaki who were displaced by the Turkish army in 1974, travelled all over Cyprus to meet with the refugees. This study, then, prefigures the multisited fieldwork ideal. With him, however, it was no

methodological ploy; his fieldwork responded to the fate that his friends and relatives were suffering from, having found temporary refuge in many places, dispersed over the south of the island.

6. Bicommunal anthropological fieldwork in Cyprus, both in the north and in the south, has been done by Papadakis (2005), Bryant (2004) and Dikomitis (2012). A multisited study in the Turkish Republic of North Cyprus is Navaro-Yashin (2012).

7. He was particularly interested in the condition of postcoloniality, and in the social bases of altruism and solidarity in Cyprus. Some of his research took place within the framework of research grants, such as the EU-funded project 'Challenges of Biomedicine', other studies of his were self-funded and independently conducted, benefiting from close cooperation with medical specialists and anthropologists in Cyprus, in particular, Violetta Anastasiadou-Christophidou (Cyprus Institute of Neurology and Genetics), Pavlos Costeas (Karaiskakio Foundation) and Costas Constantinou (University of Nicosia). See Beck 2007; Niewöhner and Beck 2009; Amelang, Beck et al 2011; Beck 2011; 2012.

8. In 1999 and 2005, I organized and directed excursions with groups of graduate students in anthropology from the Goethe University Frankfurt to Cyprus, where they conducted small-scale research projects (Welz and Ilyes 2001). From these excursions, more intense engagements of some of these students with Cyprus resulted: a few returned to Cyprus as exchange students or as fieldworkers for periods of up to three months and wrote their master's theses or doctoral dissertations under my supervision. The topics of most of these dissertations, some of which are published as book chapters in an anthology (Welz and Lottermann 2009), engaged either with the Cyprus problem and bicommunal activism, or with immigration of third-country nationals to Cyprus and the EU's border regime (see Lenz 2010).

9. In recent years, the work of legal anthropologist Annelise Riles has turned our attention to those textual genres that she considers to be the most significant artefacts of institutional life. In her work, documents, funding proposals, newsletters and organizational charts have figured prominently (Riles 2001, 2006). Anthropologists are increasingly including these textual genres in their work.

10. Among them are the work of Julie Scott on transformations of the tourism economy in northern Cyprus (Scott and Selwyn 2011), the ethnography of Ramona Lenz on the tourism sector of the Republic of Cyprus as a labour market for immigrants (Lenz 2010) and Evi Eftychiou's critical analysis of the implementation of agrotourism in the Troodos Mountains (Eftychiou 2013).

11. Anthropologists have tended to look at social memory and heritage making in Cyprus primarily within the context of the political issue of Greek and Turkish Cypriot relations (see Bryant and Papadakis 2012). Within the context of the EU-funded project 'Identity and Conflict: Cultural Heritage and the Re-construction of Identities after Conflict', which addressed a number of postwar and conflict situations in Europe, a research team addressed Cyprus under the auspices of the Cyprus office of the Peace Research Institute of Oslo (PRIO) (see Constantinou and Hatay 2010; Demetriou 2012). One other exception is the multinational project 'Mediterranean Voices', funded by the EU under the aegis of the Euromed Heritage II programme, which created a database of oral histories and cultural traditions from thirteen cities around the Mediterranean, including Nicosia (see J. Scott 2005).

PART I

Heritage Regimes

❧

When historians and architects start to address old buildings as 'traditional houses', when these are classified as architectural heritage by preservation experts and restored according to the rules legislated by state institutions, a heritage regime is emerging. Regimes produce compliance with legislation and standards; they are forms of governing that do not exert top-down power on the subjects that they intend to bring in line, but rather enlist their collaboration. Regimes often have fuzzy boundaries, extending beyond what is recognizably connected with state bureaucracies and the implementation of legal frameworks, as they tend to rely on nonstate actors such as entrepreneurs, citizens' groups, professional associations and scientific experts. The first section of this book enquires into how the heritage regime has been implemented in the Republic of Cyprus, arguing that in the course of this process, historic buildings, the built environment of entire villages and the landscape itself are being transformed into 'European products'.

CHAPTER 1

Preserving Vernacular Architecture

❧

Kritou Tera is a community some twenty-five kilometres north of the city of Paphos in the west of the island. It is located on a plateau among a smattering of small villages. Kritou Tera is a compactly built settlement, consisting of one- and two-story stone houses along a winding road hugging the shoulder of a hill, with buildings climbing the hillside on top of a ravine. There is an open space next to the church and the old school building, and at the road junction near the lowest point of the village, an impressive row of public fountains used to provide water for the irrigation of nearby gardens, for a communal laundry and for the uses of individual households.[1] Kritou Tera was once among the largest villages of the district. However, by the beginning of the 1990s, many residential buildings were abandoned and threatened by decay, mostly as a consequence of villagers leaving the community in search of better economic opportunities elsewhere. The primary school closed down for lack of pupils, the regular bus service for Paphos was discontinued. The intensive horticulture and the care of the apricot, almond, walnut and carob trees on the centuries-old terraced parcels of land on the slopes up and down from the village was increasingly discontinued, as many elderly became unable to provide for the upkeep.

The marginality of the region had become pronounced by the end of the 1980s. Many of the villages in this area had already been considered poor and 'backwards' during the time of British colonial rule. In the 1960s, the newly independent Cypriot state counted the rural hamlets on the plateau among its more isolated and less developed communities. Caused by limited economic options, out-migration of residents to the cities of Cyprus but also to other countries had begun before independence, in the 1940s. Muslim and Christian inhabitants had coexisted in the region until the intergroup violence that erupted in Nicosia late in 1963 and then quickly spread throughout the country, which prompted most Turkish Cypriot co residents to leave the formerly mixed villages and seek refuge in so-called enclaves. Some villages whose inhabitants had already in the past been mostly or exclusively Turkish Cypriot became enclaves, but refugee camps were also set up, some under the supervision and protection of a United Nations peace mission. After 1974, the Turkish Cypriot villagers relocated to the north of the island, which had been occupied by the

Turkish army. By the beginning of the 1990s, some of the villages in the vicinity of Kritou Tera were almost depopulated, with only some, mostly elderly, Greek Cypriots staying behind.

In Kritou Tera, of around eight hundred inhabitants after the Second World War, only 164 residents were left in 1992, merely a handful younger than fifty years of age. At that time, there were few all-weather roads connecting Kritou Tera to the outside world. The main highway down in the valley bypassed the village by a considerable distance, as did the road that traverses the plateau. The plateau is called Laona, a generic name in Cyprus for such landscape formations. The relative isolation of Kritou Tera and the other villages of the Laona region was one of the reasons why tourism development had not yet touched this micro region. By the early 1990s, the coastal plain just fifteen kilometres to the south underwent massive development at a very rapid pace. Today, hotels and apartment complexes form an almost unbroken line along some stretches of the coast. This was the situation that caused a Cypriot environmentalist organization, the Cyprus Conservation Foundation, to initiate a project to stop the further decline of the communities of the Laona area. In 1989, the Laona Project received funding for a five-year period from the European Union.[2]

The Laona Project lends itself to a close-up study[3] of how principles of historic preservation that had been developed in other European countries were introduced to the Republic of Cyprus, transposed into legal frameworks of protecting architectural heritage and implemented by the relevant bodies of government. It all started here, in the Laona villages, initiated by a handful of architects, art historians and public intellectuals. None of them were locals; rather, they represented the urban elite of postcolonial Cypriot society. In what follows, I will show how this pilot project paved the way for a new discourse on the significance of village houses that before were thought to be of no particularly value. The chapter then enquires into heritage management as a European governance regime and discusses its implications for Cyprus.

Heritage and Nationalism in Cyprus

In postcolonial Cyprus, the heritagization of village houses that were considered comparatively worthless economically and of little historical or cultural value provides a useful case in point to show how heritage – both the material artefacts and society's understandings of what constitutes heritage – became effectively Europeanized in the Republic of Cyprus. The focus in this chapter will be on what is sometimes called 'minor heritage', denoting the rather common examples of vernacular architecture that are ubiquitous throughout rural communities in Cyprus but received little attention until recently. In contrast, the impressive historic monuments and unique archaeological sites that Cyprus

is known for internationally had already been established during colonial rule (Hardy 2011) and since have been bolstered by the presence of international archaeological teams conducting excavations. Some sites were declared World Heritage sites by the United Nations Educational, Scientific and Cultural Organization (UNESCO).[4]

Clearly, heritage policies in the Republic of Cyprus cannot be fully understood without reference to the colonial period, and could even be seen as a continuation of the symbolic domination by the British. The British colonial administration introduced discourses and practices of valuing and venerating the Hellenic legacy of the island and created institutions and infrastructures, such as the Department of Antiquities, that were dedicated to salvaging and safeguarding archaeological sites and relics. Some authors point out that the heritage ideologies of the colonial period have imbued the present-day practices of the Greek Cypriot patrimonial regime with a largely unquestioned nationalist bias that excludes the Turkish Cypriot minority from also being considered heirs to the island's legacies (Bryant 2004; Hardy 2011).

However, architectural heritage became a significant object of contention between Greek and Turkish Cypriots in the aftermath of the intergroup violence of the 1960s and the Turkish invasion in 1974. In nationalist discourses of both sides, heritage emerged as a symbol of injustice and usurpation (Papadakis 1993, 1998). As a consequence of the de facto division of the country and the displacement and population exchange along ethnic lines, numerous buildings of intense cultural salience for either community became inaccessible after the 1974 invasion, when their location was on the – as it were – wrong side of the Green Line, and until 2003 remained largely out of reach. The destruction or defacement of historic buildings and, in particular, of religious sites such as churches, monasteries, convents, mosques, sites of pilgrimage and cemeteries figure prominently in narratives of mutual accusation between Greek and Turkish Cypriots. As recently as 2012, the Greek Cypriot government published an elaborate brochure, titled 'The Loss of a Civilization: Destruction of Cultural Heritage in Occupied Cyprus', giving evidence of Turkish Cypriot atrocities committed against churches, cemeteries and other exemplars of Greek Cypriot architectural heritage in the north of the island.[5]

Obviously, as is attested to by many examples from other countries, a single building can come to signify the patrimony of an entire nation. Returning to the discussion of the Laona Project, it is interesting that the discourse of historic preservationists and architects describes the area of the Laona villages as a Homeric landscape, dotted with archaic relics. Even without an explicit reference to a presumed Hellenic heritage of the area, such allusions invoke images of the area as being a stronghold of an autochthonous Greek population on the island. The essence of the original landscape is considered to be Greek, with the Ottoman rule and the coexistence of Greek and Muslim populations

constituting a brief interlude in the long history of this region. Because of prevalent social discourses in Greek Cypriot society that seek to define the status of Greekness vis-à-vis the collective identities of the island's diverse populations, issues that come to the fore nationally are played out here in Kritou Tera and the other villages of the Laona region.

The built environment of the Laona villages also stands witness to more recent events in the island's history. Only a ravine separates Kritou Tera from its sister community, Tera, half an hour away on foot. While Kritou Tera's residents were mainly Greek-speaking Christians with a minority of Muslim co villagers, Tera was exclusively Turkish Cypriot, a prosperous community with a plentiful water supply and large houses set among gardens planted with vines and fruit trees, grouped loosely around a shapely mosque. Elderly Greek Cypriot residents of Kritou Tera like to tell of the good-neighbourly relations with the Muslim villagers, saying that 'in times before the troubles, we went to their weddings, and they came to ours'. In 1964, at the time of intergroup violence in the still young Republic of Cyprus, the Turkish Cypriots who had made up a quarter of the population of Kritou Tera left and settled across the ravine in Tera, and Kritou Tera became an exclusively Greek Cypriot village.[6] After the Turkish invasion of 1974 in the north of the island, the Turkish Cypriots remaining in enclave communities such as Tera were effectively prisoners in their own land. A year later, in the summer of 1975, they were evacuated by the UN and escorted to the Turkish-controlled north. Tera, then, was deserted.

In 1975, the Greek Cypriot government requisitioned all Turkish Cypriot properties in the area under its control and set up a state authority for their administration, in order to provide housing for the Greek Cypriot refugees who had been displaced by the Turkish invasion of 1974. Abandoned Turkish Cypriot agricultural land and businesses in the south were leased to Greek Cypriot farmers, artisans and shopkeepers who had lost their means of subsistence due to the invasion. The relevant legal basis and institutional setting was reformed in 1991, creating the office of the Guardian of Turkish Cypriot Properties, and then amended again in 2010. In contrast, the Turkish Cypriot regime in the north illegally appropriated Greek Cypriot properties, transferring them to new owners who were given title deeds for properties effectively stolen from Greek Cypriot owners.[7] The fact that the Republic of Cyprus keeps Turkish Cypriot real estate in trust, mostly restricting its use to temporary leases by Greek Cypriots displaced from the north, serves to underline what Greek Cypriots consider their morally superior position in the Cyprus conflict. In addition to the dispossession of Greek Cypriots in the Turkish-occupied areas whose properties were usurped, the blatant neglect, vandalism or destruction of Christian churches, cemeteries and monasteries in the north figure prominently in Greek Cypriot discourse about the Cyprus conflict. Conversely, the Greek Cypriot state pays for the upkeep of mosque buildings and Muslim

cemeteries in the area over which it exercises sovereignty. Some of them have become sightseeing destinations for tourists, while a few, located in the cities where Muslim immigrants are more numerous, have retained their religious function. However, in rural areas where most of the former Turkish Cypriot villages in the south are located, the state of repair of mosque buildings is often not very good.[8]

Initially, after the invasion, Greek Cypriot families displaced from the occupied north came to stay in Tera. A few years later, many Greek Cypriot refugees left the rural villages where they had been resettled by the government and moved to towns instead where they could find work. Tera, like many other Turkish Cypriot villages in the area, since then has become a place of Greek Cypriots' weekend homes and summer residences. In the 1990s, legal changes made it easier for Greek Cypriots to rent Turkish Cypriot houses from the government authority administering these properties. Tenants who sign a lease for Turkish Cypriot property have to guarantee the upkeep of the property and consent to return it to its owner in the case of a solution. Unlike property owners in the Republic of Cyprus, who only have to submit to the preservation regime when they receive subsidies from the state, those who take a lease on a Turkish Cypriot house held in trust must comply with rigid historic preservation guidelines, prohibiting them from using any building materials not in character with the vernacular architecture.[9]

Villages Frozen in Time

In international architectural discourse, vernacular architecture denotes structures erected according to cultural traditions. The construction of vernacular buildings does not require formalized expert knowledge such as architecture and engineering, but rests on the experience and embodied knowledge of local builders, stone masons, carpenters and the like. In Cyprus, vernacular buildings are quite modest, both in size and in terms of the materials used. Most of the building materials originally were from the region, or at least from the island. Walls were constructed either of fieldstones or mud bricks or both, with some variation between the lowlands and the higher elevations, where stone was used exclusively. Only some materials were imported from abroad, such as roof tiles.

> One of the main elements characterising rural dwellings is that they are built without following a set plan.... These houses were usually composed of two or three narrow long rooms, the 'makrinaria', which were always positioned against the boundary edges of the plots, either in a linear or an 'L' shape formation. The rooms are rarely linked to each other and have doors only toward the courtyard. (Department of Town Planning and Housing 2004: 27)

Only when the courtyard was too small for extensions would a second story be built on top. More spacious rural dwellings were constructed around a central room open to the courtyard, the *iliakos*, which often was supported by a stone arch. There was little regional variation between rural dwellings in the past, the main division in architectural styles being the one between rural and urban houses. Most authors also insist that the vernacular architectures of Turkish and Greek Cypriots exhibit no major differences (Numan and Dincyurek 2005; Philokyprou and Michael 2012).

A 'traditional house' is not simply an old building, but has to be produced by normative assessments of its historic, cultural and aesthetic value. These are usually based on hegemonic definitions by cultural elites and then in turn are authorized by state bureaucracies. Throughout Europe, the principles and terminologies of historic preservation became increasingly standardized starting in the 1970s. In the Republic of Cyrus, local actors started, with some delay, to copy and implement them.[10] The Laona Project was instrumental in this process. It is significant that the Laona Project was no government-led initiative, but a pilot project conducted by civil society actors who acquired EU funding long before the Republic of Cyprus acceded to the European Union. The intention of the project was to transpose to Cyprus the very preservation expertise and restoration practices that had already been tested and applied in other European countries that had started to salvage and safeguard the often humble buildings of rural communities.

What exactly happened in the case of the Laona Project? Its objective was the conservation of the historical built environment of Kritou Tera and four other villages, intending to use it as a model for the preservation of vernacular architecture throughout Cyprus. In addition, it was also concerned with offering sustainable economic options, such as agrotourism, to the villagers. Therefore, under the aegis of the project, village residents willing to renovate abandoned buildings received subsidies to pay the interest on bank loans towards the cost of building restoration, in order to transform old houses into tourist apartments. A strict framework of guidelines was worked out by the preservation architects of the project in order to safeguard and restore the original character of the structures. In Kritou Tera, a taverna was opened at the entrance to the village that served only traditional regional dishes according to season. In other project villages, the project reconstructed a grain mill, established a small store selling regional products – honey, nuts, basketry, woven carpets – and cultivated a herb garden where tourists could buy locally grown spices, teas and medicinal herbs. On a hillside outside of another community, a dilapidated chapel dedicated to a local saint was restored in order to serve as a focus for tourist interest. In addition to renting the apartments to guests on a weekly basis, it was also hoped that visitors staying at the conventional mass tourism accommodations on the coast would come on day trips, go on

nature hikes and sample the various products and sights. The revival of traditional agrarian products and techniques, some already abandoned by the local population in favour of more modern procedures, was supposed to provide a basis for sustainable local economic development. In addition, the old school of Kritou Tera was transformed to house the offices and seminar rooms of the Environmental Studies Centre. Since its inception, this educational institution offers field trips and hands-on ecological training to primary schools in the Paphos district as well as to groups of students from all over the eastern Mediterranean and the Near East. Because the visiting student groups initially were fed in the taverna and housed in the accommodation units created by the Laona Project, the centre was also expected to have a positive economic impact.

Heritage policy sets in motion a process of valuation that typically proceeds via two distinct stages, first by 'encouraging villagers to see humble, neglected functional objects … as pieces of art' that are 'to be handled with care under expert guidance' (Filippucci 2004: 76). In a second step, this process of upgrading is based on 'centrally formulated classifications of the culturally valuable' by specialists who downplay the historicity of the individual building, the traces of actual use and appropriation, in favour of its typicality for the regional vernacular style. Social anthropologist Paola Filippucci's study (2004) presents an acute analysis of heritage policy in a region of northern France, and many of her findings resonate with the observations made in the Laona villages in the 1990s. The Cypriot preservation architects also borrowed important tropes from European preservationist discourses that claim that vernacular architecture is 'the principal signifier of local specificity and character, materializing the successful adaptation of people to soil, displayed by their practical knowledge of local materials' (Filippucci 2004: 79). Reports written by the Laona Project staff use organic analogies and naturalizing metaphors when describing the principles of construction, the building materials and the basic architectural tenets of the built environment of these villages. Structures were presumed to have manifested themselves according to laws of nature, as their anonymous builders drew the necessary skills from their familiarity with the environment: 'Nature and the environment provided the knowledge' (Evthyvoulos 1997).[11] Tradition was naturalized, imagined as a hidden quality that is discernable only to the initiated observer (Beck and Welz 1997).

In the Laona villages, the renovation work was geared towards reconstructing the original state of structures, many of which dated from the nineteenth or early twentieth century. This meant removing any changes that successive owners and residents had added on since. At the same time, any future interventions were precluded by preservationist measures. The restored buildings had to be immunized against processes of change. For this reason, stucco and paint were removed from the fieldstone walls. Window shutters made of wood as well as wooden doors and gates were created in the old style by carpenters,

to replace iron, aluminum and plastic. The carpentry work was not painted any colour, so the natural wood was left to the view. Otherwise, throughout the villages, shutters and doors are often painted blue, sometimes green or even red. The renovated buildings all looked the same. The synchronization of village structures according to a unified vision of historical architecture also had the effect of effacing all traces of the historical process. Indeed, even the contemporary function of the buildings could no longer be perceived by the onlooker, because most signs of residential and agricultural use had been erased or hidden. The yards and streets were emptied of anything that could possibly disturb the visual appropriation by tourists. Fertilizer bags, broken-down machinery, boxes and implements that could bear witness to agricultural production disappeared and were replaced by decorative pots planted with flowers. The life world of the villagers was transformed into a 'typical example' of traditional architecture. The fiction of the past made accessible in the contemporary world froze the village in a homogenous temporal horizon. Historic preservation, like other types of heritage management, is 'a rationalizing project which potentially limits the capacity of marginalized rural communities to reproduce themselves as active subjects of history' (Leitch 2003: 441). Cultural anthropologist Nadia Seremetakis, in her study of the relationship between sensory perception and identity construction in Greece, even goes as far as claiming that the European Union's interventions in the heritage field entail a massive 're-organisation of public memory' (1994: 3).

Preservation Standards and Aesthetic Control

During the 1990s, the outside intervention by the Laona Project led to the intensification of internal social conflict within Kritou Tera and the other project villages, as the infusion of additional funds and resources into the fragile village economy made competition between households come to the fore. But even more so, conflict erupted between local residents on the one hand and the Laona Project on the other. Many villagers felt patronized by the project team, whose agenda disregarded what they perceived as their legitimate local needs. The fact that the project director and the architects came from the cities of Limassol and Nicosia, representing the upper classes of urban Cyprus, did not help. In particular, the local population chafed against the Laona Project's prohibitive stance against new construction activities. Some of the families had plans to open businesses, such as a supermarket or even a petrol station, and met with staunch resistance from the project management. A struggle ensued when a *mukhtar*, a community leader of one of the villages, used government money allocated to the community to upgrade the road connecting the village to the highway. This happened behind the backs of the preservationists, who

had earmarked the funds for the reconstruction of the old well in the village. The village leader argued quite craftily that without a blacktop road, the tourist buses bringing business to the agrotourism apartments would not be able to reach the village. Yet, this particular instance of conflict, for the project staff, constituted evidence of the intransigence of the villagers. Conversely, the villagers were enraged at what they perceived as arrogant and denigrating treatment by the urbanites, especially in terms of the extremely rigid restrictions concerning the renovation of individual houses as well as the conservation of a so-called traditional appearance of the village and its streets. The furnishings of the tourist apartments in the renovated buildings was prescribed by a handbook that regulated even tiny details and represented all its rules in the form of pictographs. This created the impression that the authors of the handbook expected the villagers to be illiterate, which constituted a heavy insult for the local residents, who are well schooled and count university graduates among them.

In a recent study of the implementation of agrotourism in two communities of the Troodos region of Cyprus, social anthropologist Evi Eftychiou also found that urban experts chided the local population for its apparent obstinacy and lack of taste in terms of the 'new traditionalist aesthetic' (2013: 262) that is being promoted by government officials as part of the heritage regime of historic preservation. In this context, Eftychiou asserts that while the villages are being dominated by way of instruments of 'monitoring' and 'inspection', the local population attempts to resist in many ways. This resonates with Michael Herzfeld's findings in the Cretan town of Rethimnon, where conservationist practice aimed at keeping the built environment unchanged, while for the residents 'who have gradually modified their physical environment without making radical changes, it is a shocking destruction of the familiar; not continuity, but radical change' (Herzfeld 1991: 14). Once the built environment of a community undergoes a valorization process and becomes transformed into a 'monument' in the sense that Herzfeld describes, the legitimacy of the 'social time' of the residents is contested by the authorities.

In the Laona region of Cyprus, villagers believed that modernization had bypassed them, unfairly favouring other villages closer to the coast or to the highway instead. They refused to be allocated the role of carriers of tradition. Rather, they wanted to be free to decide for themselves what to do with their property. For them, upholding tradition meant to adapt old buildings to present needs, or to build new houses for their children. Conversely, for the Laona Project and its proponents, the introduction of internationally acclaimed standards of building preservation in Cyprus was an opportunity to prove that they themselves were truly modern because of their adherence to European standards. In the event, however, they also came to the realization that a top-down implementation that generates confrontation rather than consensus ultimately will be far from successful. When they engaged in a new project, they

pursued a much more participatory approach. During the years 1999 to 2002, the Cyprus Conservation Foundation conducted a second project in another area of the Paphos district. With the River Valleys Project,[12] the foundation took a different approach. Here, the objective was to work in an integrated way towards sustainable land uses in the area under study (Amato 2001). The project received funding from the same sources as the Laona Project, but in contrast to the Laona Project, it was designed in response to a request from local community leaders. Many of these communities have since been revitalized, in many cases due to strong community leadership and local initiatives supported by former village residents who moved to the cities.[13] Conversely, in the area that the Laona Project was established in 1989, the trajectory of community development did not follow the route that the initiators of the Laona Project had envisioned. Some years after the project ended, social anthropologist Anne Jepson conducted a long-term ethnographic study in Kritou Tera. From 1999 until 2001, she enquired into how local horticultural practices engage with the construction of subjectivities and collective identities. In her ethnography, the practice of gardening emerged as a mode of attaching oneself to place. For those involved in it, it produced a sense of social rootedness. She found that in Kritou Tera, gardens were functioning as 'areas of mediation' between social actors, between past and present, as well as negotiating cultural constructions of nature and the social (Jepson 2006). Jepson's study suggests that their abandonment would greatly impoverish the social universe of the village. Today, though, many orchards and fields around the village are no longer maintained, even though the irrigation channels near the old fountain have been cleaned up and some of the gardens in its vicinity taken under cultivation again. Sadly, many traditional buildings that were converted into agrotourism accommodations in the 1990s in Kritou Tera remain permanently closed today. The population number is dwindling, as the elderly are passing away and young families have moved to the rapidly expanding urban agglomeration of Paphos. Increasingly, houses are being sold to foreigners making a second home in Cyprus.

Conclusion: 'Streamlined Along the European Prototype'

Initially, after Cyprus became independent, there was scant attention paid to the aesthetic appeal and historical value of old village houses. 'While the state provided funds and legislation for the protection of important archaeological and historical monuments and sites, traditional architecture remained unprotected, subject to the rapid construction growth that occurred in Cyprus in the decades 1960–1980,'[14] as a documentation compiled in 2012 by the Department of Town Planning and Housing of the Ministry of the Interior surmises in retrospect (Department of Town Planning and Housing 2012: 69).

However, already in 1976, legal measures were taken to make the protection of vernacular architecture possible, with the first preservation orders issued in 1979, for buildings in the old part of Nicosia. Yet, it was only in 1987, with Cyprus becoming a contracting party of the Convention for the Protection of the Architectural Heritage of Europe, that preservation started to receive more attention as an important obligation of the government. Also, a number of financial incentive programmes for owners willing to renovate buildings were established then, and the Listed Buildings Act came into effect in 1992. The Laona Project was an important contribution to the effort to develop criteria for the renovation of vernacular architecture and minor heritage in the Republic of Cyprus.

Today, the Conservation Sector of the Department of Town Planning and Housing considers 'aesthetic control' to be one of its imperatives, in order to ensure that restoration work on historic buildings is carried out in keeping with the ideals of heritage preservation. In the early days of establishing preservation practice, this was achieved by close cooperation between the planners at the department, the owners of buildings applying for subsidies, and the engineers and architects working on the restorations. One of the planning officers went as far as collecting photographs of particularly bad examples of renovations that were conducted by owners without consultation with the ministry. To the planners' eyes, these unregulated modernizations of old buildings resulted in particularly unfortunate design decisions; they manifest utter ignorance of architectural 'best practice' and, quite as often, plain bad taste. Such an 'atrocity file' is both a pedagogical tool and proof of what the experts consider their superior aesthetic judgement. Critical heritage scholar Kristin Kuutma reminds us of the deeply problematic effect of classificatory systems such as lists and inventories of heritage, claiming that these are always culturally biased, entailing 'choices of inclusion that are based on representational agendas and preservation policies' defined by 'cultural custodians' that privilege certain social groups while excluding others (Kuutma 2012: 26). In recent years, brochures and books that present particularly well-done examples of restoring vernacular architecture throughout the Republic of Cyprus have also been published and disseminated by the ministry. Increasingly, these also include private homes in vernacular structures that have been substantially remodelled by architects to allow for modern conveniences such as artist studios, swimming pools and wellness spas.[15]

In the Republic of Cyprus, property owners become entangled with the preservation regime whenever they want to take advantage of government subsidies for the restoration of historic buildings. Since 1985, the Ministry of the Interior's Department of Town Planning and Housing gives incentives to owners of structures that can be classified as architectural heritage. By 2009, close to seven million euros were spent in subsidies per year, to enable owners to rehabilitate their buildings. Representatives of the government are acutely

aware of the fact that their ability to actually influence the aesthetics of the historic built environment is, however, with few exceptions, limited to those cases where proprietors apply for subsidies from the government. Funding is only given for complete restorations. As these require that proprietors shoulder at least 50 per cent of the cost, this is an option that low-income homeowners often cannot take. The group of elderly homeowners subsisting on small pensions that actually make up a large portion of village residents will instead opt for piecemeal work and small-scale repairs. For these, there are no subsidies – and consequently no supervision by the ministry. One of the officers implementing the architectural heritage management of the Ministry of the Interior states that 'every year, people make alterations and little by little, they change the character of the house'. Clearly, the exigencies of living in an old structure that requires repairs and the limited financial options of low-income residents that do not allow for a whole-scale renovation of a building actually mean that this group of homeowners neither benefits from subsidies nor submits to the discipline exerted by the experts. Even when there is no money to repair a house and it becomes unliveable and is eventually abandoned, families usually do not put it on the market: 'People do not sell houses, even if they collapse. They may sell land, but not houses', the officer quoted above adds, indicating that this is a particularly Cypriot approach to property. This, however, resonates with what anthropologists have found in others areas of Europe as well (Filippucci 2004; Silva 2011).

While so far, vernacular architecture only comes into the purview of planning experts when the owner is restoring a building and seeking subsidies from the government, the preservation regime of the Republic of Cyprus is expanding, ultimately to encompass all existing historic buildings. New legal instruments instigated by the European Union, such as 'local plans' for municipalities and villages as well as 'area schemes' that are replacing the earlier planning framework for rural areas, are integrating concerns of historic preservation. Also, the Department of Town Planning and Housing of the Ministry of the Interior has established an Architectural Heritage Inventory. On the basis of community surveys, information on the built environment of entire settlements as well as on individual structures is collected and indexed (Enotiades 2001). Index cards constitute a simple but effective technology of collecting information and categorizing objects. Lists are taxonomic devices, and listing as a practice materializes the act of placing a building under preservation orders when protected structures are entered into a roster of 'listed buildings'. Since 1978, preservation orders have been issued for a total of more than 2,500 buildings in Cyprus.[16] The department has produced a 'Manual for Listed Buildings' to make available to property owners in order to educate them about 'appropriate preservation techniques' that will further formalize preservation principles and aesthetic standards. In creating this manual, Cypriot architects and planners were obvi-

ously building on earlier expertise such as the achievements of the Laona Project. They also engaged with Europe-wide knowledge networks and technology transfer. Not surprisingly, the close relationship with the relevant authorities in Greece has been very important for planners and architects engaged with implementing the new heritage regime in Cyprus.[17]

Indeed, the preservation of historic buildings is a good example of how expert judgements and authoritative definitions of heritage value are brought to bear on the materiality of tangible artefacts. Markus Tauschek argues that the listing of heritage is one of the most common bureaucratic tools that translates an object – in this case, most often a building – into a valuable monument (Tauschek 2012: 208). Also, Sharon Macdonald has pointed out that discourses, technologies and bureaucracies of heritage making that are applied in order to mark places, histories and cultural artefacts as unique and one of a kind are becoming increasingly standardized across Europe. The phenomenon of marking place distinctiveness by way of reference to narratives of the past can be observed throughout Europe. Macdonald calls it 'historical theming' and contends that 'ironically, rather than differentiating, this theming risks creating an apparent sameness of place … through its promulgation of similar strategies or techniques of historical marking' (Macdonald 2013: 4). Adopting Kirshenblatt-Gimblett's assertion that heritage making is a 'metacultural operation' (Kirshenblatt-Gimblett 2006), Macdonald emphasizes that similar heritage management practices and discourses can be observed throughout Europe, in spite of marked differences in 'what is meant by "heritage" – and the expectations that flow from it' in various countries. Indeed, heritage making is a good example of standardized differentiation (Busch 2011), deploying standard operations to mark a defined set of differences.

In the case of Cyprus, it is possible to closely observe how transnational standards of heritage management were introduced and implemented from the 1990s onwards, that is, before the accession process to the European Union was initiated. As a consequence, a new type of political, legal and bureaucratic framework emerged in the Republic of Cyprus, not unlike what Tauschek (2012) calls 'the patrimonial field'. Government officials, but also civil society actors, were striving to emulate the 'best practices' authorized by Europe-wide institutions and networks of knowledge transfer, such as competing for the European Union Prize for Cultural Heritage, Europa Nostra, and hosting events within the framework of the European Heritage Days, a programme jointly organized by the European Commission and the Council of Europe. Already in 2001, three years before Cyprus's European Union accession, a report presented by urban planners of the Ministry of the Interior proudly declared that in the field of architectural heritage preservation, the government's policies have to a large extent been 'streamlined along the European prototype'. As mentioned above, in 1987, Cyprus had become a signatory to the Convention

for the Protection of the Architectural Heritage of Europe, the so-called Granada Convention, and adapted legislation accordingly. During the past decade, representatives of the government have been participating even more intensely in many of the transnational initiatives and networks that disseminate information and harmonize legislation throughout Europe, under the auspices of the European Union, the Council of Europe and related programmes such as Euromed, the Euro-Mediterranean Partnership. To say that heritage is a European product, however, not only refers to a Europe-wide standardization of heritage management practices, or the role that transnational bodies such as the Council of Europe and the European Union are playing in this process. Rather, heritage has become an important element in the symbolic repertoire of European integration in a paradoxical way, relying on rather than breaking the intimate link between patrimonial regimes and national identities. In a divided country such as Cyprus, where patrimony is a contested issue, this process is bound to produce controversial and often ambivalent results that make, but also sometimes unmake, heritage.

Notes

1. Historiography links Kritou Tera to the period of Ottoman rule, as it is the birthplace of Kornesius, an important dragoman during the late eighteenth century. In the Ottoman Empire, dragomans served as liaisons between the Ottoman rulers and non-Muslim population groups, in the case of Cyprus, the Orthodox Christians. Kornesius rose to prominence in the period between 1779 and 1809. At the time of my fieldwork during the 1990s, the long-time *mukhtar*, the village leader, kept a picture of Kornesius, the most important son of the village, on the wall behind his desk, next to the photograph of Archbishop Makarios III, the first president of postcolonial independent Cyprus.

2. Funding was made available by the EU within the environmental policy framework of L'Instrument Financier pour l'Environment (LIFE). LIFE projects are also available for non-EU countries. At the time of the inception of the Laona Project, the Republic of Cyprus had not started accession talks. The second important funding source of the project was the Leventis Foundation, a domestic sponsor of cultural activities and archaeology.

3. This chapter's starting point is an earlier study that I conducted between 1995 and 1997 in cooperation with Stefan Beck, analyzing the strategies and effects of the Laona Project (see Beck and Welz 1997). We conducted interviews with representatives of the project, local stakeholders and residents between 1995 and 1997. Since then, I have been able to gauge the long-term impact of the project and subsequent processes of social and economic change in the village, returning to the area annually and conducting additional interviews. Research on the Laona Project area since 1997 was based on regular visits to the communities and interviews with experts such as the director of the Laona Foundation, Dr. Artemis Yiordamli (1999, 2000, 2008), one of the project's architects, Antonia Theodosiou (2000), Environmental Studies Centre director Nicholas Symons (1999, 2004, 2008) and other staff at the centre, as well as resident social anthropologist Ann Jepson (2003, 2004). Research on the River Valleys Project was conducted in 1999 and 2000. In October 1999, the

leading architect of the project, Elena Kalliri, introduced the author and a group of students from the Goethe University Frankfurt to the communities of Salamiou and Amargeti (see also Amato 2001). An in-depth interview with Elena Kalliri conducted in October 2000 in her Nicosia studio provided additional insights. Sadly, Elena Kalliri passed away in September 2001. Important contextual information on the status of vernacular architecture within the framework of historic preservation in Cyprus was provided in meetings with the late Pefkios Georgiades (1999) – he then served as chair of the Pan-Cyprian Organisation of Preservation Architects, and later became Minister of Culture and Education during the Papadopoulos administration – as well as with archaeologist and art historian Anna Marangou (1999, 2000) and architect Sevina Floridou Zesimou (2004). Repeated meetings and interviews with planning officers in the Department of Town Planning and Housing of the Ministry of the Interior provided important insights into preservation legislation and its implementation (1999, 2000, 2004, 2008, 2010, 2012). In addition, many documents and reports published by the Department of Town Planning and Housing were analyzed.

4. Properties inscribed on the World Heritage List of UNESCO are the site of the Neolithic settlement of Choirokoitia (1998), the painted churches of the Troodos region (1985) and the archaeological sites of Paphos (1980).

5. See Press and Information Office (2012). Conversely, under the auspices of the Nicosia Masterplan, funded by the UN and, since 2004, increasingly by the European Union, the restoration of Christian churches and other historical buildings as well as protective measures in order to salvage the Greek Cypriot architectural heritage in the north of the island have made much progress. Also, the political negotiations between both sides included issues of heritage protection; to this end, a bicommunal Technical Committee was set up. See also chapter 7 of this book.

6. A research project conducted by the Peace Research Institute of Oslo has assembled, combined and analyzed publicly available information on displacement and population exchange, presenting data for individual communities. The website notes that 'in late 1963, when inter-communal fighting broke out again, the displaced were largely Turkish Cypriots (25,000 according to the UN) who abandoned their villages for the security of protected enclaves' (see PRIO 2011). For ethnographic data on Turkish Cypriot families from villages in the vicinity of Kritou Tera who relocated to the north of the island, see also Dikomitis 2012.

7. In her ethnography of northern Cyprus, social anthropologist Yael Navaro-Yashin writes about the allocation of looted properties to the displaced Turkish Cypriots by the authorities in the north, and the fact that they had to renounce their ownership of property in the south in order to be given new homes (Navaro-Yashin 2012: 188ff.). The sale of such properties to foreigners who are making a second home in the north of Cyprus has propelled debates and indeed lawsuits, even before European courts. The displacement of people from their homes, the relocation of refugees to new settlements and the almost complete population exchange after the 1974 invasion are today discussed by political actors almost exclusively in terms of ownership, access, use and rights of sale of real estate (see also Trimikliniotis and Demetriou 2012). For a discussion of the historical development of property rights in Cyprus, see Erdal 2010.

8. Conversely, criticism has been voiced against the Greek Cypriot government's practice of restoring mosques to their previous, preconflict state, which glosses over any destruction these buildings suffered at the hands of Greek Cypriot forces or irregulars during the so-called troubles of the 1960s and during the year 1974, after the coup and the invasion (see Hardy 2013).

9. This makes sense against the backdrop of the office of the Guardian of Turkish Cypriot Properties actually paying for the upkeep and executing necessary repairs on the buildings, acting on the expectation that these houses will be returned to their rightful owners once a 'solution' – to the Cyprus problem – is achieved. In practice, however, many of the Greek Cypriot tenants undertook radical changes to the buildings, involving structure and outside appearance, in order to make them more conducive to their present uses as weekend and holiday homes. This was possible because the construction activities, even though illegal, were not monitored or sanctioned. Only very recently, in 2014, political debates erupted in the Republic of Cyprus demanding a more transparent handling of the Turkish Cypriot properties held in trust. While there are some anthropological enquiries into what it means for Turkish Cypriots to live in residential spaces that were left behind by Greek Cypriots fleeing from the Turkish invasion forces (Navaro-Yashin 2012; Dikomitis 2012), an ethnographic study of the Greek Cypriot urban middle-class leisure culture that evolved in the former Turkish Cypriot villages still remains to be undertaken.

10. The process started when the so-called Venice Charter was adopted by the Second International Congress of Architects and Specialists of Historic Buildings in 1964. The European Charter of the Architectural Heritage was adopted by the Committee of Ministers of the Council of Europe in 1975. The Convention for the Protection of the Architectural Heritage of Europe, developed under the auspices of the Council of Europe and known as the Granada Convention of 1985, was ratified by the Republic of Cyprus in 1987.

11. The article reviews at length a book on the vernacular architecture of the Laona communities published under the aegis of the project by architects Antonia Theodosiou and Anastasia Pitta in 1996. Five villages participated in the Laona Project: Kathikas, Kritou Tera, Kato Akourdalia, Pano Akourdalia and Miliou (see Foundation for the Revival of Laona 1995).

12. The project area covered about 160 square kilometres and was located in the eastern part of the Paphos district, where three river valleys descend from the forests of the Troodos Mountains towards the flood plains and the coast: the Ezousas, Xeros, and Dhiarizos. Jointly, the valleys are known as the Kilades. An overview of the project is given in Cyprus Conservation Foundation (2000).

13. This is particularly evident in the communities of Amargeti and Salamiou, where community leaders have been able to acquire additional state and EU funding after the River Valleys Project was completed. Today, Salamiou boasts a cultural centre with a theatrical stage for a local lay theatre troupe, a day care centre for the elderly, an environmental studies centre and a rural medical unit, while Amargeti has created a museum and built a public hall for multiple uses, where as a response to the 2013 crisis provisions for needy families were collected.

14. In this brochure published by the Ministry of the Interior, the historic development of legislation and state funding for historic preservation is reported in detail.

15. This clearly presents a departure from the earlier principles that were applied in the 1990s in projects such as the Laona Project. Presently, regulations allow for additions and alterations to historic structures but require these to be of a contemporary design, clearly distinguishable from the authentic historic building. Creative solutions and state-of-the-art architectural design are invited. The glossy photographs that adorn the pages of recent brochures of the Department of Town Planning and Housing show that modern architecture has successfully made inroads into heritage restorations in Cyprus, also attesting to the fact that the urban middle class has discovered vernacular architecture as an investment and a status symbol.

16. Ecclesiastical buildings – churches, chapels, monasteries, as well as the mosques of the Turkish Cypriot minority – are included in this number, with the exception of those prominent buildings that are listed in the so-called A-list of 'scheduled ancient monuments'.

17. Also because of the shared language, Greek Cypriot planning culture appears to be strongly influenced by institutions and discourses in Greece. Literature and the wording of regulations from Greece can easily be communicated to local architects as well as to owners of historic buildings. The Greek and Cypriot governments cooperated on producing a Greek-language version of a thesaurus produced by the European heritage network HEREIN. It contains technical terms for architectural and archaeological heritage, achieving terminological standardization throughout Europe (see also Hadjisavva 2010).

Packaging Hospitality

Even in the pale winter sun of January, the limestone walls of the houses of Tochni give off a golden glow. Substantial stone buildings climb the steep hillsides on both sides of the narrow valley. The church stands next to the bridge linking both banks of the stream. The establishment of tourist accommodations in historical buildings saved this village in the Larnaca district from the decline that many other communities in inland Cyprus experienced when the transformation of the economy drew rural residents away to the coast and the urban centres. In the old core of the village, rehabilitated buildings, with their stonework left open to view, are adorned with rustic-looking wooden signs that advertise apartments for rent to holidaymakers. Following the narrow winding street on the right hand to the top of the hill, the traveller arrives at a building complex that combines a lobby and reception, a swimming pool and a restaurant furnished with antiques and handicrafts from the area. The porch running the entire side of the building, shaded by vines and bougainvillea to keep away the glaring sun during the summer months, offers a breathtaking view of the valley, which opens towards the coastal plain. Here, the offices of the largest agrotourism enterprise in Cyprus are located. It operates dozens of tourism accommodations not only in this village, but also in other communities of the area.[1]

Tochni, as well as neighbouring communities such as Kalavasos, has frequently been cited as evidence that an alternative to conventional mass tourism can be established in Cyprus by utilizing so-called traditional houses in the rural villages of inland areas. Because of their distance from the coast, many of these villages remain largely untouched by mass tourism. The preceding chapter analyzed the valorization of vernacular architecture within the framework of an emerging heritage regime that is based on expert knowledge and closely aligned with national as well as transnational governance. The example of Tochni, and of many villages like it, draws our attention to another type of valorizing the built environment of rural villages in Cyprus, namely, its appropriation as a specialized tourism product to be marketed to consumers from other European countries. In fact, heritage management and tourism marketing in many instances coincide and overlap, but also just as often are at odds with each other.

A Sustainable Alternative to Mass Tourism

In 1991, a new product called 'agrotourism' was created by the semi governmental authority in charge of tourism planning, implementation and monitoring, the Cyprus Tourism Organisation (CTO). Just like the heritagization of rural village buildings, economic valorization is a knowledge-based operation that relies on expertise. In what follows, two categories of experts – bureaucrats who are engaged in planning and implementing the Cyprus tourism product and local entrepreneurs who try to take advantage of the opportunity structure that governmental programmes and the international tourism economy are offering – figure prominently. Rural sociologists consider rural tourism entrepreneurs to be the protagonists of marketing agrotourism, as they function as cultural brokers who 'act as the main interface between local territories and tourism demand and consumption' (Figueiredo and Raschi 2011: 5). However, in the case of the Republic of Cyprus, the role of the government in conceiving and implementing tourism products has been stronger than in other European countries, so that state planning policies and governance influence the development and operation of agrotourism. This chapter takes a closer look at the material-discursive practices that create an interface between 'traditional houses' and agrotourism consumers, arguing that these practices effectively 'package' for consumption what is considered genuine Cypriot hospitality by the government planners.

In past decades, tourism development occurred primarily in the coastal areas. Cyprus was marketed as a sun-and-sea destination on the European market. This in turn created regional imbalances in public infrastructure, labour markets and residential development. A marked littoralization of economic and demographic growth worked to the detriment of inland and particularly mountainous areas of the island. In retrospect, studies of tourism development contend that especially after 1974, there was no alternative for Cyprus but to market its obvious assets of climate and coastline. However, after an initial boom that lasted into the 1990s, tourism's contribution to the gross domestic product steadily dropped well below the 20 per cent threshold. While this also reflects more general shifts in the tertiary sector-dominated economy of Cyprus, experts in tourism research had warned earlier that Cyprus's sun-and-sea-product would not be competitive in the long run. A tourism economy based on fairly ubiquitous assets such as a sunny climate and long shoreline can only remain attractive when it is able to operate at low cost. Therefore, the quasi-governmental Cyprus Tourism Organisation aimed for a diversification of the Cyprus tourism product. So-called quality tourism was billed as the rescue for the ailing economic sector. Major hopes were pinned on large-scale projects targeting high-end consumers, such as golf resorts, marina developments and, most recently, gambling casinos. However, 'diversification' also included the

developing of niche products such as medical tourism, heritage destinations and sports tourism.

By the early 1990s, the Cyprus Tourism Organisation also started to explore the economic potential of rural tourism. An incentive programme and a marketing platform were initiated. In Cyprus, however, there was no attempt made to create a product similar to agrotourism as it had been already disseminated in parts of Germany, Austria, Switzerland and Italy. There, agrotourism is often paraphrased as a 'holiday on the farm' because it is based on the notion that tourists should be able to temporarily become part of village life and, in particular, of the annual cycle of agricultural work. In these countries, and especially in the Alpine regions of continental Europe, agrotourism is intended to supplement the income of agricultural businesses operating in rural communities, helping them become pluriactive in the face of a restructuring economy that lead to declining incomes from agricultural production. Conversely, the development of the agrotourism product by the Cyprus Tourism Organisation in the beginning was exclusively focused on converting abandoned or underused buildings into tourism accommodations. These were in some cases operated as hotels, but mostly as self-catering tourist apartments. In Cyprus, there was evidently no attempt to link the provision of tourism accommodations with farming. The programme targeted exclusively rural communities that were doubly disadvantaged, both because they suffered from an aging population and increased out-migration of residents, and because they were located at a considerable distance from those coastal regions where tourism development had occurred at a fast pace and opened new income sources for the population.

Indeed, there is no single or universally valid definition of agrotourism (Amato 2001; Gronau and Kaufmann 2009). Agrotourism can, however, be grouped with those types of 'soft tourism', such as rural tourism and ecotourism, that British geographers Martin Mowforth and Ian Munt in their acute analysis of the political economy of sustainable tourism call 'new tourism' (Mowforth and Munt 1998). New tourism is marketed and consumed as an alternative to conventional forms of leisure and travel, most particularly as the antithesis of package tours. Mowforth and Munt are critical of the assumption that such forms of tourism are less interventionist, socially as well as environmentally, than mass tourism. Precisely because this 'alternative' market banks on the desire of consumers for 'off-the-beaten-track' destinations, it constantly seeks to integrate areas into the tourism economy that so far had not been part of it. In the Republic of Cyprus, the government-led agrotourism programme gave an impetus to transform nonused or only seasonally used buildings in villages into a productive resource. As has become obvious in the preceding chapter, buildings standing empty for all or most of the year are not scarce

in rural areas of Cyprus. To transform such housing stock into an economic asset by establishing them as tourist accommodation has been a route taken by the Cyprus Tourism Organisation since 1991. Its newly established agrotourism programme offered financial incentives by partially subsidizing the interest payments on loans undertaken by owners of such buildings. By the end of the 1990s, close to fifty units, mostly self-catering tourist apartments situated in villages situated in the interior, had been opened within the framework of the programme. In 2004, the comparatively limited subsidies extended by the Cyprus Tourism Organisation were replaced by a more generous Agrotourism Funding Scheme that was cofunded by the EU's Structural Funds and is to this day administered by the Department of Town Planning and Housing of the Ministry of the Interior, the same government authority that is in charge of the historic preservation measures discussed in the preceding chapter. Irrespective of the funding source attained for the building conversion, in the end, it is the CTO's rules that the owners have to follow in order to obtain licences for the operation of tourism premises.

By 2004, the number of agrotourism establishments in the Republic of Cyprus had risen to almost seventy units with a total of seven hundred beds. However, these represent a minuscule portion of the overall tourism sector in the Republic of Cyprus. Today, little more than 1 per cent of bed capacity in tourism accommodations licensed by the Cyprus Tourism Organisation is in hotels and self-catering apartments of the category that the CTO statistics call 'traditional houses'. Of the more than two million 'guest nights' that Cyprus averages every year, not even 1 per cent are spent in accommodations licensed under the CTO agrotourism scheme.[2] After 2001, when Cyprus was affected by a tourism downturn, the niche product of agrotourism was more heavily affected than conventional tourism. In some years, only 25 per cent of the capacity was used, compared to about 60 per cent bed occupancy rates reached in conventional accommodations. Yet, recently, agrotourism seems to have made a comeback. According to a report published in 2012 in an English-language local newspaper, the majority of visitors of agrotourism establishments today are urban Cypriots who spend weekends or summer holidays in agrotourism units. The largest group of foreign tourists who book agrotourism accommodation are from Germany, followed by French and Dutch tourists. None of these groups are particularly numerous within the overall picture of tourism arrivals in Cyprus, currently dominated by British and Russian tourists. Clearly, agrotourism is not among the most successful of the internationally well-known products of the Cypriot tourism economy. In order to achieve some degree of visibility, owners of establishments have formed a marketing and booking agency, the Cyprus Agrotourism Company (CAC), which operates under the aegis of the Cyprus Tourism Organisation.

The *Philoxenia* Standard

The advertisements of agrotourism accommodations that you find on the Cyprus Agrotourism Company's website as well as on countless Internet portals, brochures and other advertising materials that market Cyprus as a tourism destination are rife with visual depictions that invariably show rustic stone walls and wooden doors. The accompanying text often refers to the beautiful countryside, age-old traditions, hospitable locals, romantic views and unspoiled nature. Buildings and apartments always have a name, more often than not the first name of a member of the owner's family, thereby conveying the type of personalized hospitality that is an important component of the agrotourism product. Indeed, the CTO puts an emphasis on a normative construct that they call 'Cypriot hospitality' or *philoxenia*. The Greek word *philoxenia* denotes the hospitality shown to a guest. According to premodern social norms, hospitality was a moral duty that implied that a stranger 'is always honoured as a special guest' (Zarkia 1996: 163). Contemporary tourism marketing reproduces an essentialized version of this notion, reinterpreting it as a specific trait of Greek and Greek Cypriot society.

Above and beyond obviating the tension between culturally embedded notions of hospitality and their commodification in tourism,[3] the CTO's use of the term 'Cypriot hospitality' is also a code, calling on establishment owners to refrain from employing immigrants, that is, non-Cypriots, in positions where they would interact with tourists (Lenz 2010). During the 1990s, not just in coastal and urban settings but also in remote villages, domestic workers as well as agricultural labour from Asian countries was prevalent. In addition, the normative dimension of *philoxenia* also equals hospitality with face-to-face relations. An agrotourism host who is not present in the village and may leave the keys to the premises to be picked up elsewhere is not an exemplar of true Cypriot *philoxenia*. Evie Panayiotou, who is managing the Cyprus Agrotourism Company, is adamant that such misbehaviour leads to exclusion from the company and its advertising and booking faculty. This is important to note, as many if not most property owners in the agrotourism programme are not residents of the villages where their enterprises are located. Rather, they live in the big cities of Cyprus, even though their families often originate from the rural area where their business is located.[4]

Guidelines that tell the homeowners how to make a building look authentically rural are an important instrument in the conversion of lived-in space into an economic commodity. Tourism planners and administrators attempt to align local culture with their own idea of authenticity. For social anthropologist Evi Eftychiou, who conducted fieldwork in the mountain communities of Kyperounta and Kakopetria, tourism planning and its implementation constitute an important arena of identity politics, reflecting and also reproducing social

hierarchies – between rural populations and urban elites within Cyprus, and between Greek Cypriot postcolonial society and the West (Eftychiou 2013).

In my own fieldwork, I also found that when owners of buildings were confronted with a set of rules, they often found them difficult to fulfil but had to comply in order to be allowed to open an agrotourism establishment subsidized and licensed by the Cyprus Tourism Organisation. Today, detailed guidelines regulate the materials and designs used in building restoration, furniture and textiles that convey a properly traditional atmosphere, the layout of gardens and patios, as well as the selection of foods for agrotourism gastronomy (Mavrou et al. 2012). A new handbook for owners was developed in 2012 by a team of conservation architects. It is illustrated with a plethora of photos of recommended furnishings and implements and is reminiscent of a similar handbook that was developed within the framework of the Laona Project in the 1990s (see chapter 1). The Laona handbook aimed to impose standards of properly 'authentic' tradition on a rural population considered ignorant and uneducated by the urban elite. Indeed, Eftychiou claims 'that the native elites' modernist discourse normalized the representation of rural areas as backward, traditional and underdeveloped, thereby creating a division between urban and rural Cyprus' (Eftychiou 2013: 186). Interestingly, the new handbook disseminated by the CTO in 2012 explicitly engages with the aesthetic sensibilities of members of the new middle class. Today, the CTO no longer targets rural homeowners, but increasingly communicates its message to urbanites who own or have acquired historical housing stock in inland communities and may be interested in operating sophisticated agrotourism businesses.

Because of the CTO's original intention to build up an alternative to coastal tourism, most of the agrotourism establishments that were developed in the 1990s and since are located in villages that are a fair distance from the coast and its tourism infrastructure. Many of these villages suffer from out-migration and population imbalances. Comparatively few of the people actually living in the villages entitled to subsidization within the CTO's agrotourism framework initially took advantage of the programme. They 'have been mostly unwilling, due to their age, their background (mostly farmers, not tourism professions) and their generally weak finances, to venture in this line of business' (Press and Information Office 1999: 11), as one of the officers in charge of the programme pointed out to me as well. In addition to a low level of interest coming from the villagers, the CTO also restricted the volume of the programme. Thirty beds per village were considered a maximum threshold for the 'carrying capacity' of rural villages. While a limit to tolerable tourism impact in itself is not a bad thing, its application led to a situation where only a few buildings in each village became part of the project. The resulting problem was a high degree of spatial fragmentation. The majority of the agrotourism establishments of the CTO programme are spread over fifty villages, many with one or two units per village

with two to four beds each. Very rarely, enterprises like the one in Tochni have emerged that take advantage of local clusters of agrotourism establishments to build additional infrastructure in order to offer leisure activities and gastronomy to their guests.

After Cyprus's accession to the European Union, an additional funding source for agrotourism became available with the EU's Structural Funds and a new Agrotourism Promotion Scheme was set up within the Ministry of the Interior's Department of Town Planning and Housing. As a consequence, the criteria for a homeowner's eligibility for funding changed. Within the CTO framework throughout the 1990s and up until 2004, only local owners were entitled to CTO subsidies and to inclusion in the Cyprus Agrotourism Company. The definition of local ownership within the CTO programmes resonated with established notions of social belonging in Greek Cypriot society, as it connected the definition of the 'local owner' with descent membership in the village community. At the start of a meeting with an agrotourism entrepreneur in 1999, an official of the CTO's agrotourism unit introduced the entrepreneur to me and explained:

> Yianoula is an example of a typical agrotouristic owner. She comes from the village of P. That is, her parents lived in P. but she lives in Nicosia. She restored the house of her grandmother. Yianoula, because she is from P., could buy another house in P., restore it [and receive financial support within the CTO scheme]. I cannot go to P. and buy a house and benefit from the incentives of our scheme, because I come from another village, in Lemesos district. Within our scheme we have incentives for people from the countryside and coming from a specific village to stick to that village, to bring life back to that village, to strengthen the ties of the inhabitants of the cities with their villages [of origin].

Officers in charge of the CTO agrotourism programme today confirm that there is an increasing interest in the urban middle classes to rediscover and strengthen their ancestral rural roots, a desire that often takes the form of starting an agrotourism business, or renovating an old village house for personal use as a weekend and holiday home. This social construction of the category of the 'local', as it was implied in the earlier implementation of agrotourism development by the CTO, often had the unexpected effect of making urbanites, not rural residents, the prime beneficiaries of the programme, with absentee ownership of agrotourism holdings the rule and not the exception during the 1990s.

In recent years, educated middle-class Cypriots have emerged as the social group most interested in restoring old structures in villages that they may have either inherited or bought and converting them to new uses. Their appreciation of vernacular architecture is a strategy of social distinction that allows them to distinguish themselves both from the nouveaux riches as well as from the popular tastes of rural populations and the urban working class.

With Cyprus's accession to the European Union, however, this incentive scheme was changed. European Union guidelines preclude the exclusion of economic actors on the basis of their descent or family background. The agro-tourism promotion scheme that is funded by the EU's Structural Funds, then, is open to any proprietor of a building in the villages that fall within the confines of the areas eligible for funding because they are considered disadvantaged. Yet, the main objective of agrotourism is still, as one of the Structural Funds administrators at the Department of Town Planning and Housing asserted in an interview, 'to make these places come alive. It is better if we keep the local people there. But we also want to give incentives to people from other areas, people who like a village and want to invest there. For instance, if I like a village, why should I not go and invest there?' While before entitlement was regulated via exclusivist criteria of traditional descent categories and property relations, now, in the Europeanized version of the programme, more 'rational' selection criteria have been introduced, with a system of points awarded for various aspects of the proposed enterprise. Applicants are invariably required to submit business plans and often commission private companies to conduct feasibility studies beforehand. In the most recent round of selecting applications, particular emphasis was given to projects that are aiming for what the officials call 'enriching uses'. These value-adding strategies go beyond merely offering accommodation, gastronomy or a combination of both. 'Enriching uses' combine the conventional agrotourism model with other options for leisure and 'educational' activities, such as local crafts workshops, thematic museums, herb gardens, wineries, food processing such as bakeries, butcheries or cheese making, as well as more contemporary leisure, arts, 'wellness' and therapeutic products. Here, the reinvention (Gray 1999) of rural areas, styled to become the antithesis of the urban metropolis, appears to target domestic consumers alongside tourists from abroad to become consumers of commodity heritage (Grasseni 2005).

Today, however, agrotourism in Cyprus continues to be highly dispersed, with isolated establishments located in out-of-the-way communities that have neither gastronomy nor shopping facilities. Yet, no matter how insignificant the economic impact of agrotourism, Cyprus tourism policy proves that it has embarked on the road to so-called sustainable tourism development, which is considered an essential asset for any sophisticated tourism economy.[5] So while this sector may never become a particularly successful product in terms of market shares and quantitative development, it certainly is considered an important aspect of the image that the Republic of Cyprus's tourism policy wants to project. Ultimately, by offering a small agrotourism segment in addition to its mainstream product, Cyprus is trying to demonstrate that it is a genuinely European country. However, against the backdrop of the amount of publicity and financial support that the Cyprus government affords to other types of

tourism development, such as golf resorts and marina developments, the agro-
tourism programme is mere surface decoration rather than marking a policy
turnaround.

'Branding the Culture of the Villages'

The agrotourism enterprise briefly introduced at the beginning of this chapter,
called Cyprus Villages and situated in the Larnaca district, is one of the eco-
nomically successful ventures in this particular segment of the Cyprus tourism
economy. International research conducted in economic geography and eco-
nomics claims that the competitive advantage of clusters of businesses often
has to do with their ability to combine 'localized learning' with translocal, often
global linkages (Malmberg and Maskell 2002; Bathelt, Malmberg and Maskell
2004). The remarkable success of Sofronis Potamitis, the founder of this enter-
prise, which operates tourism accommodations in Kalavasos, Tochni and half a
dozen other villages in the vicinity, can be interpreted along these lines. Cyprus
Villages started in 1987, that is, some years before CTO began addressing this
sector. Then, Potamitis started to rent buildings and sublet them to tourists.
An advertising brochure of Cyprus Villages Traditional Houses Ltd starts with
a brief biographical portrait of its founder, asserting that his original motiva-
tion for creating the company was the revitalization of rural communities and
the preservation of the traditional architecture of the past. The intention 'to
keep the picturesque villages alive by providing the younger generation with
additional income'[6] is a key topic in the promotional literature of the enter-
prise. Sustainable development figures prominently in the self-presentation of
its founder. He aims to both embody and create a new type of entrepreneur-
ship that represents a departure from, or even an antinomy to, the business
model that most small and medium-sized enterprises in tourism in Cyprus
adhered to at the time when he started. Small-scale entrepreneurs usually were
aggressively competitive and, at the same time, adverse to risk taking, often
copying a neighbour's business model that had been successful during the pre-
vious tourism season (Welz 1999). Throughout the 1990s, Potamitis slowly
built up a substantial holding of traditional buildings, reinvesting profits into
the purchase and renovation of additional houses, many of which had been
standing empty and were threatened by decay. The company Cyprus Villages
Traditional Houses Ltd today operates almost two hundred rental units with
a total of close to five hundred beds in Tochni, Kalavasos and other villages. In
addition to buildings owned by the company, it manages many apartments that
belong to other local proprietors. The enterprise is economically successful.
Even during the past years of declining tourism income in Cyprus, occupancy
rates of the units were high.

As an entrepreneur, Sofronis Potamitis initiated a process of economic revitalization that ultimately averted the decline of the villages in the Tochni area. In interviews, Potamitis makes a strong claim that his business operates in accordance with the notion of qualitative growth in economics. The company acquired its bed capacity gradually over the course of fifteen years. This year-by-year growth of the holding to its present size also minimized risk and kept the enterprise sufficiently flexible. Today, Potamitis operates a tourism complex that is comparable to a fair-sized hotel, yet its creation did not require even a fraction of the investment that such a big operation would entail. During the past ten years, Potamitis has hardly acquired any additional buildings. Rather, he invested to adjust many of the existing accommodations to the level of sophistication that today's tourists expect. The length of the season during which the units are occupied has been extended by scouting out niches and special offers, such as seminars, wellness packages and programmes for families with small children. International certification for the apartments makes their standard comparable to other European destinations, and also enables him to price them accordingly. All of these measures are unique within the overall picture of agrotourism, which is dominated by operators who mostly have chosen agrotourism as a supplementary income.

Only the present size of the enterprise makes it possible to have a stimulating effect on the local economy by creating opportunities for other businesses. Again, this is part of the self-image that the entrepreneur aims to project, and he said in an interview that it was his 'dream that this will help the community as a whole to grow and profit, not just me as an individual'. His successful enterprise – directly or indirectly – creates income for other residents of the villages. Local agriculturalists are able to sell their products to the restaurants, and the presence of tourists allows for the year-round operation of three tavernas and one supermarket as well as other services. The thriving agrotourism economy of Tochni and neighbouring villages has caused real estate prices to triple during the past fifteen years. Local owners experience keenly that 'their assets are worth more because of the tourists'. And when they want to sell their land or houses', these fetch a much higher price than a few years ago. In a more general sense, the obvious attraction that their village holds for well-to-do tourists has strengthened local identity and convinced residents of the unique character of their community. More young adults actually stay and opt for the village as a place of residence than in years before. At the inception of the enterprise, Potamitis made a point of only employing local residents, 'women from the village'.[7]

The inordinate success of this enterprise clearly does not only stem from the fact that it occupies a monopolistic position in the agrotourism sector of the area, but due to the regional concentration, critical mass was achieved that allows for additional infrastructure that isolated owners of small units cannot offer. Potamitis created what tourism marketing specialists today call an

integrated product: in addition to the nearby beaches, numerous activities – hiking, mountain biking, horse riding as well as wine tasting excursions – are offered to the guests. Yet, Sofronis Potamitis is adamant that the picturesque appeal of the village of Tochni has little to do with the success of his business – agrotourism units marketed by Cyprus Villages are also located in villages in the Troodos Mountains and in the Paphos district. Rather, he points out that the villages of the Tochni area are privileged in terms of their ready accessibility from the Larnaca airport and their relative vicinity to the beaches east of Limassol, assets that he subsumes in an interview under the term 'access': 'It could be any village if you have access.' What he also calls 'the development of the product' depends more on 'tuning' the accommodations in accordance with the requirements of the targeted consumer segment than on the uniqueness of a village location. The entrepreneur's choice of architect and interior designer make a difference here, and he asserts in the interview that 'if you have a business foundation, you can go to another village'.

Yet, Sofronis Potamitis also emphasizes that he is a native of another village in the vicinity of Tochni. Clearly, the success of his enterprise would not have been possible for a complete outsider without the social capital that kinship and other local relations constitute. It is by constantly experimenting with innovative approaches that he keeps his competitive edge. He often refers to the fact that his mother operated one of the first tourist restaurants on one of the nearby beaches, which gave him an early exposure to tourism and made him particularly sensitive to the market's needs and reactions. 'You have to listen to what the customers say, what they like and what they do not like.' His ability to 'read' the tourists' responses and to anticipate their requirements appears to be one of the most decisive assets that he himself has, allowing him to develop innovations and constantly enhance his product. This biographically acquired store of experiential knowledge cannot be easily replicated by other actors in the sector and enables him to engage in learning processes that generate new solutions and innovations. He also networks with similar projects in rural tourism in other countries and shares his expertise in agrotourism with them.

Networking and sharing are tenets that also come into play in his approach to local competitors. He prefers to enter into cooperation with them rather than to try to head them off. This is unusual, as in the sector of small and medium-sized tourism enterprises in Cyprus, economic actors rarely cooperate, but engage in often hostile competition. The multiplication of businesses competing for customers in the same segments effectively minimizes profits, and the economic culture in the coastal tourism communities is characterized by 'dirty' competition and a dog-eat-dog attitude (Welz 1999). Against this backdrop, it is interesting to note that Potamitis does not seem to be unduly troubled by other homeowners in Tochni and Kalavasos transforming their buildings into agrotourism accommodations. Clearly, there is no danger that any other eco-

nomic agent in the area could build up a similar business of comparable size. Nobody could develop the infrastructure that his company has generated over the years. As it is, Potamitis offers other owners in the area to manage their rental units for them. 'Here in the village, everybody copies us. We make that part of the system, we go together.' By integrating those individual owners who also want to participate in the agrotourism business, Potamitis not only keeps control of the market but also ensures the high quality of the product.

Potamitis enlists local food producers, farmers and fishermen in his endeavour to create an interface between rural Cyprus and the consumers from various European countries, and at the same time, to mark Tochni and the neighbouring villages as a unique site. This is what he explicitly calls the promotion of 'the culture of the villages as a brand'. Tourists staying at apartments and houses in the Tochni region are encouraged to participate in activities of agriculture and local food production. In a seasonal cycle, these include the olive harvest in late autumn, followed by picking oranges in the local citrus plantations well into spring, and accompanying the fishermen from nearby Zygi out to sea during the summer. Tourists can also be present when local women make halloumi cheese in the cheese kitchens of their farms. To Potamitis, it is important that none of these activities were created for the tourists, but would also take place without tourists present.

> We use what we already have in the area. We give income to the farmers, but there is no dependency of the farmer on the tourists, they do not need the tourists. The farmer's wife is producing the halloumi cheese anyway because she sells it.... The farmers are happy because they get cheap labour. For instance, the tourists pick the olives for free, the farmer gives them a light lunch, cheese, olives, bread, some salad, we buy the olive oil from the farmer, and then we give some to the tourists to take home with them.... The next day, we teach them how to cook with olive oil, and we let them test, so they know what good olive oil is, when they buy it. When they see olive oil in the supermarket [they] will know exactly how it is produced because they made it themselves.

Potamitis is convinced that it is the local origin of 'food, music, people' that makes his product competitive, because 'only here you can have this!' In accordance with recent marketing philosophy in tourism and gastronomy, he conceptualizes the product as an experience: 'We will manage to be competitive if we offer unique experiences that can only happen in Cyprus.' Experience, as becomes clear from how he discursively couches the concept, is ensured by the uniqueness and quality of the food products involved, but relies to a significant degree on 'atmosphere'. Even though he himself places great store with explaining Cypriot cuisine to his guests, he also readily admits that the interaction between the tourists and the farmers or the fishermen who take them on board does not depend on verbal communication, as 'you don't need communication.

You don't need to talk, that is the beauty of it.' Potamitis's theory entails that people of different cultural backgrounds will enter into an effective communication when they jointly participate in an actual, material praxis such as plucking live fish from the net pulled in or stooping to collect the olives that have been beaten from the tree. While many local residents have a fair proficiency in English, 'it is even better if they don't speak perfect English, because this way there is an effort that comes from the inside. The tourists can see that. And it is more real.' The category of the 'authentic' that is constructed here is as heavily infused with notions of premodern simplicity and archaic essence as other constructions of folk culture. However, unlike other agrotourism programmes, which require formal training of locals before they can be entrusted with the task of presenters of tradition, Potamitis has confidence in the supreme capacity of local social actors to communicate their cultural skills to outsiders.

Conclusion: The Creation of Tourist Spaces

Old village houses that have been abandoned or are in use only for part of the year are prevalent in most of the communities of the hinterland of Cyprus. The economic value of such structures has declined dramatically, but in those areas where a process of economic revalorization has set in – within the context of the tourism economy and real estate development for second homes – this is changing rapidly, as the case study on agrotourism in the villages of Tochni and Kalavasos in particular attests to. How is an old and largely worthless building transformed into a potentially profitable resource? In order to trace the material-discursive operations that effect this conversion, we need to take into account some of the characteristics of such buildings. Houses are, of course, place-bound. As fixed and quite durable objects in permanent locations with a specific history, they cannot be re-created at will, like a new hotel or beach resort that can be constructed almost anywhere from scratch. Environmental conditions, the wear and tear of the elements on the building materials and the willingness and ability of owners and users to work at the upkeep of the buildings all contribute to the state of the housing stock. Vernacular architecture and, indeed, the built environment of entire rural communities has a unique and nonreplicable materiality that is the product of social practices, artisanal skills, cultural knowledge, the topography of the site, the building materials available to local populations and the social and economic history of the community.

According to heritage classifications, architecture belongs to one of two distinct and mutually exclusive conceptual categories: it is considered 'tangible' heritage. The divide between tangible and intangible heritage pervades globally effective patrimonial regimes and has coalesced in specific legislation and

heritage interventions, such as respective lists of monuments and heritage sites on the one hand and of 'intangible' performances, rituals, oral traditions and culinary patterns on the other. The most prominent lists are mandated by UNESCO, the United Nations' cultural organization. Buildings, monuments or any other type of material artefacts that are classified as 'tangible' heritage, by the same token, would not exist without the traditional knowledge and embodied skills that went into erecting or making use of them, nor would social actors be able to discern them as culturally valuable, symbolically significant or in any way worthy of attention or protection without recourse to collective memory, academic expertise or other types of 'intangible' information. Indeed, 'tangible heritage without intangible heritage is a mere husk or inert matter' (2006: 181), as Barbara Kirshenblatt-Gimblett contends. Anthropologists and critical heritage scholars increasingly cast doubt on the usefulness of the division between tangibility and intangibility in heritage protection, arguing that it obscures the interrelatedness of structure and agency, materiality and knowledge.[8] Rather, it would be useful to differentiate between a class of things that deserve protection because their 'material instantiations' (Kirshenblatt-Gimblett 2006: 181) are at risk of being destroyed, are unique or are becoming quite rare, and another class of things that could potentially be re-created endlessly but are considered in danger because the knowledge and skills needed to make them are disappearing.

But how does a house or an entire village become semantically charged in such a way as to be perceived, marketed and consumed as a 'tourist space' (Wöhler, Pott and Denzer 2010)? The fact that a building was erected two hundred years ago on that site, is still standing and has been restored and furnished with all modern amenities does not in itself suffice to make it an agrotourism commodity. An interface has to be produced that makes the materiality of old village houses intelligible as 'authenticity', 'tradition' or 'heritage' to the casual onlooker and, especially, to the tourist consumer. From what I learned about his company and his business strategy over the years, Potamitis created such an interface by making use of 'intangibles' at hand locally, such as agricultural practices and food traditions. Also, artisans, farmers and fishermen were included and became lay presenters of vernacular practices. The farmer's wife's kitchen where she cooks the cheese, the oil mill, the fishing harbour and the orange plantation have – for short moments, at least – been converted into themed environments where performances produce 'experiences' for the tourists. The added value that artisanal skills, agricultural production and local cuisine can give to the product of tourist accommodation has been discovered by others as well, in particular by the Cyprus Agrotourism Company, the association that also operates a marketing and reservations platform for agrotourism accommodations. In 2012, the association entered into cooperation with a commercial company engaged in events marketing. This company has

been scouting out halloumi makers, carpenters, basket weavers, potters, oil mill operators, wine makers and many other representatives of traditional skills and artisanal professions throughout Cyprus. Tourists as well as local clients can book 'experiences' in a local village setting, observing and learning traditional crafts.[9] Tourism theory claims that an 'articulation of uniqueness' (Pott 2007) is needed to make a destination attractive to tourists. Clearly, the emplacement of culture in a village and its embodiment in the practices of local artisans is a crucial aspect in creating the added value of the agrotourism product.

Digression: Difficult Heritage

'Turkish-Cypriot and Greek-Cypriot experiences coincide in shared spaces and materialities. The objects dispersed over the landscape of Cyprus in the aftermath of war and displacement bear the fingerprints of members of both communities, containing both viewpoints at any one time' (Navaro-Yashin 2012: xiv). Heritage as a cultural category becomes problematic when applied to sites or artefacts that are linked to war, violence, oppression or displacement. In the introduction to her book on difficult heritage, Sharon Macdonald asserts that 'because of the selective and predominantly identity-affirmative nature of heritage-making, it typically focuses on triumphs and achievements, or sacrifices involved in the struggle for realisation and recognition. Events and material remains which do not fit into such narratives are, thus, likely to be publicly ignored or removed from public space' (2009: 2). Indeed, the village of Tochni, which figures prominently in this chapter, is a place that sits uneasily with a celebratory approach to heritage making. Tochni had once been a populous village with a Turkish Cypriot majority. In Tochni, Christians and Muslims lived side by side until the hostilities of the winter of 1963/64. Turkish Cypriot inhabitants then retreated to an exclusively Turkish Cypriot quarter of the village, which later became part of a larger Turkish Cypriot enclave in the region. Today, crumbling walls and ruined residential structures at the margins of the village are what remains of the Turkish Cypriot neighbourhood, while a former mosque at the eastern periphery of Tochni is a visible reminder of a Muslim past. Writing of empty buildings left behind by refugees, anthropologist Yael Navaro-Yashin (2012) speaks eloquently of an affective presence that the absent others leave behind in those spaces that were evacuated.

For people familiar with the conflict history of Cyprus, however, the name Tochni has a particularly sinister ring to it because of incidents that occurred in 1974. In the weeks after the right-wing coup against the Makarios government, Greek Cypriot ultranationalist militias scoured the countryside rounding up Turkish Cypriots, scores of whom were murdered. They also targeted Greek Cypriot members of the Communist Party and hunted down union leaders,

some of whom were also killed. In Tochni, Greek Cypriot military forces took control of the village after the first of two invasions of the north of the island by the Turkish army in July 1974, right after the coup. On 14 August 1974, the day of the second invasion by the Turkish forces, Greek Cypriot soldiers set out to imprison their Turkish Cypriot fellow citizens in internment camps in many communities throughout the south of the island. From Tochni and neighbouring communities, they abducted almost ninety men and boys. These were murdered somewhere on the way to an internment camp in Limassol, where they never arrived. Only one man survived. As the bodies were not found, the victims of the massacre have officially been declared 'missing'. Between 1963 and 1974, in the course of the hostilities between Greek and Turkish Cypriots and during the 1974 Turkish invasion, more than two thousand individuals disappeared on the island. About five hundred were Turkish Cypriots; the majority were Greek Cypriot civilians and soldiers who fell victim to the encroaching Turkish army in 1974 and whose bodies were not recovered. The Greek Cypriot state for decades maintained the notion that they were 'missing' rather than dead. Only in recent years, the exhumation of mass graves under the auspices of the United Nations and the deployment of advanced methods of genetic identification have led to the recovery and burial of individuals who had disappeared (Sant Cassia 2005). The Tochni massacre evidently had been committed by members of the ultranationalist terrorist group EOKA-B[10], the group that was also responsible for the coup against Makarios. While some of the perpetrators are known, not one has been brought to court.[11]

None of the buildings that make up the ensemble of agrotourism accommodations in Tochni are Turkish Cypriot property.[12] The tourists who come to Tochni to stay in the restored houses of the Greek Cypriot villagers remain largely ignorant of the significance of the village for this darkest chapter of the history of Cyprus. Indeed, if they knew, some would probably stay away. The online travelogue of a British couple who stayed in Tochni ten years ago bluntly states: 'Tochni was where a massacre of Turkish men and boys took place in 1974. I might have been less keen to go there if we had known that.'[13] Even though the massacre most likely did not take place here, its victims were members of the village community. The quote shows that, for the tourism economy, it is not a good idea to make public the horrific events that took place forty years ago. However, many other places in Europe that count as conflict heritage, such as battlefields, or have even more terrible connotations are included in commemorative practices and patrimonial regimes, and often become travel destinations in their own right (Macdonald 2009, 2013; Meskell 2002). Not so in the Republic of Cyprus. Indeed, there is a widespread silence in contemporary Greek Cypriot society about what Turkish Cypriots call 'the massacre of Tashkent' – Tashkent being the given Turkish name of the village of Tochni. Anthropologist Yiannis Papadakis argues that both sides in the Cyprus conflict

to this very day engage in highly selective strategies of memory and forgetting, constructing starkly contrasting narratives of the same time periods and events (Papadakis 1993). For Greek Cypriots who want to overcome the division of the island, any past event that contradicts the notion of a history of peaceful Greek and Turkish Cypriot coexistence is viewed, at best, ambivalently.[14] From an anthropological perspective, Papadakis strives to explain rather than simply condemn the disinclination of the Greek Cypriot public to delve into this and similar issues. As mirror images of each other, Greek Cypriot and Turkish Cypriot memorials of the conflict commemorate the pain and injustice inflicted on members of one's own community at the hands of the respective enemy, thereby enshrining victimhood and martyrdom. Papadakis asserts that 'no evidence was ever collected, or seriously considered, on the sufferings inflicted by one's own side against the others' (2006: 69).

Against the backdrop of comparative analyses of many instances of 'conflicted' or 'difficult' heritage in Europe, however, Sharon Macdonald suggests that 'ignoring, silencing or destroying are not always options – and the awkward may break through in some form.... It may be because some groups or individuals – "memorial entrepreneurs" – try to propel public remembrance, perhaps of events of which they were victims or which they feel morally driven to commemorate, perhaps because they fear that forgetting risks atrocity being repeated in the future' (2009: 3). In the Republic of Cyprus, the role of 'memorial entrepreneurs' was taken over since the 1990s by a handful of investigative journalists, documentary filmmakers and social scientists. In many instances, however, it is the materiality of ruins – roofless buildings with gaping windows, crumbling stone walls overgrown by weeds – that remains the only reminder of the inability of both communities to come to terms with the suffering that they inflicted on others.

Notes

1. This chapter was written against the backdrop of many on-site visits to agrotourism projects, especially in the Paphos district in the years 1997–2008, and taped interviews as well as more informal talks with a number of experts in the field of agrotourism and rural development. Earlier German-language publications that resulted from this work are Welz (2006b, 2010). Interviews at the Cyprus Tourism Organisation included Costas Kattamis, tourism officer (1997, 1999, 2000, 2004), Maro Kazepi, tourism officer (2000, 2004), George Ioannou, information and reservations officer, Cyprus Agrotourism Company (2000), and Evie Panayiotou, manager of the Cyprus Agrotourism Company (2012). Also, owners of agrotourism accommodation and tour operators in the field of agro- and ecotourism were included. Among them were Brigitte Ioannou, Jalos Activ, Polis Chrysochous (1995, 1997, 2004, 2005), Yiannoula Katseli, Palati Apartments, Pano Panayia (1999), Katerina Papaefstathio, Fontana Tours, Polis Chrysochous (1997, 2000), Christos Charalambous, Ecologia Tours, Pafos (1995, 1997, 1999, 2008), Sofronis Potamitis, Cyprus Villages Tra-

ditional Houses Ltd, Tochni (2000, 2004, 2005, 2008), and Alexis Onoufriou, Amaaaze. com (2012). Bernard Musyck, an economist teaching at Frederick University in Cyprus, initially got me interested in studying agrotourism in Cyprus in 2000. Repeated discussions with Werner Gronau, a human geographer engaged with tourism research (2005), Ramona Lenz, a cultural anthropologist studying immigrants working in the tourism sector of Cyprus (2005–9), and Evi Eftychiou, a social anthropologist affiliated with the University of Nicosia (2012), helped deepen my understanding of the context of agrotourism in Cyprus.

2. During the 1990s, agrotourism accommodations were considerably cheaper than hotels and apartment rentals in the coastal communities; more recently, because of rising standards and sometimes quite luxurious furnishings, guests in the so-called agrotourism sector may have to pay more than they would in an average, modern standard hotel or tourist apartment (see also Cyprus Tourism Organisation 2012).

3. In chapter 4, historically generated practices of showing hospitality to strangers, and their transformation within the economic framework of tourism, are discussed in regards to gastronomy and culinary heritage.

4. In the early agrotourism incentive programme administered by CTO until 2004, this was a prerequisite. Only local owners – meaning that their family was from the village where the property was situated – were eligible. People from 'outside' only qualified if they had bought their premises prior to 1989, two years before the programme actually started.

5. To this end, CTO is also advertising agrotourism accommodation within a scheme for marketing 'rural Cyprus'. Cofinanced by the European Regional Development Fund (ERDF), so-called thematic routes were created, villages squares and streets renovated, existing hiking paths upgraded and promotional literature produced that presents local artisans, traditional food, religious customs, natural landscapes as well as sites of architectural heritage and archaeological significance.

6. Paraphrased from a German-language brochure of Cyprus Villages Traditional Houses Ltd.

7. Conversely, it is not uncommon to find immigrant domestic workers employed in other agrotourism enterprises. During the 1990s, not only urban households in Cyprus routinely started employing migrant workers from Asia and Eastern Europe as housemaids, kitchen help, babysitters and caretakers, but also businesses in tourism, gastronomy, agriculture and construction in rural areas increasingly relied on an immigrant workforce, some of it undocumented labour. For an in-depth study, see Lenz (2010).

8. For instance, see Smith (2006) and Macdonald (2013).

9. The guidelines that 'agrotourism hosts', as the business operators are invariably called by CTO, have to follow also recommend organizing events and 'experiential workshops' for guests that convey 'authentic cultural knowledge' about food traditions, religion, crafts and music (see Mavrou et al. 2012).

10. EOKA is the acronym of the Greek name 'Ethnikí Orgánosis Kipriakoú Agónos' that translates as National Organisation of Cypriot Struggle. While EOKA was the underground liberation movement striving to free Cyprus from British colonial rule during the 1950s, EOKA-B was created in 1971 as a clandestine para-military group in an attempt by radical right-wing Greek Cypriots to achieve EOKA's original aim of unification with Greece. In the 1974 coup, they tried to assassinate President Makarios and ousted him. EOKA-B kidnapped, tortured and killed scores of Cypriots during the coup. Most of their victims were Turkish Cypriots. They also murdered Greek Cypriot members of the political left and the labour unions.

11. A request by family members of the murdered residents of Tochni to the Attorney General of the Republic of Cyprus asking for the indictment of those involved in the massacre was turned down in 2004. Investigative journalists have been tackling the case. The Peace Research Institute of Oslo's research project on internal displacement in Cyprus summarizes information on Tochni (PRIO 2011).

12. Tenants who lease Turkish Cypriot buildings from the government authorities in the Republic of Cyprus are prohibited from converting them into tourist accommodations. The Cyprus Tourism Organisation does not grant licenses to tourism businesses set up in Turkish Cypriot properties. Oral history testimony collected by investigative journalists Makarios Drousiotis and Sevgul Ülüdag among former Turkish Cypriot residents of the village, however, suggests that some Turkish Cypriot co villagers sold their houses to Greek Cypriots before they left. This happened in many other communities in Cyprus as well, as early as the 1963/64 conflicts. These transactions probably did not occur under duress, but in anticipation of Turkish Cypriot owners having to leave the village for good (see Drousiotis 2005).

13. Retrieved 6 March 2014 from http://www.pippins.me.uk/2003/2003_cyprus.htm

14. Recently, the terrible incidents of the Tochni massacre became once again a topic of media coverage when, in February 2014, human remains discovered in a mass grave in a former quarry near the road to Limassol were linked to five of the victims from Tochni by forensic analyses.

CHAPTER 3

Inventing the Rural

❦

On a Sunday in autumn, I am travelling with a friend from Nicosia along the mountain roads of Pitsilia, a region in the northern part of the Troodos Mountains. Clouds are hanging low and rain is imminent. It is November, and the leaves of the trees have turned a brilliant yellow and orange. Seen from the road, the fruit orchards and vineyards show signs of neglect, the walls of the ancient terraces are slipping on the slopes and the forest is encroaching on land that must have been under cultivation for centuries. An elderly man from the area is accompanying us for part of the way. I ask him when farmers stopped working the land. He says that during the 1950s, people in his home village of Platanistasa had already turned to wage labour. Three buses left early each morning from the village, one going to Nicosia and two going to the mines at Mitsero. Today, at the entrance to Platanistasa, dozens of placards with names are erected in a flowerbed to form a makeshift memorial for those who died early as a consequence of the unhealthy working conditions in the mines.[1] Later on, we continue our journey towards the village of Alona. At the request of our companion, we stop at a roadside where three hunters stand, surrounded by a pack of hounds. The hunting season was officially opened two weeks before, and every year, tens of thousands of hunters acquire licences and scrounge the hills and mountains for rabbits and small fowl. The three men are expensively attired and look as if they have stepped off the glossy pages of some hunting magazine. Evidently they did not shoot anything yet and have no hunting trophy to show for their day on the damp and cold mountain slopes. Our companion rolls down the car window and engages in friendly banter with them. Later, when we are back on the road, he turns to us wonderingly, but also with a tone of exasperation in his voice: 'Lemeshani!' The trio came from Limassol, the city on the southern coast. They are urbanites, well equipped but clearly inexperienced. While Limassol, for the Platanistasa native, obviously seems far away, for the hunters, with their powerful four-wheel-drive 'leisure utility vehicle', it is not a long trip.

We arrive in Alona, where pergolas overgrown with grape arbours form arches over the winding main road of the village. At an altitude of 1,200 metres, the winter months bring copious snow. Even now, with the rain setting

in, the temperature quickly drops below ten degrees Celsius. In contrast, in Nicosia, less than an hour's journey by car, midday temperatures that week are still warm, above twenty degrees. This contrast makes me understand why the government of the Republic of Cyprus for decades had subsidized the heating bills of residents of mountain villages. Recently, this support was diminished and then abolished completely, as the government has been reducing its public spending in response to the demands of the Troika of the International Monetary Fund, the European Central Bank and the European Commission.

In Alona, we have lunch at the cafeteria restaurant that serves as the headquarters of APOA, an organization that is part sports club, part association committed to community improvement. It boasts almost 140 members, their main commitment being the organization of the community's annual festival, an occasion that brings migrants who have left the village back for a weekend in the summer. In a village with less than seventy permanent residents, this organization channels and stimulates the willingness of former residents and their children – invariably called 'expatriates' – to 'try as much as they can to elevate the village', as the community council's website claims: 'Despite rural depopulation which bedevils our village, the progressive residents of our village, urged by an intense public spirit, continue their efforts for progress at their place of birth.'[2] A belief in the morally uplifting capacity of progress was much in evidence among Cypriots during the colonial period. After independence, modernity was embraced as a 'liberating ideology' (Bryant 2006: 49).

At lunchtime, the restaurant section of the centre, overlooking the valley with its hazelnut groves, fills up with two- and three-generation families who settle down for the simple but sumptuous meal of meat and potatoes. Quite a few of them appear to have come for the day to visit relatives who live in the village. In the front of the premises, where the coffee shop is situated, young people congregate around a table with their laptops, drinking frappés and soft drinks. The Cyprus Telecommunications Authority (CYTA) has established a wireless zone in the village's central square and its environs, with an LED display outside at the *plateia* advertising this 'Wi-Fi hotspot'. I remember having read in an updated version of the national Rural Development Plan that the extension of broadband Internet connection to outlying mountain villages has become one of the priority measures taken by the government, in order to 'improve the quality of life' in rural communities. A few days later, I read in the newspaper that Alona is one of the sites of the newly created Zivania Festival that takes place in a number of Troodos communities late in November. It was initiated in 2010 by the Troodos Regional Tourism Board[3] and is organized in cooperation with the Alona Community Council[4] and the Pitsilia Expatriates Society. Buses bring tourists from Nicosia and Limassol for free, who can then sample the distilled spirit called *zivania*, made from the residue of pressed grapes, and enjoy 'a few basic mezedes'. Locals will also sell more substantial

food and drink, while local dance and music groups perform. At the occasion of last year's festival, the president of the Pitsilia Expatriates Society was quoted as lamenting 'the huge wave of urbanisation which left the mountain regions bereft of young residents.'[5] Out-migration from Alona – and the difficult reintegration of return migrants who had spent some time in Great Britain – was one of the topics of an ethnographic study conducted in the 1950s by the eminent Greek Cypriot social anthropologist John Peristiany. He as well as other social scientists observed that the Pitsilia communities were economically at a disadvantage and in need of development measures. Peristiany's well-known ethnography of the village formed the starting point for his theory of Mediterranean societies' forms of social integration being based on the norms of 'honour and shame' (Peristiany 1965).

Alona, then, for decades has been indicative of changes and trends that can be observed in the mountainous central areas of inland Cyprus, but more widely as well. However, even a perfunctory look, with impressions gathered on one Sunday afternoon, complicates any simple projections of marginality, backwardness and unbridgeable distance from urban, modern life. Whose interests shape villages like Alona today? What is the impact of political interventions and modernization projects, engineered by transnational organizations? Who benefits? What is considered 'rural' today in Cyprus? What does it mean to live in a rural community in twenty-first-century Cyprus? These are questions that impel the enquiry into rural development that I pursue in this chapter. The chapter addresses rural development policies as a governing technology. I will explore how this governing technology produces new categories of social actors as well as new discourses about what 'the rural' entails and what its functions are supposed to be. The chapter is written against the backdrop a decade of intermittent research at government offices in the capital, Nicosia, and my familiarity with the affected regions going back for many years.[6] My focus here, however, is not on the local populations, but instead on administrators and planners. How they talk about what they do, both in verbal interaction and in written form, is indicative of the changes and continuities of rural development policies during the Europeanization process. In addition to analyzing the particular genre of organizational texts that transnational development policies generate, a short-term fieldwork visit at the European Commission in 2011, including talks with members of the European Parliament and their staff as well as with representatives of state and NGO interests in Brussels, provided indispensable additional insights and make this particular chapter's empirical basis more 'multisited' than some of the other chapters in this book. In what follows, the chapter will first enquire into 'development' as a Western hegemonic concept and its deployment in postcolonial Cyprus. A World Bank–funded project of the late 1970s serves as a case in point. I will explore its impact in the very same region where the community of Alona is located and link it to

strategies of rural development that emerged globally, mostly in the context of U.S.-dominated economic and geopolitical frameworks. In 2004, thirty years after the World Bank project, the Republic of Cyprus became a member of the European Union. Since then, regional planning and agricultural policy instruments of the European Union have come to bear on the rural areas of Cyprus.

European Union policies show some continuity with the earlier development strategies under the aegis of the World Bank, but also reflect important changes that are addressed in the second section of this chapter, which deals with Structural Funds–supported interventions and the EU's new Rural Development Programme (RDP) as part of the reformed Common Agricultural Policy (CAP). Contrary to earlier development policies that aimed at making agricultural production in outlying areas competitive, more recent development policies abandon the notion of rural areas being primarily devoted to agricultural production, instead investing them with new functions that, as some critics claim, ultimately remake them as consumption spaces for urban middle classes. The policy goal of 'upgrading the rural heritage' plays an important role in this context. Its impact will be discussed in the third section of the chapter. A final section returns to the overall concerns of Part I of the book. I will show how the governance technology of regional development ties in with historic preservation regimes and resonates with the commodification of rural settlements for tourism and visual consumption.

A Lesson in Development

In the 1960s, when Cyprus was decolonized, the Pitsilia region where Alona is located was already in decline, suffering from population losses and an increasingly unprofitable agriculture. At the same time, other areas of Cyprus were improving economically, with incomes rising and urban centres expanding. A new commitment to regional development that the Cypriot government had included in its 1972–76 Five-Year Plan acquired unexpected urgency in 1974, when the Turkish invasion and the de facto partition of the country required the resettlement and economic integration of close to two hundred thousand displaced persons and caused an economic downturn that was exacerbated by the fact that the Turkish occupation claimed some of the areas that had been economically most productive. It was in this climate of crisis and dislocation that the Republic of Cyprus prepared a development project for the Pitsilia region. Considered the poorest area of the country, with per capita incomes of less than 30 per cent of the Cypriot average annual income, Pitsilia was selected for the implementation of a project that was similar in scope and intention to projects conducted in Africa, Asia and Latin America. The Pitsilia project was at the time the only one of its kind in Europe.

It followed a blueprint provided by the International Bank for Reconstruction and Development (IBRD), the predecessor of the World Bank, which initiated and funded development measures in so-called Third World countries in conjunction with the Food and Agriculture Organization (FAO), the United Nations organization in charge of monitoring food supply and counteracting hunger worldwide. These agencies had created an instrument called Integrated Rural Development Projects, a standardized set of measures to be implemented in a similar fashion worldwide, with a focus on modernization of agricultural production, so-called social programmes and infrastructure improvement. Arturo Escobar, a cultural anthropologist and prominent critic of development policy implemented in the Third World, along with other protagonists of the anthropology of development that emerged in the 1990s, has pointed out that the development policies deployed by Western-dominated agencies throughout the Third World created 'efficient ways of managing economics and populations' (Escobar 1995: 72), based on science, technological progress and the integration of local production into global trade. Development proceeded from the assumption that economic growth was the only 'remedy for poverty and unemployment' (Escobar 1995: 73) and that an 'underdeveloped economy' was one that was characterized by 'low productivity, lack of capital, and inadequate industrialisation' (Escobar 1995: 83). By inventing and propagating this notion of development, the World Bank became an institution that achieved and 'maintains intellectual and financial hegemony in development' (Escobar 1995: 165). Today, we can surmise that these development measures did not eradicate poverty but instead deepened the dependence of the Global South on international markets, and that development policies have been 'imposing a single, technologically efficient vision of modernity on much of the third world. … Development [is] both a symbol and one of the most potent instruments of western hegemony, outwardly defined as assimilation, but practically intended as dominance' (Herzfeld 2001: 152). Escobar shows that development policies open 'new regions to investment through transportation, electrification, and telecommunications projects' and often foster projects that benefit domestic elites in disadvantaged countries while aggravating the living conditions and subsistence opportunities of the general population. James Ferguson calls development policy 'anthropology's evil twin', because not only do anthropologists and development experts often work in identical settings – mostly remote, economically depressed and socially marginal rural areas – but also because the very concept of 'development' as a set of measures that transform traditional societies into modern ones is based on an 'assumed identity of development with a process of moral and economic progress' (Ferguson 2005: 146) that attests to the durability of the notions of anthropological evolutionism. Ultimately, development and its counterpart, underdevelopment, constitute an interpretive grid (Ferguson 1990) through which all parts of the world are evaluated today.

Within the framework of World Bank–funded development, 'infrastructure' usually denoted the road network, electricity provision and water management, in particular irrigation, while other types of infrastructure – education, health provision – were considered 'social'.[7] In Pitsilia, the main emphasis – 65 per cent of the investment of the project – was on the water supply of the region, as 'insufficient water availability has been correctly perceived as the main limiting factor to increased agricultural production' (Phocas 1997: 97). One large dam, the Xyliatos, was constructed as part of the project, and a quantity of water catchment measures were executed, such as the creation of stream ponds, the drilling of boreholes and the replacement of older dry-wall terraces with large bench terraces suited for rain-fed agriculture. The accessibility of freshwater to households was grouped under 'social investments', and the residents in twenty-three villages received piped water to their houses, while 'all villages were supplied with drinking water in adequate quantities' (Phocas 1997: 99). The project report claims that 'the Project has transformed a large part of the landscape in the arid and mountainous Pitsilia area to a terraced, well-organized, and productive agricultural land which is supported by much advanced social, infrastructural and farmers-oriented services than earlier' (Phocas 1997: 103).

This retrospective look at the Pitsilia project of the 1970s is useful, not just because of its insights into postcolonial development policies, but also because it contrasts markedly with contemporary approaches to regional development. Since 2004, the rural development policy of the Republic of Cyprus has become aligned with the European Commission's hegemonic ideas of how rural economies operate and what land uses are beneficial for rural environments and populations. Today, throughout Europe, rural sociologists diagnose a 'continuing loss of economic and social relevance of agricultural activities, together with the undeniable environmental impacts of industrial agriculture and with the wider awareness of the environmental and social functions rural areas' (Figueiredo and Raschi 2011: 2). Consequently, rural areas are reconceptualized as multifunctional. 'It is currently expected that rural areas could have part in environmental protection and nature conservation, and host tourism and leisure activities' (Figueiredo and Raschi 2011: 2). This is also mirrored in the changed thrust of agricultural policies in Europe since the beginning of the twenty-first century. Rural areas are no longer considered to be important only because of their agricultural production, as was still the case when the Pitsilia project was incepted, but also – or even more so – as reservoirs of biodiversity and as environmental resources. Rural areas are valued because they ensure the quality and the quantity of the water supply, clean air and climate stability. In addition, they acquire further roles as areas of recreational activities and the visual consumption of landscapes. This represents a marked departure from earlier policy goals, which had been towards technologically enhanced, agricultural mass production with a high degree of integration into domestic and

transnational markets – which was what the Pitsilia project of the 1970s had ultimately aimed for.

European Union Policies

Even though a number of projects in regional development, nature conservation and heritage preservation in Cyprus received European Union funding already during the 1990s, it was only after the 2004 EU accession of the Republic of Cyprus that declining rural areas could benefit from funding extended by the European Union. At the time of EU accession, the rural population in Cyprus was steadily decreasing, and agricultural land, especially in the mountainous areas, had been successively abandoned. In 2007, less than 7 per cent of all employed were working in the agricultural sector. About 30 per cent of the entire population of the Republic of Cyprus resided in areas that the national government classified as rural – that is, outside of urban centres and agglomerations.[8]

Agricultural policy throughout Europe was dedicated to a growth imperative since the 1950s, deploying planning expertise, scientific knowledge and financial subsidies to increase the volume and quality of agricultural production. Predictably, these policies worked towards small farms eventually disappearing in many countries, leaving only those big enough to mechanize profitably. Indeed, right after the Second World War, the intention had been to develop a joint strategy in Europe to increase the productivity of agriculture, to provide food to consumers at reasonable prices and to guarantee sufficient incomes to farmers. This, in fact, had stood at the very beginning of the European integration process. The objectives of what later became known as the Common Agricultural Policy were already laid out with the Treaty of Rome of 1957. Its primary instrument were subsidies paid to private businesses, that is, farms and agricultural enterprises. The observation that the EU's agricultural subsidies represented a massive intervention in the market and, in the long run, had hugely detrimental effects on the economies of the Global South – whose products could not compete with cheap imports from Europe, especially when the EU started to engage in what is called today 'agricultural dumping' – has been criticized widely. By the 1990s, efforts were made to revise policies and counteract some of these detrimental effects.[9]

In 2003, a reform of the Common Agricultural Policy came into effect. From now on, subsidies to agricultural producers were increasingly decoupled from production volume. Before, these payments had worked toward encouraging farmers to produce overcapacities of those products that incurred especially high payments. Also, subsidies started to be connected to new types of incentives and penalties ('cross-compliance'), in order to make agricultural producers engage in forms of production more conducive to environmental protection

and biodiversity maintenance. Meanwhile, in the EU's regional development policies as well, new approaches had been introduced. Policy goals and instruments such as sustainable development, local capacity building, citizens' participation and the increased reliance on the so-called endogenous potential of regions were gaining widespread acceptance among policy makers on the national and the supranational level. Out of earlier funding instruments, the so-called Structural Funds[10] emerged in 1988, to be significantly expanded in 1994. This also meant that funds formerly devoted to agricultural growth were now channelled towards regional development. By the end of the 1990s, Structural Funds accounted for one-third of the EU's budget. Since then, the proportion of agricultural subsidies within the framework of the CAP has been steadily reduced and also partly redirected towards measures such as strengthening the 'quality of life' in rural areas. Increasingly, rural areas began to be given a new role, as compensatory spaces making up for the environmental problems of urban agglomerations.

What does this mean for the Republic of Cyprus? Here, rural areas, especially those located in mountainous, inland areas considered peripheral and 'backwards', are no longer invested with the expectation to become more productive agriculturally, as had been the case in the Pitsilia project of the 1970s. Instead, profit and productivity are increasingly supposed to be generated by tourism, gastronomy, nature-oriented leisure activities and food production and processing. Contrary to earlier development policies, where agricultural products would be exported from rural areas to urban centres and also abroad, consumers for these new services and products are 'imported' into rural areas, as tourists from abroad or weekend sojourners from the urban centres. Indeed, not just tourist apartments, hiking trails or traditional sausages are being marketed, but the rural area as a whole, and along with it the ideal of rurality that it is supposed to embody, is becoming a commodity to be sold, on domestic as well as international markets. These strategies are deemed useful especially for those inland regions, particularly in the Troodos Mountains, that are characterized by depopulation, a high percentage of aged residents, widespread unemployment, deterioration of the built environment because of abandonment and deficient infrastructure.

Even though agrotourism, as shown in the preceding chapter, is but a niche sector within the overall service economy of Cyprus, the new Structural Funds–based regional development policy implemented by the EU relies on agrotourism as one of the instruments to alleviate regional economic disparities. While in the 1970s, development still meant creating a viable economic basis by modernizing agriculture, conversely, in the twenty-first century, the 'major developmental comparative advantage' identified in Cyprus is 'a remarkable natural landscape and a distinctive traditional socio-cultural heritage … which present an excellent developmental potential for rural tourism' (Structural Funds Pro-

gramming Document n.d.: 83). Policy discourse combines rural tourism with small-scale manufacturing in the food sector ('microenterprises') and artisanal products ('taking advantage of locally available resources'), and invest all of these endeavours with the ability to counter the decreasing competitiveness of domestic agricultural products in a globalized economy. When the EU started contributing to the Republic of Cyprus's agrotourism programme via the Structural Funds by 2004, this set in motion a series of changes. Importantly, the EU introduced a normative notion of 'entrepreneurship' that had not been as pronounced in the earlier programme that had been set by the Cyprus government and implemented by the Cyprus Tourism Organisation in the 1990s. Today, applicants have to comply with more rigid requirements. Business plans, feasibility studies and financial documentation have to be submitted when applying for funding, and beneficiaries have to submit to monitoring instruments, audits and inspections. This is indicative of an economic regime that also shapes the new subjectivity of the 'enterprising self'. Sociologists argue that the social production of this new type of subjectivity is not confined to the business world or to economic actors, but has to be associated with the emergence and spread of 'neoliberal' governmentality (Dunn 2005). This means that owners of guesthouses or restaurants are no longer considered 'agrotourism hosts', as the Cyprus Tourism Organisation's programme invariably called them in line with the notion of 'Cypriot hospitality'. Rather, they have to qualify as entrepreneurs in order to receive funding within the new Structural Funds programme.

Within the framework of EU programmes, measures for the beautification of village streets and squares and the restoration of heritage sites are also being funded in rural areas. These are attributed with a dual function, namely, improving the quality of life of the resident population and upgrading the attractiveness of local communities for tourist consumers (Structural Funds Programming Document n.d.: 76–78). When I talked to officials in the various government sectors concerned with tourism and rural development late in 2012, among them officials of the Cyprus Tourism Organisation, the Department of Town Planning and Housing, the EU funding units and monitoring agencies dealing with Structural Funds and CAP funding, they all agreed that options, both for local communities and for homeowners and entrepreneurs, to apply for funding and even to combine various funding sources had multiplied in recent years. Decisions on funding are now routinely made in multidisciplinary commissions staffed by officials from all of the involved government sectors, including regional administrations and the Cyprus Tourism Organisation. The unnecessarily narrow focus of the early, pre-2004 funding for agrotourism has been abandoned, and instead, a more integrated approach has been developed that acknowledges and actively invites interactions between tourist accommodations, second homes, sightseeing attractions such as museums, gastronomy, and workshops and stores selling 'traditional' products. This may all happen

within one village, or include a cluster of villages situated in close vicinity, so that 'synergies' of the type that Sofronis Potamitis initiated in the Tochni area are more likely to happen in other regions of inland Cyprus as well.

Many of these new projects started with what an official at the European Commission somewhat bluntly called 'public intervention'. By this he meant that the initial stimulus or a suggestion to local actors to apply for funding came from the Cyprus government. But, as he observed, 'in some of the villages, people are now engaging more in integrated project creation themselves, without any top-down impetus'. He quoted Agros, another community in the Pitsilia region, as a particularly positive example in this respect, where agrotourism, crafts workshops and small food processing plants – smoked meats and sausages, but also products using rose oil or rose water – have been established and appear, to his mind, to have generated synergy effects, not just economically but also socially. 'The links between the different actors seem to thicken, which is something very difficult to measure, but once you are there, you can see it in those villages.... The reasons for the flourishing of some new approaches in projects may also have to do with contacts', he suggests, explaining that local entrepreneurs and communities are increasingly networked with others within the EU and travel to countries that have had an earlier start counteracting rural problems by taking advantage of EU funding. The effect seems to be 'following examples mostly. I have not seen anything particularly innovative being created in Cyprus, at the moment, they are mostly adapting things'. This Brussels official, being a native of Cyprus himself, was clearly happy about the fact that some of his compatriots in the more disadvantaged of the country are benefitting and 'getting more involved'.

His colleagues in Nicosia, who actually administer the various European Union funding instruments for rural areas, came across as much less convinced of the benefits of agrotourism and the creation of new places of interest and sightseeing attractions in marginal areas. In their opinion, such projects are considered much less effective 'to make people stay', that is, to prevent out-migration, than infrastructural improvements funded by the EU's cohesion funds, especially road building, which makes outlying communities more accessible by car. These officials considered anything that makes the lives of rural residents 'nicer and easier' more important than village beautification and heritage sites. To their mind, the only other type of community project that directly meets residents' needs are the so-called multifunctional centres that offer special services to the aged population as well as leisure activities for younger residents. Yet, most of the officials that I talked to at various government branches in Nicosia in the autumn of 2012 were also anticipating that due to the state's debt crisis, many of the regional development projects envisioned might not materialize in future years, as the government will be increasingly less able to

put up the domestic funding that the European Union requires in order to contribute the so-called matching funds.

Upgrading Rural Heritage

'Upgrading of the rural heritage' was a recurrent phrase in Cyprus's Rural Development Programme for the European Union's programming period of 2007–13. Admittedly, within the overall picture of rural development, this is a small sector, dedicated to 'quality of life' and diversification of economic options in rural areas and making up no more than 8 per cent of the projected expenditures for rural development (Mavrommatis and Sokratous 2007). Still, it is worthwhile to look more closely at what types of projects and activities were initiated, and what assumptions – about what 'rural heritage' is, and how it can be 'upgraded' – underlie the projects that community councils, entrepreneurs and local associations from the eligible village communities proposed and eventually received funding for. As already mentioned in the portrait of Alona at the beginning of this chapter, the establishment of regional tourism development boards in individual districts, as well as in transdistrict areas such as the Troodos Mountains, to some extent gives local groups an opportunity to participate in and benefit from these value-adding strategies, notwithstanding the problematic aspects of commodifying local social practices and traditional artefacts. Traditional village fairs, often celebrated on the feast day of the local church's patron saint, are remodelled as tourist attractions, with bus service from the major coastal tourism areas, and new festivals are invented in order to market local culinary and artisanal traditions, such as wine and other grape products. 'Thematic routes', recommending that motorized tourists visit sites along the road, as well as hiking and biking trails facilitate the visual appropriation of landscapes, packaging the villages and rural areas for the 'tourist gaze' (Urry 1990).

The overwhelming majority of projects funded under the aegis of this programme, however, were renovations of buildings for local museums. A surprisingly high number of local community councils applied for funding under the Rural Development Programme in order to renovate some abandoned structure, with the intention of using it to house an existing local collection of historic artefacts. In rural Cyprus today, local museums clearly are considered a respected form of displaying and consuming cultural heritage, of enhancing community pride and of celebrating local identity.[11] Most of these museums are based on collections by self-taught historians and amateur folklorists, some of whom have also created exhibits and even founded museums, often in privately owned houses. For decades, because of a lack of public funding and gov-

ernment support, such collections had often been created independently by laypersons in Cyprus. Also, private sponsors of the arts and archaeology did not consider laypersons' local collections worthy of their attention, and did not extend funding for them. Conversely, contemporary museum theory today recognizes grassroots collecting, amateur curation and 'handmade' exhibit design as a significant cultural practice in late modern societies. These are considered to enable social actors, often of lower classes or belonging to minority groups, to appropriate elite forms of self-representation and use them to their own ends (Macdonald 2006). Some scholars call the institutions that emerge from such small-scale amateur initiatives 'wild museums' (Jannelli 2012), conveying the impression that these are nondomesticated, undisciplined forms of cultural expression. However, in Cyprus, nothing could be further from the truth. Rather, these are layperson's appropriations of – or at least, approximations to – a prestigious, scholarly format of knowledge production, namely, the Greek folk arts collection. In the Greek-speaking world, this is a historically generated genre that reifies notions of authentic cultural identity, predicated on the traditional life world of local peasant communities, with the patriarchal family and a social order that complies with and is infused with Orthodox theology.[12] In Cyprus, the collections that were assembled, in most cases over decades, by private individuals, often teachers who acted as local historians and amateur folklorists, are very much alike, as object categories and their grouping in sections are structured by the canon of folklore research.

In many rural communities in Cyprus, new local museums have been created as funding has became available within the rural development framework. The collections that they exhibit usually assemble artefacts that document the material culture of the respective village, with a focus on the first half of the twentieth century. Tools and implements from agriculture, equipment used by local craftsmen, kitchenware, cooking and baking implements, storage vessels, objects of religious worship, a few pieces of furniture as well as textiles figure prominently, and sometimes also local costumes are displayed. Many of these objects are handmade by local craftsmen, some from materials that can be found in the area, but quite a few are mass-produced and even store-bought, such as china plates, sewing machines and the scales that the traders used to weigh the produce that the farmer wanted to sell. Rarely are these objects dated, or the families who donated or loaned the objects mentioned. The visitor comes away from these simple yet attractively designed exhibits with the impression of a homogeneous community where traditional life remained rather static during the first decades of the twentieth century, guided by patterns handed down from generation to generation. The stated intention of local associations that initiate and operate such museums is to draw attention to the simple and decent life that the generations of parents and grandparents led, and to honour their struggles in the 'difficult and challenging years' until the end of the Sec-

ond World War.[13] The exhibits reconstruct tradition in a uniform time hori-
zon called 'the past'. Except for 'famous sons of the village', individuals are not
featured. Connections between the village and other places – in Cyprus and in
other countries – that resulted from trade, the colonial presence and migration
are hardly ever mentioned, as they appear to contradict the holistic notion of
the village community. This is what the local community elites proudly present
as the heritage of the village, to local visitors and to tourists from abroad.

In modernizing European societies since the nineteenth century, museums
acquired an important role as agencies for articulating narratives of collective
belonging, most significantly within the context of nation-building processes.
Later, in the twentieth century, museums became ubiquitous. The identity-
producing and identity-amplifying function of museums was increasingly res-
caled, as well as appropriated on the regional and the local level. Museum the-
orist Sharon Macdonald remarks that, increasingly, 'just having a museum [is]
itself a performative utterance of having an identity' (2003: 3). By fusing social
memory, local narratives, visual imagery and material culture within the for-
mat of exhibits of artefacts, pictures and textual commentary, museums make
claims to roots, heritage and tradition palpable and plausible.

Conclusion: The Rural as a European Product

British sociologists Phil Macnaghten and John Urry propose that a rural area
does not simply exist, but is the product of practices that organize and rep-
resent space. In their book *Contested Nature*, they present a case study of the
social production of 'the countryside' in England since the eighteenth century,
which was heralded by new types of leisurely activity invented by the landown-
ing classes and accompanied by new discourses and pictorial representations
such as landscape painting. In England, and also in other European countries,
the emphasis on visual appropriation of this socially produced 'countryside' and
the particular notions of what constitutes the beauty of a landscape to be gazed
upon went hand in hand with regulating proper uses, such as 'rather passive
and non-engaging leisure uses of countryside space' (Macnaghten and Urry
1998: 187). Reference to the way the English ideal of 'countryside' was pro-
duced, even while pertaining to northern Europe, is not irrelevant for the Cy-
prus case, given the British colonial presence in Cyprus and the fact that much
land use and planning legislation still valid in the Republic of Cyprus dates
back to preindependence times. Indeed, the zoning regulation that legislates
land uses outside of areas that are provided for in specific local plans makes
explicit reference to the 'countryside'. Macnaghten and Urry point out that this
is 'a model of the countryside leisure experience related to the landscape aes-
thetic' that excludes people from using this space in ways that digress from or

conflict with this type of purely visual appropriation (1998: 188). During the 1990s, Macnaghten and Urry also observed an increasing tendency for spaces designated as 'countryside' to be commodified, which also leads 'to the marketing and further economic exploitation of a wide range of rural activities' and to environmental qualities acquiring economic value (1998: 191).

Indeed, throughout the European Union, rural areas are being reshaped and reconceptualized. In Cyprus, even in remote mountain areas, rural areas are being reconfigured as spaces to be consumed by people who do not live there, urban dwellers from the cities of Cyprus, but of course also tourists from abroad. 'Rural areas ... become managed by market strategies and established as attractions in which the environmental qualities and the cultural aspects become commodities', as rural sociologists Figueiredo and Raschi contend (2011: 4). As I have shown in this chapter, rural areas in Cyprus have been reconfigured along the lines of European Union policy in order to meet requirements and comply with criteria set by the European Commission, and as a consequence, rurality itself, both as a discursive construct[14] and as an environmental materiality, has been transformed.

In many ways, the new regional development policy for rural inland areas of Cyprus is a continuation and indeed an intensification of the state's efforts to generate agrotourism that I reported on in the preceding chapter. But the thrust of the measures is rural development rather than special interest tourism; agrotourism, here, is deployed primarily as an instrument of economic policy in disadvantaged regions, and only secondarily within the overall framework of tourism policy and planning. As rural sociologists have pointed out, 'despite little evidence of its general positive impacts in rural development, tourism is often considered ... as the panacea for the problems peripheral rural areas are facing' (Figueiredo and Raschi 2011: 2). The programmes and projects aimed at implementing agrotourism in disadvantaged rural areas of Cyprus represent a complex interplay of globalized markets for tourism products, mechanisms of state intervention and visions of 'development'. All of these are based on the same normative concepts of 'cultural authenticity' and make use of existing, abandoned or underused historical buildings as a 'local resource'. The effects of government funding made available for renovating vernacular architecture that figured prominently in chapter 1 have an important role to play, both when it comes to agrotourism, discussed in chapter 2, and when the broader concerns of 'developing' rural hinterland areas are addressed, which form the central focus of the present chapter. They rely on historical buildings being primed for visual appropriation as 'traditional houses' by applying Europe-wide standards that in turn ascertain that restored buildings are recognizably 'rustic' and 'authentic'. A house's or village's local embeddedness, and their link to a community's history, are rearticulated within the framework of agrotourism. This is achieved partly by material operations of on-site preservation, restoration and

modernization of the existing housing stock, which in turn is regulated by the state, which subsidizes restoration in order to exert aesthetic control and grants operating licences that are predicated on standards of commodified hospitality. Importantly, a culturally constructed interface between the agrotourism destinations and the prospective tourist consumers is created.

All of this is happening within the framework of an increasing standardization of heritage management instigated by the European Union and other Europe-wide agencies and implemented by the nation-state. Heritage preservation has become what political scientists call a 'mobile policy' that travels transnationally and is adopted locally (McCann and Ward 2011). Even before the Cypriot government became involved in European governance networks that were concerned with implementing standard procedures in historic preservation, urban planning and regional development throughout Europe, individual Greek Cypriot architects, planners and other specialists actively sought out European expertise and contacts with colleagues in other European countries. The Laona Project is an exemplary case for this process.

European ethnologist Markus Tauschek contends that heritage regimes have to be conceptualized as 'patrimonial fields' (2012: 198) that are framed by legal contexts and institutions, both on the nation-state and the transnational level. 'Heritage emerges from the nexus of politics and power', asserts Kristin Kuutma, who also calls heritage 'a project of symbolic domination' that 'privileges and empowers an elitist narrative of place' (2012: 23). We may well see heritage making as a regime that enlists bureaucratic techniques and expert knowledge with the aim of imposing dominant ideologies. The state's assumption of the custody of the national cultural heritage contributes to the transformation of rural hinterland Cyprus into a new type of European Union–regulated 'agro environmental' region. Reinvented rurality is a European product.

Notes

1. A permanent monument is going to replace this installation. The Mitsero Community Council presents oral history testimony of the dismal working conditions in the mine on its website. Retrieved 11 March 2014 from http://www.mitsero.org.cy/english/minings_life .shtm.
2. The passage is quoted verbatim from a website created by the Alona Community Council in 2011. Retrieved 11 March 2014 from www.alona.org.cy/english/history.shtm.
3. The Troodos Regional Tourism Board is an association of local authorities and regional tourism stakeholders under the auspices of the CTO, advertising the Troodos area – which is no administrative district but a transdistrict entity – as a tourism destination. It is one of two regional associations dedicated to furthering the regional tourism economy (see Eftychiou 2013).
4. The Alona Community Council is currently engaged in a number of restoration and beautification projects for the public spaces of the village. Funds have been made available by

the Department of Antiquities, the Cyprus Tourism Organisation and the Nicosia District Office. Also, as part of the regional development strategy implemented by the Department of Town Planning and Housing since 2004, a Community Action Plan for Alona was developed by a team of planners, suggesting a number of renovations and improvements of the built environment.

5. Quoted in Pantelides (2011).

6. This chapter was written against the backdrop of numerous visits to peripheral and disadvantaged rural areas in the Republic of Cyprus in the time period between 1995 and 2012, especially in the Paphos district (Akamas and Laona; Kilades, Tylliria) and in the Nicosia district section of the Troodos area (especially in Pitsilia and Solea). Interviews were conducted in Nicosia, with officials in branches of the government in charge of regional development and planning for the rural areas of Cyprus, at the Ministry of the Interior, Department of Town Planning and Housing, European Funds Management Unit (2004, 2012), EU Objective II Programme and Agrotourism Funding Scheme (2004, 2005, 2006, 2008, 2012), Local Action Plans (2008), Cultural Heritage Conservation Section (2012), at the Planning Bureau, Integrated Rural Development Planning (1999, 2000), and at the Cyprus Tourism Organisation, Planning Department (2012). In Brussels, a series of interviews was conducted, with a focus on the reform of the Common Agricultural Policy and the role of rural development as an EU policy area. The research in Brussels was conducted in cooperation with Franziska Sperling.

7. In 1977, the Cyprus government signed a contract with the World Bank's forerunner, the IBRD, for a loan of ten million U.S. dollars to be disbursed over a period of six years. This was expected to cover 40 per cent of the expenditures for the project, which officially started at the end of 1977 and ended in 1984. The region that the measures addressed was comprised of fifty villages with a total population of twenty thousand inhabitants, located at an intersection of three administrative territorial units of the republic – the Nicosia, Limassol and Larnaca districts.

8. The European Commission employs an urban-rural typology that is based on criteria developed by the Organisation for Economic Co-operation and Development (OECD). According to this, Cyprus as a whole is classified as 'intermediate', that is, neither urban nor rural. Conversely, when implementing EU programmes, the Republic of Cyprus uses the designation 'rural' according to established practice in Cyprus, dating back to the British colonial administration, whereby rural areas are generally areas outside of urban centres and agglomerations. Within the framework of Structural Funds territorial designation, most of the territory of the Republic of Cyprus qualifies as so-called 'objective 2' areas considered to be facing 'structural difficulties', most of these classified as 'declining rural areas'.

9. For critiques of the development of the European Union's agricultural policy from social science perspectives, see Patel (2009) and Fouilleux (2010).

10. The Structural Funds of the EU address economic disparities between European regions, with the intention to increase the economic and social cohesion within Europe. Under the umbrella term of 'Structural Funds' that I adopt for this chapter, actually a number of discrete programmes are included, such as the European Regional Development Fund (ERDF), which assists 'regions whose development is lagging behind and those undergoing economic conversion or experiencing structural difficulties', the European Social Fund (ESF), which 'provides assistance under the European employment strategy', and the European Agricultural Guidance and Guarantee Fund (EAGGF) Guidance Section, targeting 'the development and the structural adjustment of rural areas whose development is lagging behind' (see European Commission 2007).

11. The delay may have something to do with the largely centralized cultural sector and museum infrastructure that post independence Cyprus created. Local museums for many years came about only at the initiative of private individuals who would present their collections in their own homes or buildings they owned. A forerunner is the folklore museum in Paphos. The collection was assembled and the museum created and operated privately by G. S. Eliades, a retired lyceum teacher. It was opened in 1958 and in 1971 acquired the name Private Ethnographic Museum (see Eliades n.d.).

12. On the role of folklore for nation building in Greece, see Herzfeld (1991, 2004).

13. From the brochure *The Steni Museum of Village Life* (2008).

14. Consumers of this reinvented landscape are increasingly not only foreign tourists or lifestyle migrants from abroad. In the rural hinterlands, especially in the Troodos Mountains in the centre of the island, the clientele who consumes this newly reconfigured 'rural idyll' are likely to be Greek Cypriots living in the cities of the country. Communities like Alona, and the area of Pitsilia that it is situated in, draw urban residents whose parents or grandparents originate from these communities and cater to their wish to be reconnected to what they consider their legacy. For them, the contrast that the area offers to the hot, congested and somehow 'artificial' city is confirmed and amplified by strategies that reconfigure it as a haven of tradition, nature and authenticity.

PART II

Food, Culture and Heritagization

❧

Food production and consumption are important sites for the creation, negotiation and contestation of culturally specific meanings. As boundary markers, differences in culinary culture become expressive of social divides. Cuisines are often taken to be potent symbols of national identities. Insistence on ethnic or national 'ownership' of a food tradition, then, is discursively linked to evidence of a groups' social and territorial integrity through history. These assumptions have been guiding anthropological research for some time. Today, they are being reframed by the increasing transnational mobility of social actors, by the worldwide sourcing and diffusion of food products and by the ongoing globalization of the agricultural economy. Is the renewed emphasis on regional or national food cultures an attempt to salvage and protect traditions that are threatened by these changes? Heritage making enlists references to history and culture and puts them in the service of contemporary societies' interests. Many if not most heritage interventions not only venerate and celebrate traditional artefacts or practices, but also are fuelled by economic concerns, either directly, by giving added value to a cultural good that can be marketed and fetch a higher price, or indirectly, for instance, by enhancing the attractiveness of sites for tourist consumption. Part II will explore these issues by looking at the production of food in Greek Cypriot society and the state practices that govern it, both on the national and on the European level.

CHAPTER 4

'Full *Meze*'

Tourism, Modernity, Crisis

❧

When Cyprus became one of the destination areas of Mediterranean mass tourism in the second half of the twentieth century, tavernas and restaurants began to advertise 'full *meze*'. 'Cyprus *meze*' consists of many dishes, served in three or four courses of about half a dozen individual food items each, and is ordered as a set meal at a restaurant. The essence of a *meze* is not in the individual food items that make it up, but rather in its special character as a somewhat variable, modular food service pattern that induces sharing among the participants assembled around a table. *Meze* can easily be qualified as a 'tourist production'. Anthropologists define tourist productions as settings, events and artefacts created for tourists (Kirshenblatt-Gimblett and Bruner 1989); the term refers explicitly to the metacultural operations that represent culture for the consumption of outsiders.[1] As an analytical concept, 'tourist production' avoids the treacherous distinction between authentic culture and 'fake' fabrications that for so long dominated the anthropology of tourism. Instead, the concept lends itself to looking closely at the social practices of creating such settings, events or artefacts, encouraging us to enquire into their materiality and into the discourses and visual regimes that make the claims to typicality plausible. Cyprus *meze* embodies many of the tensions and contradictions that characterize Cyprus as a postcolony and, during the past decade or more, as a society restructured by European Union regulatory regimes. This chapter addresses three of these tensions or contradictions. First, *meze* appears to be uneasily poised between the claim of being typical for Cyprus – or even for Greek Cypriot culture exclusively – and its status as a generic Mediterranean tourism commodity. Second, there is a tension between culturally coded 'hospitality' and the economic logic of the tourism economy. The *meze* restaurant is an arena where this tension is performed rather than resolved. Third, as a feast-type meal situation tending towards excess, *meze* is also entangled with the socially constructed categories of abundance and waste. We can expect these to shift and to be radically redefined in a situation of crisis, when saving, sharing and donating food, instead of discarding waste, are being declared social virtues. The concluding part of the chapter also ties *meze* in with the larger

framework of patrimonial regimes that valorize the 'Mediterranean' food heritage and thereby reinvent the Mediterranean as a so-called culture area. The cultural unity[2] of the circum-Mediterranean region is a construction, created by way of discursive as well as practical cultural operations, enlisting materiality and metaphor to weave together social imaginaries, people and the physical environment in a potent symbolic artefact. In the case of the Mediterranean, food has been deployed as a major element in this construction for a long time, most probably for thousands of years.

The Cultural Logic of Mass Tourism

My own work on *meze*[3] dates back to the late 1990s when I conducted research on small entrepreneurs in the tourism economy of the Paphos district, looking into how they constructed a cultural interface between local practices and tourist expectations. In the north of the district, the abandonment and closing of a copper mine that had for many decades provided employment for workers, as well as the economic downturn after the Turkish invasion of 1974, prompted young men to leave the area well into the 1980s. However, only a decade later, coastal areas began to be transformed to become mass tourism destinations. Many local residents then opted for becoming self-employed, opening businesses in tourism and gastronomy. In 1997, my fieldwork focused on emigrants who had returned from abroad, lured by opportunities in the burgeoning tourism sector. In the small town of Polis Chrysochous, cafés, restaurants, apartment hotels, shops, car rentals and other services had been springing up in rapid succession. Eventually, this increase in businesses resulted in overcapacities, and competition became fierce. Not all of the new businesses survived for long, even though many believed that by hard work and sheer willpower they would be able to outdo their competitors (Welz 1999). Indeed, all of the restaurants offered the same specialty, namely, 'full *meze*', in much the same fashion, and for more or less the same price – regulated by the Cyprus Tourism Organisation, which also monitored the menus of licensed restaurants.

Restaurant-style Cyprus *meze* in the late 1990s consisted of a series of twenty or more small dishes, with starters such as dips and salads, proceeding to more substantial dishes, climaxing in an abundance of grilled meats and other main courses, finally settling down to fresh fruits and desserts. Clearly, it is a cultural product that differs from historically generated food service patterns variably called *mezze, mesé* or *mesedes* that can be found in Greece, Turkey and some Near Eastern societies, where plates of various hors d'oeuvres are served as accompaniments to drinks, often in a male-dominated taverna environment. In the tourism-oriented gastronomy of Cyprus, however, *meze* is a culinary event, and often the most expensive item on the restaurant's menu.

It requires that at least two customers have to join in ordering it. Usually, the Cyprus *meze* restaurant does not give guests any choice about the individual items of the *meze*, but submits them to a continuous series of whatever the kitchen produces. While the number and identity of individual dishes is not predefined, there is some pattern to the choreography and its progress through different food categories – from cold to hot, from raw to cooked and grilled, from dairy and vegetable to meat or fish. No dish will appear twice. All through the course of the meal, freshly arrived platters and bowls circulate among the company of those assembled around the table, and each takes as much as he or she wants before handing the dish on. This way, tourists are introduced to the social practice of commensality. The Cyprus Tourism Organisation early on made claims to this pattern being uniquely Cypriot. Along with dips, salads, grilled meats and meatballs that can easily be associated with Greek cuisine, some other specialties are offered that one rarely finds outside of Cyprus: smoked meats like hiromeri and lountza, loukanika sausages, grilled halloumi cheese made of goat and sheep milk, and shieftalia meatballs, to name a few. Also, main dishes such as pork cubes marinated in wine, fried liver, rabbit stew and lamb from the oven are incorporated in the *meze*. In coastal areas, fish and seafood dishes may substitute for or complement the meat varieties.[4]

The invention of the 'Cyprus *meze*' predates the Republic of Cyprus's accession to the European Union; indeed, it can be traced to times before the inception of the European Union itself, as tavernas that serve Cyprus *meze* go back to pre-1960 colonial Cyprus.[5] During the 1950s, the British colonial administration expanded considerable 'efforts to establish the colony as a holiday resort for wealthy Britons' (Morgan 2010: 203), and the island's airline, Cyprus Airways, started operating between London and Nicosia. Already in the 1920s, the mountain communities where higher-echelon British military families customarily spent the time of the worst summer heat had attracted English investors, who started building hotels in the so-called hill resorts (Eftychiou 2013). In the postindependence period of the 1960s, tourism development took off most markedly along the Famagusta coast, with high-rise hotel buildings and modern infrastructure to cater to mass tourism, primarily from Great Britain. Kyrenia and surrounding communities that had already been 'discovered' during the British colonial period remained attractive both to foreign tourists and as destinations for domestic holidays and weekend visits. In the aftermath of the Turkish invasion, these destination areas became inaccessible to Greek Cypriots and were cut off from international mass tourism. The Greek Cypriot tourism sector suffered a huge setback (Andronicou 1979; Christodoulou 1992). Many entrepreneurs and hoteliers lost their businesses and had to start all over again. This in turn led to new investments and the creation of tourism infrastructure in sites along the eastern and southern coasts of Cyprus that previously had not been within the purview of tourism development,

Protaras and Ayia Napa areas in the east and, after some delay, also Paphos in the southwest. Tourism specialists Sofronis Clerides and Nicoletta Pashourti-dou (2007: 51) assert that '[t]ourism has been a major engine of growth for the Cyprus economy in the post-1974 period. The development of a tourism in-frastructure in the difficult years after the invasion was instrumental in achiev-ing the impressive economic turnaround of the late 1970s and early 1980s.' The sector grew until the 1990s, when tourism revenues accounted for more than 20 per cent of the gross domestic product. Since then, the tourism econ-omy has not experienced any marked growth. Instead, the Republic of Cyprus as a destination became less competitive with other countries that also offer Mediterranean sun-and-sea holidays but at considerably lower rates (Ioannides 1992). Today, Cyprus increasingly finds itself priced out of a market that offers consumers fairly standardized 'packages' of travel and recreation.

In his analysis of the development of tourism in the Mediterranean, eth-nologist and cultural historian Orvar Löfgren claims that in the 'Mediterra-nean in the age of mass tourism, ... the tourist industry constantly develops new destinations, communities, and local cultures but within a rather stable and homogenizing framework' (1999: 156). Löfgren suggests that while each country of southern Europe and, indeed, each individual destination area of the circum-Mediterranean region claims to be unique, their intention is to of-fer commodities and services that consumers can easily associate with what is being marketed as 'typically Mediterranean'. Not just historical architecture, linguistic diversity and culinary traditions, but topography, climate and the nat-ural environment are rendered Mediterranean by deploying an internationally standardized vocabulary and imagery. Löfgren's study of the cultural history of Mediterranean tourism suggests that the infrastructure of tourism and its economic logic exhibit a marked trend towards homogenization. The industri-alization of the tourism economy has not only made destination areas around the Mediterranean Sea – and elsewhere – look alike. In addition, the tour op-erators, the transportation providers and the accommodation sector that make up the infrastructure of Mediterranean tourism have become coordinated by selling package holidays. Löfgren cites the emergence of the so-called charter tour week, which in turn 'created a characteristic rhythm of tourists coming and going at regular intervals' and gave rise to specific products offered to tourists that are pretty much the same all over the Mediterranean, such as the 'wel-come reception', the 'sightseeing bus tour', the 'village fiesta' and the 'local buffet' (1999: 189). Löfgren encourages cultural analysts to interpret these elements of the standardized holiday product as cultural artefacts. Indeed, the so-called tourist cuisine, an assemblage of internationally standardized meals that stem from many different destination areas, is such a cultural artefact.

Cyprus *meze*, then, can be interpreted as an attempt by local gastronomy and national tourism planners in the Republic of Cyprus to come up with a

tourist production that may help to distinguish Cyprus from other destination areas. However, all claims to uniqueness to the contrary, *meze* is not at all dissimilar from formats that Löfgren calls the 'local buffet'; *meze* also fits well with the genre of the 'village fiesta' that usually is the destination of bus tours or organized evening excursions for package tourists. As an attempt to create a 'typical' culinary artefact that communicates what is unique about the culture of the island, the Cyprus *meze* is an exemplary case of a tourist production. Rather than exposing the inherently fabricated nature of artefacts and events produced for tourist consumption and bemoaning the supposed loss of authenticity that goes with it, *meze* allows us to enquire into the cultural techniques that create touristic settings, events or artefacts, and into the discursive practices that make their claims to 'typicality' plausible. In an increasingly globalized world that appears to sever the links between transnationally available products and their places of origin, local places of food consumption and usage are often enhanced by the deployment of geographical knowledge. Human geographers Ian Cook and Philip Crang contend that tourism and gastronomy cater to consumers' desire to differentiate specific food items 'from the devalued functionality and homogeneity of standardized products, tastes and places' (1996: 132) by strategically deploying geographical knowledge and thereby 'reenchanting' food items.

What Makes *Meze* Cypriot?

How did *meze* come to designate what is typical about Cyprus and its culinary traditions? Food and drink often function as symbols of ethnic or national identity. The ethnologist Konrad Köstlin (1998) asserts that patterns most likely to be selected as typical are those that have a few, clearly recognizable traits that set them apart from those of other culinary traditions. Again, if these are easily communicable across cultural boundaries, this facilitates their transnational, even global marketing and diffusion, a quality that is relevant both in tourism and gastronomy. So-called national cuisines, for instance, in Italy and France, emerged since the eighteenth century by combining regional dishes and products to be canonized as elements of a homogenized framework that was then standardized in cookbooks, in cookery schools and by the growing gastronomic sector (DeSoucey 2010). Conversely, Cyprus cuisine appeared on the scene rather late and was forged through transnational contact – in the context of colonial rule since the late nineteenth century and of mass tourism in the twentieth century.

In the past, the day-to-day fare of the rural population in Cyprus was very unlike what is served as *meze* in contemporary restaurants. Up until the middle of the last century, Cyprus was a slowly urbanizing and modernizing colonial

society, with a sizeable part of the population still engaged in the agrarian economy. However, meal systems or food service patterns that assume the character of a regional or national specialty need not be the foods that the majority of the population habitually cooks and consumes at home. Quite the contrary: cross-culturally comparative research in folklore and anthropology shows that often it is not what the common people are eating on an everyday basis that is transformed into a symbol of cultural identity, but food items that are prepared rarely and consumed only for life cycle rituals such as weddings or on religious holidays such as Easter. Indeed, food practices that mark special occasions, that stand out in the course of day-to-day life, are more likely to become 'traditionalized' and to finally embody the very essence of a culture. Some authors relate the emergence of *meze* to the feasts that, in the traditional agrarian culture of Cyprus, marked religious festivals and special events such as weddings (Nicolaou 1980). In the past, these were the only occasions on which alcoholic beverages were consumed and food was prepared on a grand scale for people outside the circle of family and kin.

In addition to the process of cultural selection and amplification that goes into creating 'national' culinary patterns, the sociotechnical system of gastronomy also exerts a considerable influence on food cultures. Restaurant food, by its very nature, tends towards standardization, the repertoire being structured by the menu and by the economic and technological exigencies of supply, storage and speedy preparation of orders. Therefore, the seasonal variability of food items is largely eliminated in the commercial gastronomic context. While seasonal offerings such as mushrooms, snails, wild asparagus or zucchini blossoms may make an appearance occasionally, the *meze* served stays more or less the same throughout the year. Conversely, premodern nutrition in Cyprus consisted of seasonal fresh products and foodstuffs conserved by traditional means of curing, drying and pickling. In the twentieth century, with refrigeration technologies and long-haul logistics, but also as a consequence of innovations in agriculture and increased food imports from abroad, restaurants have become largely independent of what is available locally or seasonally. Nor is there much variation between Cyprus *meze* served in different regions of the Republic of Cyprus.

The origin of Cyprus *meze* is discursively emplotted in a narrative that insists forcefully on its centrality to Greek Cypriot culture. *Meze* also serves as an ambassador of Cypriotness abroad. A Paphos restaurant owner whom I interviewed in the course of a research project on small entrepreneurs in the local tourism economy (Welz 1999) told me of the restaurant that he and his brother had operated for some years in Vienna. He says, 'We always did the *meze*. You do not have that in Greece. And we behaved like Cypriots. People would say, "You are different from the Greeks." And we would respond, "Yes, it is because we are Greek Cypriots."' His insistent claim on the distinctiveness

Cypriot *meze* reflects an awareness of what social anthropologists call 'the two ways of being Greek' (Argyrou 1996) – the Cypriot and the mainland Greek one.

References to cultural identity are never uncomplicated on a divided island. In the south of the island, *meze* functions as a marker and medium of Greek Cypriot cultural identity. However, Turkish Cypriot restaurants and tavernas in the north of the island also offer Cyprus *meze* to their customers, albeit sometimes enhanced with elements imported from mainland Turkey. Ultimately, of course, *meze* as a traditional food service pattern is not limited to Cyprus, south or north, but can be found in other cultures of the region as well (Hatay 2006). In the chapter titled 'Meze' in one of her cookbooks, Ayla Algar, a professor of Turkish literature in Berkeley, suggests that *meze*

> reflects beautifully an attitude towards life shared by many peoples of the Balkans, Turkey, and the Middle East. Part of their shared culture and outlook on life is a determination to appreciate the varied pleasures of human existence. They have a keen appreciation of the transitory nature of life, of the fragile nature of the existence on which Westerners habitually lavish such proud and obsessive concern. This perception often induces a dignified melancholy that has a thousand cultural expressions and enhances the ability to enjoy a few simple pleasures, at the head of which stand eating and drinking in a leisurely manner and congenial company. From this has arisen the tradition of certain types of food known as *meze*. (Algar 1991: 45)

In the process of establishing the uniqueness of *meze* as Greek Cypriot cultural patrimony, references to historic written sources and local folklore research have been instrumental. One origin narrative of the Cyprus *meze* traces its provenance to customary practices of hospitality that could be observed in rural premodern Cyprus. In the late nineteenth century, German author and photographer Magda Ohnefalsch-Richter travelled all over Cyprus, accompanying her husband, Max Hermann Ohnefalsch-Richter, who since 1878 had been active in Cyprus as an amateur archaeologist and as a trader in antiquities.[6] Magda Ohnefalsch-Richter observed that Greek Cypriot households welcomed unexpected visitors with a plethora of 'small tasty tidbits' served alongside a drink of *zivania*, a strong, clear spirit distilled from grapes. In 1913, she published a book about her travels in Cyprus with a renowned Berlin company specializing in archaeological and ethnological works, illustrated with many of the photographs she had taken. In the book, she repeatedly refers to the abundance of small delicacies and sweets that were served to guests, even at the homes of the humblest peasants. Invariably, hosts would insist that the unexpected visitors stay and spend the night. They would then offer a long series of small quantities of foods. These varied according to what the season offered or what the household could afford[7] – which may have been only a piece of

bread and then some dried or fresh fruit, cheese, bits of egg, radishes and salad (Ohnefalsch-Richter 1913: 134). Ohnefalsch-Richter set out to offer evidence that in the rural Greek Cypriot folk culture of the island, relics of Greek antiquity could still be found that had disappeared elsewhere. In her book, she reproduced widely accepted assumptions about unbroken historical continuities and the unchanging nature of archaic traditions that were promoted by the emerging scholarly discipline of *Volkskunde* in the late nineteenth century. The book, however, is also very informative about everyday life in urban Cyprus at the turn of the century, the economic reforms introduced by the British colonial power and competing geopolitical interests homing in on Cyprus in the years before the First World War.

For the specific practice of demonstrative hospitality, Magda Ohnefalsch-Richter adopts the locally used term *mesé*. Tourism marketing and other related discourses such as cookery literature, restaurant reviews and travel books about Cyprus often include a reference to Ohnefalsch-Richter's book, which was given a second lease on life in Greek translation in 1994 to serve as a source-book for Greek cultural nationalism on the island. According to widely held assumptions in Greek Cypriot society, *meze* today implies a social bonding between the people gathered around a table, eating and drinking in the company of friends and family. It also constitutes a special relationship between the persons offering the food and those consuming it. Food researcher Nicos Andilios quotes the late Peter Loizos, stating that 'food is the basic symbolic currency of all serious friendship in Cyprus' (Andilios 1998). Against this backdrop of rapid and then stagnating tourism development, Cyprus *meze* has expanded to become the centrepiece of gastronomy in the restaurant and catering sector of the Republic of Cyprus. Tour operators and government agencies in Cyprus managed to construct the narrative of an evolutionary development that claims to connect it to the noncommercial, 'traditional' custom of *philoxenia*.

Performing Asymmetry

Cyprus *meze*, first and foremost, is a tourist commodity. By claiming that it originated with rural households demonstratively asserting their hospitality towards welcome and even unwelcome strangers, tour operators, guide books and the restaurant and catering sector are communicating a favoured self-image of Greek Cypriot culture as hospitable, socially inclusive and inherently generous. This serves to obscure the economic logic that underlies transactions between tourists and local businesses. In Greece, the stranger was to be treated generously as an honoured guest. In its purest form, *philoxenia* implied that the host's generosity should be total. Cultural anthropologist Michael Herzfeld, in his study of a sheepherders' community in Crete, writes that 'the ultimate

example of social excellence is given as the poor widow's reaction to unexpected guests; her offering of a glass of water and a handful of olives, the best she can do, is valued as an act of total generosity'. Herzfeld goes on to describe how the male head of a household would respond to the arrival of unexpected guests:

> He may apologize for the poverty of his table, pointing out that the guests would have to be content with 'whatever can be found'. This phrase invokes a crucial principle. Ability to improvise, to make the most of whatever chance offers, is the mark of the true man. It is unthinkable … to refuse to entertain extra guests; on the contrary, he is expected to make the most of what he has, announcing that 'food for nine [people] also defeats ten'. (Herzfeld 1985: 135)

This stance can also be observed in Cyprus. Some years ago, in a taverna in a Paphos district village, the owner would habitually greet new arrivals with the words, 'I am very sorry, but potatoes are the only thing we still have, everything else is used up.' However, shortly after, staff would bring plate after plate heaped with different *meze* items, overwhelming the guests with a plethora of tasty dishes – certainly much more than mere potatoes. Initially creating the impression of being somewhat unprofessional – after all, a restaurant running out of food to serve the guests – and then claiming that he improvised a very impressive meal out of nothing, this was not just a joke that invariably got a good laugh out of his guests. Rather, this ploy ultimately enhanced his attitude of being proud of the abundance and diversity of the food that he was able to offer to his guests.

Anthropologists emphasize that in many premodern societies, hospitality, extended as well as received, is a cultural mechanism that articulated social differences and power asymmetries – between co-villagers of different families, between those from inside and outside the village, between village and city, or between villagers and the foreign travellers coming through. It is considered to be embedded in a cultural order that places much importance on reciprocity as a mechanism of social integration. Pierre Bourdieu's observations from his 1950s fieldwork in the Maghreb attest to the powerful symbolism of making and returning gifts of food between households, and to the high degree of cultural mastery required of those who skilfully manipulated its meanings (Bourdieu 1977). Today, in the tourism economy, social differences and power asymmetries frame the relationship between tourists and the social group of 'locals' whom they interact with, which consists of tourism entrepreneurs, service staff and residents of destination areas, some of whom are employed in tourism or related economic sectors. In the business transactions of tourism, reciprocity as a social principle is usually short-circuited by the closure that payment brings. Indeed, 'the tourist-local relationship is odd in many ways. One member is at play, one is at work; one has economic assets and little cultural knowledge, the other has cultural capital but no money' (Crick 1989: 467).

Clearly, with gastronomy constituting a commercial exchange ruled by economic principles, this culturally coded relationship of *philoxenia* changes to become a transaction between a 'hospitality worker' and a consumer. When a certain degree of professionalization is achieved, this business transaction may, however, be couched in terms of a host-guest relationship, with 'personalized' service being offered. 'Today, the guest-xenos is a tourist, who is a client. The host offers "services" and not "friendship", and the xenos-tourist pays for it. Their relationship is ruled by the laws of commerce and now the xeno is in superior position, since he has the money', writes anthropologist Cornelia Zarkia (1996: 163). However, the *meze* is a culinary genre that allows for the restaurant proprietor to regain some of the culturally accorded symbolic dominance that is inherent in the stance of the host. As the restaurant menu refrains from giving detailed step-by-step information, allowing for a degree of variation on the part of the kitchen, the *meze* always contains some element of surprise. Tourists who experience a *meze* for the first time do not know what to expect. Their ignorance puts them in a position of weakness vis-à-vis the restaurant staff that compounds a situation where at least some of the dishes offered are unfamiliar to them. This asymmetrical relationship appears to be an inbuilt feature of the serving pattern of the *meze* that subverts or at least ironically underscores the prevalent relations of inequality that characterize the commercial transactions between gastronomic businesses and their customers.

In the conventionally coded interactions that make up the cultural space of the restaurant in modern societies, restaurant goers enjoy the privilege of giving orders to staff who in turn will attempt to fulfil these in order to receive payment for the services rendered. Conversely, in a *meze* restaurant, as pointed out already, customers may well feel at the mercy of the restaurant owner and his staff. Indeed, rarely are the guests able to finish what is laid out on the table – and some who have not approached the initial servings with the appropriate restraint will find themselves unable to go on before the highlights of the *meze* have even reached the table. I have seen visitors hoisting a napkin as a white flag signalling surrender (Welz 2000).

The *meze* restaurant emerges as an arena where this unequal relationship is articulated, performed and sometimes subverted. Restaurant owners, chefs and service staff are often very adept at staging the asymmetry that underlies the economic transactions of the restaurant business. In traditional host-guest relationships, the power imbalance privileges the host, at whose mercy the guest has placed himself. As David Sutton in his acute analysis of Greek food cultures has observed, 'hospitality can be aggressive' (Sutton 2001: 47ff.; see also Herzfeld 1985). In the restaurant, the guest believes that the imbalance is reversed here and he or she is in charge because of his or her buying power as a consumer. However, in the *meze* restaurant, guests are at the receiving end of a seemingly endless stream of dishes being served, which is strategically calcu-

lated to overwhelm them and put them in a subservient role. This is also very evident in the verbal communication by the serving staff or the chef – they always have the last word and, of course, yet another dish they can deploy to shame and silence the guests. As such, hospitality is always 'at once a performance and a space for performance' (D. Scott 2006: 70).

Modernity and the Mutations of Cypriot *Meze*

As has become obvious throughout this chapter, three different food patterns can be referred to when speaking of *meze*. First is the social practice of households to offer hospitality in the home. This is often part of a nonmonetary exchange system, and the food offered alongside something to drink here functions first and foremost as a symbolic token of adhering to the traditional moral order and fulfilling the expectation of reciprocity. Second, in many societies of the eastern Mediterranean, tavernas, bars and night cafés serve hors d'oeuvres for free to accompany drinks, mostly alongside alcoholic beverages. Here the practice is associated with urban culture, and its identity clearly is masculine. The tourist meal that has been at the centre of this chapter, however, is an invention that has been abstracted and disembedded from local everyday life. Its commodification has led to the creation of a cultural artefact that has taken on a life of its own, and indeed exhibits only a somewhat tenuous connection with what people eat and drink in the privacy of their homes, at communal events or at public functions. Yet, while the restaurant *meze* serves as an interface between tourists from various countries and the tourism economy of postcolonial modern Greek Cypriot society, its role is not exhaustively described by its function of communicating a favoured self-image of Greek Cypriot culture to outsiders: as hospitable, generous and able to command an unending flow of food. Rather, *meze* restaurants also serve as an arena for demonstrating the local populations' consumption preferences and for performing their self-ascribed identities as members of a modern and prospering society. Greek Cypriots also go out and have *meze* at a restaurant. Indeed, the major periods of tourist developments coincided with a process of rapid modernization of Cypriot society. Since the 1960s, the standard of living greatly improved, first in the urban centres and surrounding areas, and then also in rural and mountainous regions. Social change, measured in terms of modern value orientations, educational achievement, political pluralism and material prosperity, was observed by social scientists doing research in post independence Cyprus (Attalides 1981; Markides, Nikita and Rangou 1978). Some of these studies were criticized later for adopting conventional models of Western modernization theories and projecting them onto colonial and postcolonial Cyprus (Welz 1999). Yet, it is undisputable that the 1970s and 1980s saw the emergence of culturally expres-

sive class differences in Cyprus and the emergence of new patterns of sociability, consumption and aesthetic preferences (Argyrou 1996). The evolution of *meze* demonstrates some of these changes as well. What characterizes the restaurant *meze* of today is an overwhelming abundance of foodstuffs that communicates a sense of 'opulence', a term that social anthropologist Olga Demetriou deploys to characterize the cultural habitus of the post independence urban upper class in Cyprus (Demetriou 2012). Until a few years ago, before the first signs of economic crisis appeared on the horizon, the Republic of Cyprus was proud of its recent prosperity, having transformed itself into a booming service economy that generated high incomes for large parts of the population. This was also reflected in the *meze* served at restaurants frequented by local residents. Most evident was the volume and diversity of multiple meat dishes – predominantly lamb, pork and chicken, prepared in a variety of ways. Any one of them would have been considered a rare treat in the past. Now Cypriots could afford not only to eat as much of them as they would like – or offer them to tourists – but they could also afford to discard them. In a good *meze* restaurant, many platters and plates would go back to the kitchen, still heaped with offerings only half-eaten. On Internet-based social media, which increasingly serve also as instant archives for images of culinary consumption, Nicosia restaurant goers uploaded photos and videos of restaurant tables that look like battlegrounds where both armies of combatants ultimately surrendered. Hardly ever would customers ask staff to have leftovers bagged so they can take them home. The celebratory attitude towards abundance and waste appear to be indicative of the need of Greek Cypriots to advertise their prosperity and well-being, if one interprets it along the lines of what anthropologists call a potlatch, a ritualized destruction of material wealth that serves to enhance one's status. A full *meze*, then, is also appreciated for its potential to demonstrate one's ability to be wasteful.

The symbolic idiom that conveys these messages, however, has much in common with the 'traditionalist' habitus of the Greek Cypriot working class, if we follow Vassos Argyrou's analysis. Indeed, *meze* seems to amplify the mentality of a previously poor population that became rich unexpectedly and in a very brief time span. In that sense, *meze* is not so much evidence for the persistence of traditional food ways. Rather, it is a symbol of Cypriot modernity. Prosperity's downside – increasing numbers of children suffering from obesity, the proverbial cases of overeating adults that end up in hospital emergency rooms at Easter, after the fasting period is over – constitutes a staple of Greek Cypriot media coverage these days. Conversely, among the urban elites and the middle class, aligning themselves with what are considered Western European lifestyles, eating 'à la carte' in restaurants offering 'international' cuisine or Italian-derived meals is becoming more common, especially in the urban centres. Yet, even for them, a full *meze* at a taverna known for its abundant offerings is

still the preference on a summer weekend at the beach or in the mountains with family and friends.

Meze, however, in essence is more than just a commodity that allows Cypriots to be modern and down-to-earth at the same time by going to a restaurant and adhering to habitual food preferences. The very materiality of *meze*, the assemblage-type structure of the meal, consisting of elements and modules that can be omitted, added on and replaced, lends itself to becoming expressive for social change in Cyprus. New elements such as Asian or Near Eastern dishes are being integrated into the *meze* that restaurants in urban centres are offering. Also, an emphasis on 'healthier' eating and the introduction of an element of choice, where the guest has the liberty to cancel *meze* elements that are not wanted beforehand, are tokens of a new style of *meze*. Cultural commentaries even speak of the neo-Cypriot *meze* as an expression of the tastes of the new urban middle classes.[8]

Beyond Cyprus, the type of sharing food and enjoying conviviality that *meze* embodies today has become an emblem of Mediterranean cultures and even receives recognition as patrimony of all mankind, as UNESCO included the so-called Mediterranean diet on its list of intangible cultural heritage in 2010. Here, the Mediterranean diet is considered not simply a repertoire of food items, but also a social practice. Initially, Cyprus was not among the countries pushing for the inclusion of the Mediterranean diet.[9] More recently, a second initiative has reapplied to the pertinent UNESCO bodies for a renewed listing of the Mediterranean diet. This time, the Republic of Cyprus was a member of the group of applicants. The Cyprus *meze* can be considered an ideal representative of the Mediterranean nutritional system, as it is a 'shared group meal' that embodies particular social practices that are cited in the UNESCO documentation as central for the Mediterranean diet: 'favouring neighbourliness, sharing, and conviviality'. As some authors point out, the Mediterranean diet is not just an 'invented tradition' that can be instrumental in tourism marketing; it has become the emblem of a 'Mediterraneanist imagination' (Römhild 2009) that social actors in southern Europe have begun to appropriate in order to position themselves and their societies within the European arena.

Conclusion: Wasting or Sharing?

Obviously, *meze* can be submitted to a cultural reading and serves as an indicator of societal change not only to anthropologists, but also to the social actors who sit down to the *meze* table and embark on this abundant and time-consuming meal. What will happen to *meze* in the near future? Will it change, and if so, how? *Meze* is one of the arenas of Greek Cypriot society where abundance as well as scarcity are socially produced and manipulated by symbolic

means. Human geographers and sociologists point out that waste is a socially constructed category. Practices and discourses that determine when and how a food item passes the threshold between still being edible and becoming waste to be discarded are indeed specific to individual societies and cultural milieus. What British sociologist David Evans calls 'the normativity of binning', the 'tendency for surplus food to be cast as "excess"' (2012: 1123) and discarded rather than recycled, is widespread throughout Western societies. Human geographer Nicky Gregson points out, however, that the social practices of wasting as well as of saving are meaningful, as they symbolize social relations and materialize identities (Gregson, Metcalfe and Crewe 2007).

In recent years, international food activists and critics of globalization have constructed an ethical discourse that condemns overconsumption, the food industry's global supply chains and the habitual discarding of uneaten food by private households. In many of the southern European societies that have been brought to the brink by state debt crises and failing banks as well as the austerity policies prescribed by both domestic and European political elites, challenges of a different sort, much closer to home, are coming up. With an increasing number of households without an income and an entire generation of young people being robbed of their future, access to food becomes critical once again in societies that appeared to have finally and forever emerged from hunger and want. However, new types of social activism are also emerging. The generosity of huge numbers of Cypriots who have responded to calls to donate food and other items to be collected and passed out to families in need is impressive. Indeed, in other European countries as well such as Portugal that are also suffering from the economic crisis and the austerity measures ordered by the Troika, food pantries, soup kitchens, urban gardens, barter exchanges and clothes banks are springing up. Political analysts are debating whether these constitute a solution to the problems at hand or are worrisome symptoms of neoliberal hegemony. One thing that is certain is that Cyprus *meze*, as a practice and as a social imaginary, will continue to mutate and grow into something different again to reflect these changes.

Notes

1. Barbara Kirshenblatt-Gimblett (2006) refers to heritage making as a 'metacultural' practice than generates second-order culture.
2. The assumption that the Mediterranean is a unified region with considerable homogeneity within and singular distinctiveness when compared with other regions was prominent in the humanities in the second half of the twentieth century, but was criticized by and largely abandoned within anthropology (see Goddard, Llobera and Shore 1994; Albera, Blok and Bromberger 2001; Giordano 2012).
3. This chapter takes up earlier case studies conducted in the 1990s and develops them further by engaging with recent events. A first, tentative interpretation of the Cyprus *meze* was pre-

sented at the Cyprus Tourism Organisation's 2000 meeting 'Local Food and Tourism' (Welz 2000, 2004). I also conducted a study on the 'invention of tradition' within the framework of the Laona Project in the Paphos district (Beck and Welz 1997). When I did research on the economic culture of small entrepreneurs in the Paphos district tourism sector in 1997, I interviewed more than a dozen restaurant and taverna owners. Some of these were in-depth biographical interviews, tracing their life histories through emigration and return migration (Welz 1999). Of the businesses included in the initial study, many still exist, while some have changed owners. Three of the restaurants have been visited annually, and I gathered follow-up information until 2014; also, new developments in the regional gastronomy have been noted. Included also were many observations of Nicosia's gastronomy that I was able to collect over the years. Under my supervision, one of my former students, Miriam Pfeiffer, conducted a study in 2005 on the impact of EU hygiene regulation, transposed into Cyprus law, on the restaurant and catering sector; those results, albeit unpublished, were also helpful in this context. My understanding of *meze* has also benefitted from talks with experts in Cyprus cuisine and the culinary arts, most notably Nicos Andilios, Photis Papademas and Ephrosini Rizopoulou-Egoumenidou. In 2013, I was invited to present my thoughts on recent developments of *meze* at the University of Nicosia, where I received valuable comments from Nicos Peristianis, David Officer and Evi Eftychiou, as well as other discussants.

4. For the history of Cypriot food items and nutrition practices, see Rizopoulou-Egoumenidou (2002, 2007).
5. A well-known example is Zanettos Restaurant on Trikoupi Street in Nicosia's old town, which was founded in 1938.
6. For information about Magda Ohnefalsch-Richter and her contribution to the early ethnology of Greek Cypriot culture, see Loizou Hadjigavriel and Severis (1998) and Krpata (1997). In 1997, a Greek-language edition, translated from the German by cultural historian Anna Marangou, was published by the Bank of Cyprus Foundation.
7. In the original, the book says, 'Diese Sitte, allerlei kleine Leckerbissen zum Weinbranntwein zu servieren, ist allgemein verbreitet, die je nachdem, was die Jahreszeit bietet oder im Haus vorhanden ist, wechseln. Zu kleinen Bissen Brot geben sie allerlei frische und getrocknete Früchte, Käse, Eierstücke, Radieschen, Salat. Etc. etc.' (Ohnefalsch-Richter 1913: 134). Elsewhere in the book, she mentions olives, almonds, nuts, dried figs and raisins, as well as 'coffee according to Turkish custom'. She also makes reference to ambeloupoulia, small songbirds preserved in Comandaria wine (1913: 73).
8. There has been an explosion of restaurant reviews and food journalism in the Greek Cypriot media in recent years. New trends are coproduced by food journalists who are active on online portals. Here, the so-called *magiria* are celebrated as a 'discovery'. These are urban lunch counters and small, unpretentious restaurants that offer homemade food at midday, mostly for the lunch breaks of local businesses and offices. Here, each day of the week, some variety of pulse is served, as well as a meat dish with fresh vegetables and potatoes.
9. The inclusion of the nutritional model of the Mediterranean diet – the label itself an invention of food scientists and agricultural economists – on UNESCO's registry as a cultural good that is worthy of safeguarding was initiated by a Barcelona-based nongovernmental foundation in 2004, and was subsequently picked up and pursued with great energy by the governments of four circum-Mediterranean states – Spain, Italy, Greece and Morocco (Reguant-Aleix and Sensat 2012). Their agricultural ministries spearheaded the effort, which was also supported by NGOs, universities and research institutions. They considered the traditional culinary system of Mediterranean countries to be threatened because of changing consumption patterns in these societies, but even more so as a result of the

globalized 'agrofood' market, which leads to the abandonment of land, crops, traditional professions and techniques (see UNESCO 2010). With the new 2013 inscription, the emphasis shifted somewhat towards highlighting local customs, especially traditional festivals, connected with food practices. In this, the inscription became more in line with the type of cultural expressions that are usually included on the list. This time, Cyprus was represented by the community of Agros in Pitsilia, which is known for its smoked meats and sausages as well as products made from rose petals such as rose water and rose oil (see UNESCO 2013).

CHAPTER 5

'Origin Food'
The Struggle over Halloumi

❧

A few years ago, a German enterprise based in Stuttgart registered the trademark 'hellim' for one of its dairy brands, called Gazi, with the European Union. Hellim is the Turkish-language term for the cheese known among Greek Cypriots as halloumi. Immediately after the German registration of the trademark for hellim in 2006, an association representing the interests of Greek Cypriot dairy companies lodged a complaint with the European Union's Office of Harmonization in the Internal Market (OHIM). This dairy producers' organization had also been granted a trademark by the OHIM in 2000, albeit a slightly different one called 'collective community word mark', which reserved the use of the product name 'halloumi'. Legally, the complaint by the Greek Cypriot producers relied on the allegation that consumers could easily confuse products called 'halloumi' and 'hellim'. In 2010, OHIM turned down the objection, arguing that there was no risk that consumers would mistake the German-produced 'Gazi hellim' for 'halloumi' produced on the island of Cyprus, because the words are phonetically and visually sufficiently distinct. The General Court of the European Union finally ruled in June 2012 that the Germany-based company is permitted to call its cheese product 'hellim' when exporting it throughout the European Union.[1]

The Greek Cypriot dairy sector was very displeased with the outcome of this legal altercation, and in public discourse in the Republic of Cyprus, the ruling was considered grossly unfair. The struggle over the rights to the production and marketing of halloumi cheese acquired a dimension highly charged with nationalist sentiment. In what follows, I will use the legal case between the Stuttgart-based Gazi brand and the Greek Cypriot dairy corporations as a starting point for an enquiry into how transnational regimes of trade regulation and intellectual property protection enter into an unexpected but productive liaison with cultural nationalism.[2] Historians assert that 'food consumption plays a crucial role in the construction of local and national identities and in the changing self-understanding of social groups', adding that 'foodstuffs … raise sensitive questions of authenticity' (Nützenadel and Trentmann 2008: 13). In the case of Gazi hellim, the suspected usurpation of halloumi cheese by Turk-

ish economic interests gave rise to much concern in the Republic of Cyprus. Today, the culinary heritages of European countries are marketed globally, and traditional food constitutes a growing economic sector within Europe. (Welz 2012a) As a consequence, competition between producers is growing fierce, and the need to protect the uniqueness of one's product becomes even more important than before. This chapter is based on interviews that I conducted in the Republic of Cyprus since the 2004 European Union accession.[3] In my research, I built on an earlier field study of the modernization of halloumi production before EU accession that I had conducted in collaboration with Nicholas Andilios, a Greek Cypriot educator and food researcher. In 2002, we visited both small-scale halloumi producers and the industrial mass production cheese factories. We eventually published a chapter (Welz and Andilios 2004) that was included as background documentation when the Republic of Cyprus applied to the European Union to obtain an exclusive quality label for halloumi cheese. This earlier work, which referred to the fact that both communities on the island traditionally produced the cheese under discussion, was also used by Turkish Cypriot cheese producers when they tried to make a case, albeit in vain, for inclusion in this particular application to the European Union.

Contested Claims

Even though the brand name Gazi employs a Turkish term that translates into 'veteran soldier' or 'fighter', the Stuttgart-based company producing Gazi hellim has no connections with Turkish or Turkish Cypriot business interests. It was founded by a German of partial Spanish descent. Over the years, he developed a number of brands with foreign-sounding but invented names, catering to various ethnic niche markets of immigrants from southern Europe who had settled in Germany. Increasingly, also Germans, interested in the food they had tasted while on holiday in Italy, Bulgaria, Greece or Turkey, as well as restaurants and convenience caterers became customers of this very successful company. Gazi products, like the company's other brands, are produced exclusively in Germany, utilizing milk from German dairies, and are distributed primarily within Germany, even though broader European markets are also targeted. While the brand name Gazi is a fictitious creation for marketing purposes and has no connections to brands originally produced in Turkey, the name appears to be successful in attracting the Turkish immigrant clientele residing in Germany. However, as an employee who demonstrates how to grill hellim at promotional events in immigrant supermarkets throughout Germany told me, Turkish housewives living in Germany are largely ignorant of hellim cheese and have to be told how to prepare it. This is no surprise, as hellim only became

widely available in Turkey a few years ago. There, it is not explicitly marketed as a Cypriot product.

The case of a Cypriot cheese reinvented by a German entrepreneur to cater to German residents with a Turkish background is a telling example of how associations with place and culture are deployed by the food sector in order to add value and target specific consumer groups. Because of the dominance of distributed production networks and transnational value chains, commodities today often lack clear-cut or proven connections with specific places of origin or with actually identifiable producers. These have to be added at the retail end of the chain and may as well be fabricated, unless specific regulations – such as ecolabels or fair trade certificates – plausibly support the credibility of origin claims. Producers as well as state and private regulatory bodies are increasingly making use of designations of origin to add value to food products, hoping that the distinction will make them more competitive in globalized markets. In the case of Gazi hellim, however, the insinuated connection to a country of origin is fictitious. The German enterprise makes use of Turkish-sounding names as a marketing ploy, but otherwise does not even refer to the provenance of this type of cheese from the eastern Mediterranean. With consumers in Germany, this poses no problem. Within the Cypriot context, the Stuttgart-based company's strategy is explosive, as it goes to the very heart of the cultural nationalisms that actors on both sides of the Cyprus conflict continue to wield as divisive instruments.

When the Greek Cypriot producers appealed the OHIM's ruling, the OHIM and then also the General Court of the European Union turned down their complaint. The courts based their decisions on the fact that trademarks differ from other intellectual property rights regulations that protect a design or technology. A trademark grants an economic actor the exclusive right to use a name for a product, and to take action against any other producers calling their product by the same name. Nevertheless, the trademark does not prohibit other producers from manufacturing the cheese; it even allows for using the same recipe, provided that the resulting product is labelled so that it cannot be mistaken for the trademark-protected commodity. The Greek Cypriot dairy corporations' 2012 failure to prohibit the use of the term 'hellim' by a German producer acquired particular salience against the backdrop of the Republic of Cyprus's attempt to secure a 'geolabel' of the EU for halloumi cheese produced in the Republic of Cyprus. Within the various international frameworks for intellectual property regulation, 'geolabels' and other protections of geographical origin markedly differ from such regulations as copyright, patent or – as in the example of Gazi hellim – trademark. While trademarks are conferred to entrepreneurs or companies, geographical indications are awarded to products whose provenance is territorially defined. As a consequence, geographical indications cannot generally be reserved for one producer or com-

pany, but are shared by all producers in a given area who produce the product thus protected.

Pure Products, Messy Histories

But is halloumi an exclusively Greek Cypriot product? Is the hellim produced by Turkish Cypriots a mere copy of the authentic original, as the protests by Greek Cypriot producers against Gazi hellim inferred, or do dairy producers in the north of Cyprus have a legitimate stake in this food tradition as well? Did halloumi originate on the island, and was the recipe later exported to other regions of the Near East where halloumi is known today, such as Lebanon and the Arab countries? Or was the practice of making a cheese that is resistant to melting, an effect of the fresh curd being heated before the cheese is shaped, imported to Cyprus from other areas of the eastern Mediterranean thousands of years ago? All of these questions are rife with ethnicist assumptions and economic competition. The Greek Cypriot response to the Stuttgart case, then, may well be interpreted as an example of what social anthropologist Peter Loizos once called 'invasive ethnicity', indicating that these 'ways of thinking and acting about nation, ethnic and personal identity' (Loizos 1998: 37), once they have taken hold in social life and people's subjectivities, insidiously dominate any perception of self and other.

Halloumi, or hellim, is a cheese that does not belong to any one ethnic group or nation alone. Historically, the multiethnic and multireligious population of Cyprus held many food traditions in common. Ultimately, social anthropologists contend that any claim to ethnic ownership of a food product or a recipe is always the outcome of social constructions, resting on an 'authentification regime' (Nützenadel and Trentmann 2008: 13) that privileges discursive and symbolic evidence of a group's social and territorial integrity through history. Etymologically, the term 'halloumi' points to an Arabic root, and cultural historians insist on Venetian sources that had encountered halloumi in the pre-Ottoman period (see Patapiou 2006). At the beginning of the twentieth century, German folklorist Magda Ohnefalsch-Richter mentioned halloumi as one element of a Greek Cypriot family's hospitality offered to passing travellers but did not insist on its Greekness (Ohnefalsch-Richter 1913: 96). A recent study by sociolinguists at Eastern Mediterranean University relies on Ottoman sources and attempts to trace the origins of halloumi back to the Roman Empire and ancient Egypt (Osam and Kasapoğlu 2010), claiming that halloumi/ hellim is definitely not the exclusive cultural property of Greek Cypriots. Some findings indeed suggest that the recipe and the specific technology of cheese making predates the division between Orthodox Christian and Muslim inhabitants of the island, and was known on the island long before the formation of

Greek and Turkish Cypriots as ethnic groups. Etymological origin of a term is not identical with proof of an artefact's provenance, which may have come about by way of lexical borrowing, technology transfer, a population's migration or products traded between groups. Clearly, the adoption of innovations from elsewhere has made cultural change possible in societies throughout the world for thousands of years. Contemporary anthropology is wary of explanations that cite evidence for the unequivocal provenance and historic continuity of any cultural artefact, knowledge or practice. Anthropologists consider all traditions 'invented' insofar as they are always an interpretation of the past guided by present-day interests and identities.[4] While it is often cited as common knowledge that halloumi cheese production goes back many centuries and was not exclusive to one group of the population, as both the Greek and the Turkish Cypriot rural population utilized sheep and goat milk in their food production, there is no evidence that in the village context, cheese production occurred in cross-ethnic contexts. Rather, it is safe to assume that this gendered subsistence activity, where groups of women pooled the milk of their animals to produce cheese once a week (Loizos 1981: 22), was known to and practised by Orthodox and Muslim women in their respective neighbourhood groups separately. In her ethnography of the village Kozan in the north of Cyprus – known by Greek Cypriots as Larnakas tis Lapithou – where she conducted fieldwork between 2003 and 2006, Lisa Dikomitis encountered hellim making as a family-based gendered occupation (Dikomitis 2012). Her observations of Turkish Cypriot families, many of whom were displaced from the Paphos district and resettled in Kozan, mirror firsthand observations in Greek Cypriot society among small-scale domestic halloumi producers in the south (Welz and Andilios 2004).

Halloumi/hellim is only one of a whole series of Greek and Turkish twin terms denoting the same food item familiar to and consumed by both communities (see Papadakis 2004; Welz 2013a).[5] An example people are familiar with throughout the eastern Mediterranean is the candy known as loukoumi in Greek and lokum in Turkish. In Cyprus, the Easter bread called flaouna by Greek Cypriots is known as pilavuna among Turkish Cypriots. This phenomenon is not limited to Cyprus, but can be found in other countries where Muslim and Christian populations coexisted during Ottoman rule as well (Hatay 2006). Since the 1974 Turkish invasion and the de facto division of the island, references to food and eating, with their benign connotations of conviviality, pleasure and sharing, have served to lend credibility to Greek Cypriots' insistence on the so-called good-neighbourly coexistence prior to 1964 and especially during the colonial period. During the 1990s, bicommunal peace activism on both sides of the Green Line employed the shared food culture of Greek and Turkish Cypriots as a medium for reconciliation and rapprochement, citing it as evidence of an older unity broken by the colonial regime's politics of

divide and rule. The findings of ethnologists and folklorists have been used to substantiate this view of socio-political relations between the communities under British rule (Azgin and Papadakis 1998). Conversely, as Constantinou and Hatay argue, in Greek Cypriot society today, 'non-ethnic or cross-ethnic heritage ... is underestimated, with the exception of peace activists concerned with the construction of a common Cypriot national identity' (2010: 1601).

The Europeanization of Cheese Making

The hellim cheese that farms and dairy companies in the north of Cyprus produce cannot be traded across the Green Line. According to the Green Line regulations proclaimed after the EU accession of the Republic of Cyprus, dairy and meat products are excluded from the group of goods that Turkish Cypriot producers can sell to companies and consumers in the south of the island.[6] After the failure of the 2004 referendum, Turkish Cypriot agricultural producers remain locked into an internationally nonrecognized polity, without access to European markets. Conversely, with regards to agriculture and food production, the 2004 European Union accession of the Republic of Cyprus introduced many European Union regulations, but also new funding opportunities to the Greek Cypriot agricultural sector. This tended to stabilize differences and deepen disparities between agricultural production on both sides of the Green Line.

The opening up of national markets within the framework of the Common Agricultural Policy of the European Communities, coupled with the ability of industrial food production to mass produce and widely distribute such local food products that were once limited to specific regions and dependent on artisanal production skills, increasingly marginalized the small-scale rural production of traditional foods. In addition, out-migration from rural areas to urban centres hastened the declining viability of agricultural production in many European countries. Regional diversity in food consumption throughout Europe faded in the course of the twentieth century. In most European countries, those artisanal foodstuffs that in the past used to be produced in rural households and small family-run businesses have started to disappear because of the small scale of production and limited markets. Some of them are at risk of becoming extinct altogether once the older generation of producers abandons production and no successors take over. Some products – especially cheese, sausages and smoked meats – may survive, but often only because they have already made the transition to semi-industrial or even industrial mass production (Grasseni 2005). Thus, vernacular food in the sense of traditional local food systems mostly ceased to exist decades ago. At best, 'one item in an older farming or culinary system ... has been selected out by the market, [while] the rest of the

local system is largely abandoned and unlamented' (Pratt 2007: 298). Today, most artisanal products marketed in European countries have been 'generated out of sustained commercial activity, state regulatory systems, and international trade agreements' (Pratt 2007: 298).

In addition, since the year 2000, the European Union considerably augmented its restrictive regulations in order to increase food safety for consumers throughout Europe. As a response to the bovine spongiform encephalopathy (BSE, commonly known as mad cow disease) crisis, the European Commission initiated structural reforms, tightened hygiene controls and created new Europe-wide institutions. In 2002, a new General Food Law became effective. This tightened legislation forced especially those businesses who process meat and dairy products to upgrade their production facilities in such a way as to ensure production of 'safe food' in 'hygienic conditions'. Some experts of European food cultures have been critical of these transformations, claiming that the implementation of rigid hygiene standards leads to traditional artisanal techniques being driven out by industrialized, high-tech mass production. These researchers also find much evidence that the financial burden of complying with the new regulations is often too heavy for small enterprises, so that large numbers of small agrofood businesses all over Europe – small farms, local butcheries, cheese producers – closed down in the aftermath of the implementation of the new legislation.

Indeed, two years prior to EU accession, the government of the Republic of Cyprus declared artisanal cheese production in the villages a 'public health hazard' that posed a serious danger to food safety in Greek Cypriot society. Meanwhile, industrial producers had already brought their cheese factories up-to-date with state-of-the-art food technology and hygiene (Welz and Andilios 2004), while many small rural production units eventually had to close down.[7] These developments were of course not exclusive to Cyprus. All accession countries were faced with massive interventions in their agricultural and food production sectors. In most of the recent accession countries, the implementation of EU regulations is to the detriment of subsistence farmers and small-scale food processing in rural areas. When Cyprus acceded to the EU in 2004, the government appeared to actually welcome the fact that the implementation of EU regulations led to the closing down of many small enterprises. Officials saw this as an instrument for effectively weeding out the food sector and consolidating the market, leaving only medium-sized and large companies the government considered professional and able to compete internationally. As a government official remarked to me in an interview in 2004, a few months after EU accession: 'Who says we need so many small businesses anyway!' Political analysts have pointed out that there are indeed many instances where EU policies are used as a 'smoke screen' or as an 'imaginary constraint' (Agapiou-Josephides 2005) to conceal domestic interests.

However, up until the 1960s, the production of halloumi had been a gendered activity that formed part of the subsistence economy of agrarian households. It was modernization, growing prosperity and urbanization since the 1970s that turned the traditional collective cheese making into a more professional and commercialized activity, taken up by one or two villagers per community who would provide local customers, but also restaurants and grocery stores, with 'village halloumi'. Side by side with village-based small-scale production, halloumi developed into an important mass-market commodity produced by large dairy companies who dominate the national market for cheese and other milk products. Their high-tech modern factories produce halloumi primarily for export. In recent years, village-based small-scale cheese production has come under considerable pressure, also, as mentioned above, as a consequence of the financial burden of implementing new food hygiene measures as required by the European Union. Overall, the dairy sector in Cyprus has been undergoing a process of concentration, and today is dominated by a handful of companies. At the same time, halloumi exports have multiplied in the past decade, with their annual value averaging more than sixty million euros.[8]

Managed Diversity

Halloumi/hellim and its messy genealogy mirror the complicated histories of the peoples of the eastern Mediterranean. Ultimately, any claim of a collectivity to ownership of this or that tradition or cultural artefact is a construction that is guided by present-day interests and identity politics rather than being evidence of centuries of unbroken transmission and in-group purity. Yet, it is precisely such claims – to unbroken transmission and purity – that the European Union's instruments of regulation appear to be inviting, facilitating and stabilizing. It was in 1992 when the member states of the European Union first decided to establish a quality label system for the protection of geographically specific food products. Since 1996, the European Union has given official recognition to regional culinary traditions by extending copyright protection to so-called origin foods. By reserving the use of the name of the product to a certified group of regional producers and monitoring production to be sure it continues to follow the traditional recipe, with ingredients sourced from the region, the relationship between the product and its area of origin is protected and competition from other areas excluded. Thus, the European Commission has created legal as well as administrative procedures that establish who holds the rights to the sale of a traditional food product, who owns its recipe and who controls the proper production methods. These procedures are implemented by the individual EU member states whose interest it is to sell the products of their countries in European markets as well as globally. For the European

Commission, the goals of the programme are manifold. The creation and protection of niche markets will also serve the ends of sustainable regional development, create employment in rural areas and make Europe more competitive in global markets for high-priced delicacies.

The European Union's origin foods system, valid only within the European Union, is one of a number of frameworks of geographical indications established worldwide. Systems of geographical indications that build on origin as a quality attribute and prohibit producers from outside a defined area from using the place name in labelling or marketing have become more prevalent in recent years in many countries, and in larger frameworks of transnational trade as well. Transnational regulatory bodies such as the World Trade Organization (WTO) and the Agreement on Trade-Related Aspects of Intellectual Property Rights (TRIPS) as well as the World Intellectual Property Organization (WIPO) continue to be engaged in negotiations with the European Union and other actors (Creditt 2009) over the status of the EU's system of 'origin food' labelling vis-à-vis their regimes of intellectual property protection.[9] The pertinent European Union regulation distinguishes between two categories of protected names: the protected designation of origin (PDO) and the protected geographical indication (PGI).[10] The inclusion in the public register of protected product names is preceded by a publication in the *Official Journal of the European Union*. When the label is awarded, the product is also listed on the Internet. To be eligible for the protected designation of origin (PDO), a product must meet the following conditions:

> The quality or characteristics of the product must be essentially or exclusively due to the particular geographical environment of the place of origin; the geographical environment is taken to include inherent natural and human factors, such as climate, soil quality, and local know-how; the production and processing of the raw materials, up to the stage of the finished product, must take place in the defined geographical area whose name the product bears.[11]

For the protected geographical indication (PGI), the requirements are less stringent. It is sufficient that one of the stages of production takes place in the defined area. In both cases, however, elaborate product specifications form the basis for the European Commission's decision to include the product in its list of 'origin products' and to give the applicants the right to print the certification seal on the product label. Specifications are required to give precise information on the 'authentic' and 'unvarying' production methods as well as any other properties that allow for 'the objective differentiation of the product from other products of the same category through characteristics conferred on the product by its origin'.[12] Among these are not only physical, chemical, microbiological or biological characteristics, but also the so-called organoleptic qualities of a product that make it unique to sensory perception, be it taste, smell, colour or texture.

The PDO/PGI system, then, does not protect the mere provenance of a food product, but engages origin as a category constructed to signify the interdependence between the place of production, the producers and their knowledge, and the historical depth of a tradition, as French food ethnologists Laurence Bérard and Philippe Marchenay (2007) contend. Most important is proof of what is called the 'link', involving documentation – such as archival materials, historical accounts and old newspaper articles – of the historical connection between the product, its name and the area. Here, biochemical data and information on plant genetics may also be engaged. It is not particularly difficult to recognize the similarity of this European regulation to the French concept of 'terroir'. Terroir presupposes 'specific rural space possessing distinctive physical characteristics … seen as the product of the interaction between a human community and the place in which it lives' (Cégarra and Verdeaux 2005: 22). Indeed, the European Union quality label system integrated and superseded the national legislation already in place in France and Italy. Economic geographers consider it an exemplary case of 'respatializing' (Feagan 2007: 23) or 'relocalizing' food systems (Brunori 2006: 121) as a reaction to the ongoing trend towards large-scale, globally distributed production networks, as PDO/PGI promised to 'reconnect' producers and consumers. The operation of 'fixing products to place through place labeling' (Feagan 2007: 27) is instrumental for the valorization of niche products and the creation of new markets for them.

Ultimately, the origin programme's emphasis on diversity and quality helped to create a market for high-end culinary specialties domestically and also to strengthen Europe's position vis-à-vis the global food market. At the same time, however, within the EU, conflicts ensued between member states over the right of producers to use particular food product designations. Some of the most publicized conflicts concerned cheese products such as the Italian regional specialty Parmigiano-Reggiano and the Greek feta cheese (DeSoucey 2010). Conflicts less well-known than the ones played out in the international arena but more indicative of the effects of the EU's quality label programme on regional food producers are conflicts over market shares and authenticity claims that have occurred within member states of the European Union and that have been studied by ethnologists and anthropologists.[13] Studies conducted in Italy show that producers outside of the regions designated as the origin of a particular product have repeatedly tried to usurp the product name or attempted to influence the application process for a quality label in such a way as to leave the door open for producers other than those with whom the product originated. In many areas, small-scale producers increasingly have to compete with big companies. These produce protected food products in an industrial fashion more cheaply, eventually pushing the small-scale producers out of the market. In Italy, some of these conflicts have been solved with the aid of marketing initiatives and social movements such as the slow food movement. It is easy to

see that while the procedure of application to the European Commission rests on an agreement, presumably of all producers in a defined region, it is rarely consensual and quite often very controversial. In many European regions, the link between the product and the area that gives it its name is also difficult to document, so disputes over property rights erupt easily.

The Ingredients of Tradition

The quality label system of the EU helps to preserve the kind of regional diversity in culinary traditions that has been historically generated in countries such as Italy or France, where each community, municipality and even the tiniest region boasts unique products that for centuries have been produced in the same place. Here, the concept of 'terroir', once used to denote small-scale differentiations within wine-growing regions, actually is reflected in a patchwork of place-specific products and production areas. Cyprus differs from these countries that were instrumental in serving both as a template for the programme and also had pertinent domestic legislation in place prior to the European quality label system. Government officials in the Republic of Cyprus contend that the main difference is the smallness of Cyprus, with its territory barely larger than individual regions or districts in some of the larger European states. However, Cyprus also differs historically from countries such as Italy or France in the ways in which agricultural production and the processing and distribution of agricultural food products were organized in the past. During the colonial administration, but also after independence, industrialized processing in the agrofood sector created a strong tendency to disarticulate regional differences in quality between agricultural products, with the possible exception of potatoes grown in the east of the island. Rather, grapes, olives and cereal from large numbers of farmers were pooled in order to manufacture standardized products of medium-range quality for the domestic market, be it olive oil, wine or wheat-based products such as flour and noodles. Only more recently have there been efforts by individual producers as well as local associations to reinstall or even invent regional specificity. This has been most successful in the wine sector. Conversely, biochemists and food scientists argue that to consider halloumi a cheese product that is uniform throughout the island disarticulates regional differences between varieties of halloumi that actually used to exist in the past. According to biochemical research, regional varieties of halloumi cheese used to differ both in terms of the recipes and in terms of taste and organoleptic quality (Papademas and Robinson 2001). Also, differences in vegetation that grazing animals feed on translates into specific qualities. In the western part of the island, such as in the Paphos district, thyme and other macchia plants are prevalent. They are consumed especially by goats and give the cheese a char-

acteristic taste. Traces of etheric oils of thyme and other macchia plants have been found in halloumi cheese made from milk originating from this region (Papademas and Robinson 2000). With the EU-driven industrialization of agriculture and animal husbandry, free-range grazing is increasingly being replaced by industrial fodder, however, so these differences will eventually also disappear.

In 2009, the Greek Cypriot government submitted a proposal to the European Commission to secure PDO status for halloumi cheese. There were many delays in the process. By 2011, even the first step of the process, the publication of the product specifications in the *Official Journal of the European Union*, which invites international objections and qualifications and must precede the actual registration procedure, had not occurred. The application submitted in 2009 laid claim to halloumi as being uniquely and exclusively Greek Cypriot. In 2008, Turkish Cypriot dairy companies located in the Turkish-controlled north went to court in the Republic of Cyprus in an attempt to halt the process of the halloumi application submitted by Cyprus to the European Commission, demanding acknowledgement of the fact that this is not an exclusively Greek Cypriot product. They referred to the fact that historically, halloumi/hellim is an element of the habitual diet shared by both the Turkish and Greek populations of the island. The complaint proved to be futile, and the Greek Cypriot application went ahead without acknowledging production in the north of the island.

But for all that, in the end, the European Commission did not have an opportunity to award the PDO label that the government of the Republic of Cyprus applied for in 2009, because the application was retracted in 2012. Why did this happen? In Brussels, doubts had been voiced as to whether it would be wise to certify a product so hotly contested. Members of the European Parliament had launched official enquiries at the European Commission, implying that a designation of halloumi as an exclusively Greek Cypriot product would unfairly discriminate against Turkish Cypriot producers of the same product and, in a more general vein, contradict the European spirit of integration and inclusiveness that the PDO/PGI programme should be infused with. Nonetheless, that the Ministry of Agriculture of the Republic of Cyprus saw itself unable to go through with the application process ultimately has less to do with conflicts over ethnicized cultural property than one would assume. Because of its high export volume, halloumi cheese is a product of paramount economic importance for the Greek Cypriot dairy sector. Since its emergence as an industrial mass-produced cheese, it became the most important agricultural export good of the Republic of Cyprus. When the Republic of Cyprus applied to the European Commission for PDO status for halloumi cheese produced in the government-controlled areas, intense struggles ensued over the ingredients that go into this cheese. Traditionally, it is a cheese produced from a mixture of

goat and sheep milk. For the industrially produced halloumi cheese in Cyprus, however, especially the grade made for export, cow milk is utilized due to its high volume of availability and its lower price compared to sheep or goat milk. National legislation passed in the 1980s allows for this practice. It specifies that a 'substantial amount of goat's and/or sheep's milk' needs to be included in a cheese called halloumi, but allows for up to half of the milk to be of bovine origin. Dairy cows had only been introduced to Cyprus on a large scale in the 1960s, so the claim that halloumi cheese that contains cow milk may still be called traditional is hotly contested. In the years before the halloumi application was submitted to the EU, the industrial dairy companies applied considerable pressure on the government bodies preparing the application for PDO status for halloumi cheese to ensure that they would be able to continue using cow milk while still acquiring the coveted designation for their cheese.

Consequently, the application to the European Commission included up to 49 per cent cow milk in the list of ingredients for the product specification. However, in 2010, the owners of large flocks of goats and sheep protested, mounting demonstrations in the island's capital and demanding assurances that goat and sheep milk would continue to be an important ingredient in the future production of the EU-certified cheese. They argued that due to lenient controls in the implementation of the 1985 law, industrial companies had for years habitually substituted the milk of goats and sheep with milk from cows to a much larger degree than provided for in the domestic halloumi law. In early 2012, fierce debates, political altercations and street protests again erupted around the issue of halloumi ingredients. As it turned out, the powerful dairy companies who also dominate the Cyprus Cheese Makers Association were not satisfied with a product specification that gave them the right to use only 49 per cent cow milk in the certified product, which would submit them to stricter controls than before. Indeed, the fact that the PDO application submitted by the Ministry of Agriculture was not restricted to the traditional product made of sheep and goats milk but allowed for cow milk to be used had been an important concession to the larger dairy companies' interests. But even though the industrial cheese makers were not satisfied, as it was their intent to have their entire output of halloumi valorized by a PDO label, and to consequently be able to sell it for a higher price. As the group of producers responsible for the PDO application, they threatened the government with retracting the halloumi application. For a short time, after intense and lengthy negotiations, it appeared that some measure of compromise had been found. Yet, in April 2012 the applicant, the Cyprus Cheese Makers Association, quit the process, leaving the Ministry of Agriculture with no other choice but to retract the application and abort the process.

Regardless, in the Greek Cypriot media and political debates, the failure to acquire a PDO label for halloumi cheese was primarily viewed as making the

cheese industry vulnerable to incursions and usurpations by competitors from other countries. Turkish Cypriot producers as well as dairy companies from Turkey and Bulgaria were particularly feared in this context.[14] Also, the case of hellim produced in the south of Germany acquired a particular salience, feeding into paranoid notions of halloumi being stolen by foreign agents. Dacian Ciolos, the European Commissioner in charge of agricultural affairs at the time, in his response to an enquiry by a member of the European Parliament in 2012, stated that he took the concerns of Turkish Cypriots seriously and urged all concerned 'to reach a mutually acceptable and sustainable solution'[15] to end the ongoing division of the island. The solution to the Cyprus problem would, so Ciolos implied, put an end to both sides trying to secure the cheese as their property. One would hope that he was correct in this view of what the future holds for halloumi/hellim. In their work on contested cultural heritage in Cyprus, Costas Constantinou and Mete Hatay claim that 'in recent years, and especially with Greek Cypriot entry into the EU, Greek Cypriot identity has been progressively redefined as a national Cypriot one, in which the essential identity of the island is Greek, but in which the majority identity can also show tolerance for other cultures' (2010: 1614). Soon after a new Greek Cypriot government took office in March 2013, a renewed effort to apply for PDO status for halloumi cheese was initiated. In July 2014, the government submitted its application to the European Commission.[16] This time, it aims to protect 'halloumi and hellim' (European Commission 2014). Whether a renewed application will eventually give producers in the north a fair share of the real and symbolic benefits of origin certification or whether it is an attempt to colonize Turkish Cypriot hellim and subsume it under a product legislated by the Republic of Cyprus remains to be seen. As Turkish Cypriot cheese producers do not yet have access to the European market and also cannot trade across the Green Line, due to the fact that their production facilities so far are not monitored according to EU food safety standards, the obstacles for them are high – and conversely, the risk that they may pose competition for producers in the south, fairly low. The Stuttgart-based Gazi brand, however, would have to find a new name for its hellim cheese, if the application is approved.

When food is discursively distinguished and politically regulated in order to become commodity heritage (Grasseni 2005), it is taken to represent a group's history, and the distribution of that artefact is mapped onto the group's territory. Claims for origin foods, then, may be based on notions of an ethnicized ownership of tradition or even on 'gastronationalism' (DeSoucey 2010). However, this is by no means inevitable. Examples from other member states of the European Union show that the origin foods programme can also be deployed politically to enhance both regional diversity and cultural heterogeneity within a country. In some cases, European quality labels have even been awarded to 'origin products' that are produced across national boundaries, giving producers

in two countries the right to carry the quality label on their products. Thus, the origin foods programme does offer an opportunity for Cyprus to both affirm its hybrid legacy as a country that links Europe and the Middle East and supersede its ongoing division.

Conclusion: Heritage Effects and Property Regimes

The taste of food can evoke emotions and, as literary examples and scholarly writing suggest, help recall long-lost memories. Structures and built environments, in their own way, also generate an affective presence (see Kirshenblatt-Gimblett 2006; Navaro-Yashin 2012).[17] Heritage interventions manipulate and often short-circuit these properties. However, material attributes also define the range of heritage practices that a certain class of objects affords. A piece of cheese cannot be put into a glass case in a museum – or rather, if one did do this, the cheese would most certainly become malodorous and decompose after some time. More importantly, perhaps, the act of making an exposition of cheese contradicts historically evolved cultural conventions about what sort of objects can or cannot be exhibited in a museum context. By the same token, it does not make sense to break up the stones of a wall into little pieces and package and label them much like you would with slices or loaves of cheese to distribute them for sale in speciality stores around the world – unless, of course, the wall in question is the Berlin Wall, which was breached and finally torn down after the reunification of Germany, with many fragments taken away as mementos and sold as souvenirs.

Heritage making is a historically conventionalized procedure that operates by way of particular kinds of institutions and formalized practices. These, however, cannot escape an engagement with the physical properties of heritage artefacts. Sharon Macdonald points out that 'certain material characteristics or relativities may prompt, or suggest, particular ways of understanding or relating to them' (2009: 26). Physical characteristics give rise to quite specific 'heritage effects' that have to do with the materiality of artefacts: 'How readily something persists or perishes over time, how easily it can be transported, whether it can be replicated, how much effort is needed to create it and how large it is, all play into the work that particular material forms do in relation to memory – though not in neatly pre-determinable ways' (Macdonald 2013: 84). How does this work when applied to the food traditions that figured prominently in this chapter? Food products vary in terms of their durability, but they have in common that they are not made to last forever, but are intended to be ingested. Yet, in contrast to other heritage artefacts, they can be re-created again and again, provided that the ingredients, the skills and the implements required for the production are on hand. Also, food is a mobile commodity, especially

since cooling, storage and transport technologies have made global distribution possible. With traditional food products, at least some of the ingredients were usually of local origin. Customarily, traditional food production required skills and knowledge that could not be acquired in formalized training – as a dairy technician or food scientist – but were experience-based and embodied. Also, there often was a direct, face-to-face relationship between producers and consumers. Yet, when local food products start to circulate in translocal markets, truth claims as to their origin become decisive in establishing their authenticity. The case study dealing with the changing production of halloumi cheese illustrates very acutely what heritage making in the food sector entails, and how legislation and state practices combine with economic interests to regulate product quality, hygiene, pricing, sourcing and markets. In the end, a hybrid artefact is created that Cristina Grasseni, in her study of cheese making in northern Italy, has called 'commodity-heritage' (Grasseni 2005: 80). The labels PDO and PGI that the European Commission awards to regionally specific products sometimes generate paradoxical effects. Heritage designations may even lead to the exclusion of the original producers from access to the market.

Architecture has physical properties that are quite different from those of food products. Social theorists suggest that because of the durability of structures, buildings also stabilize social life.[18] The particular spatial relativities embodied by these two categories – food that is easily transferable, buildings that remain place-bound – allow certain kinds of commodification and heritagization and preclude others. Yet, in both cases, the embeddedness of a heritage artefact in a specific group's history and territory are emphasized and rearticulated within the framework of standardized definitions of heritage. For buildings, measures of on-site preservation and restoration are typical, regulated by the state in terms of relevant legal instruments such as 'lists' or designations that demand compliance with rigid aesthetic and structural prescriptions. In the case of traditional food, the link to a specific locale has to be proven and demonstrated in ways that are both transportable and translatable to consumers in such a way as to inspire trust. It is often certified labels that provide consumers with reliable information about the production process when face-to-face contact between producer and consumer is not possible. Often enough, the labels derive their authority and credibility from official lists of registered products. The practice of public inscription and the symbolic power of classifications, then, are instrumental in both cases, with food heritage and historic buildings alike.

Yet, we do not need to imagine a piece of cheese in a museum's glass case to realize that vernacular architecture and traditional food belong to separate artefact categories that also differ markedly in terms of their temporal relativities. Heritage making is a practice that attempts to manipulate the durability of these categories of objects. With buildings, the aims and effects are quite

straightforward. Preservation often freezes buildings in a homogenized time horizon. They are also safeguarded against further change, that is, made even more durable. As a consequence, as social anthropologist Paola Filippucci asserts, the 'heterogeneous, multi-vocal connections in time and space' (2004: 77) that the inhabitants have forged with their community are made invisible. A somewhat similar effect occurs when traditional food is certified by the EU, which requires detailed product specifications that, once accepted by the European Commission, cannot be changed and producers are bound to follow. Variations in the ingredients of the product according to their seasonal availability or from one year to the next, then, are no longer permitted. In their susceptibility to a kind of 'fossilization' in the course of heritage making, buildings and food products are not all that dissimilar.

The halloumi controversy also shows how the protection of food heritage is becoming closely aligned with transnational intellectual property regulations. This redefines cultural traditions to accommodate the regulation of ownership rights, as Vladimir Hafstein asserts: 'In a private property regime, culture is appropriated and defined as an asset, much in the same way that land is translated into real estate; it enters into the system of property relations and acquires exchange-value. … [C]ulture suddenly becomes subject to theft. Imitation has to be regulated and unlimited proliferation of copies becomes inappropriate' (2007: 84). Greek Cypriot producers and the alliances that they have formed vie with each other and with competitors from the north of the island and from abroad for the exclusive right to call the cheese they produce 'halloumi'. This takes the form of legal struggles over trademarks, brand names and 'collective community word marks'. Halloumi cheese, as well as many foods like it, is not a product invented by a particularly creative food designer. Rather, the knowledge of how to make this cheese was historically generated and transmitted from generation to generation by ordinary people. It used to be shared among its rural populations – both Christian and Muslim – until very recently. Such products sit uneasily with intellectual property regulations. Hafstein (2007: 86ff.) argues that the fact that cultural traditions do not have an author and do not originate with an inventor or designer puts them at a disadvantage when trying to acquire protection against incursions from economic actors who appropriate or copy them. In response, folklorists and anthropologists have introduced concepts such as 'popular tradition' and the 'public domain' into intellectual property discourse, concepts that are used to emphasize the rights of indigenous people to their cultural properties, even though they cannot prove authorship or originality (Hafstein 2007; Bendix and Hafstein 2009). In 2015, the application for PDO status to be awarded to halloumi cheese is still pending. If successful, designated producers in a region that will be defined as the entire Republic of Cyprus, and possibly also the north of the island, will receive the denomination of 'protected denomination of origin', which they will be al-

lowed to print on the label of the cheese. It will enable them to take legal steps against any producer outside this area who unlawfully calls his or her product 'halloumi' or 'hellim'. By the same token, they themselves will be closely monitored to ensure that the production process and the ingredients that go into their cheese comply with the product specification that was submitted to the European Commission. Ultimately, the system of geographical designations is the advance guard of a property regime that privatizes a cultural good that was formerly held in common by all Cypriots.

Notes

1. For the judgement in the case *Organismos Kypriakis Galaktokomikis Viomichanias v. OHIM – Garmo (Hellim)*, see General Court of the European Union (2012).
2. This chapter is a revised and expanded version of Welz (2013b). For a somewhat different perspective on the topic, comparing the halloumi conflict with a case study of Loukoumi Yeroskipou, see Welz (2013a).
3. Among the experts included in my 2005–2011 study were entrepreneurs engaged in marketing regional specialties, administrators who implement the EU's food quality programmes – both in Nicosia and in Brussels, consultants who assist producers in complying with food hygiene guidelines, food scientists at research institutions, representatives of NGOs that safeguard consumer rights, public health officials, veterinary officers, restaurant chefs and hotel owners.
4. As opposed to the historian Eric Hobsbawm (1992), who distinguishes 'invented traditions' created within the context of early modern nation-state building from those traditions that have been around for a much longer time, anthropologists and folklorists tend to conceptualize 'tradition' as a social construction that ascribes 'pastness' to certain kinds of artefacts or practices (see also Macdonald 2012).
5. Peter Loizos in his work repeatedly referred to the importance of commensality and culinary practices to both Greek and Turkish Cypriots (Loizos 2008). In his 1998 chapter, 'How Might Turkish and Greek Cypriots See Each Other More Clearly?', he explored commonalities in daily life and social terminologies, many also mentioned by Papadakis (2005), asserting that 'bridges might be built by understandings in historical depth of more detailed and specific local similarities – and differences' (Loizos 1998: 46). Documentary films made by George Sycallides (2004a, 2004b) also provide important insights. In the work of ethnologist Ephrosini Rizopoulou-Egoumenidou, there is also ample evidence of shared culinary cultural traditions between Greek and Turkish Cypriots (see, e.g., Rizopoulou-Egoumenidou 2008, 2012).
6. Agricultural products make up only a small portion of trading goods that come from the north of the island. Mostly, building materials such as stones and bricks, cheap furniture and plastic goods are traded by Turkish Cypriot companies. Among the food products, fish and vegetables, mostly potatoes, beets and asparagus, figure prominently. While local interlocutors also mention kolokasi, the local variety of taro plant, available statistics show no evidence of this. Trade volume has markedly fallen off in recent years, contributing to the deepening economic crisis in the north of the island.
7. On the effects of the introduction of food hygiene protocols such as hazard analysis and critical control points (HACCP) in Cyprus, see Welz and Andilios (2004). When employ-

ing HACCP, the risk of bacterial pollution or similar threats is to be eliminated by following self-checking and documentation procedures implemented by the company and its employees on a daily basis. For a comprehensive critical assessment of the General Food Law and other legislative and institutional changes in the EU's food hygiene regime, see Halkier and Holm (2006).

8. In 2012, the total value of exports of halloumi cheese amounted to more than sixty-one million euros (see Statistical Service of the Republic of Cyprus 2013). More recently, unconfirmed sources claim the volume has increased to about seventy-five million euros in 2013. For a retrospective perspective on the growth of cheese exports from Cyprus, see Gibbs, Morphitou and Savva (2004).

9. Critical media reporting on the ongoing negotiations for a new free trade accord between the European Union and the United States suggest that U.S. negotiators consider the PGO/PDI system an obstacle to free trade and an 'unfair' market intervention created by the European Commission.

10. A third label, the traditional specialty guaranteed (TSG), which was intended to protect recipes rather than origin and provenance, has rarely been applied for and is being phased out by the European Commission.

11. Quoted from the implementation guideline (European Commission 2004).

12. Ibid.

13. Case studies include Brunori (2006), Grasseni (2005), Leitch (2003), Mattioli (2013), May (2013) and Tschofen (2008).

14. In 2014, a U.K.-based Greek Cypriot entrepreneur planned to manufacture high-quality halloumi made from sheep and goat milk exclusively with no admixture of bovine milk in England, causing great concern to producers in the Republic of Cyprus.

15. For the enquiry and the European Parliament's response, see European Parliament (2012).

16. Predictably, the protests of the powerful dairy corporations and cattle farmers' associations in the Republic of Cyprus against the government's insistence on at least 51 per cent sheep and/or goat milk as ingredients have not abated. They have threatened to file an appeal with the Supreme Court and halt the application procedure.

17. For an exhaustive discussion of the affective dimension of food and eating as an anthropological issue, see Sutton (2001).

18. Thomas Gieryn (2002), in his article 'What Buildings Do', contends that buildings stabilize social order only imperfectly and themselves are subject to symbolic as well as very real deconstruction.

PART III

Ambient Heritage

Over thousands of years, human-environment relations have shaped the landscapes on the island of Cyprus. Today, only a few stretches of coast remain that are not affected by real estate development and tourism infrastructure. Here, the richness of diverse ecosystems has become the focus of intensified environmental protection efforts. In a different register, the historically generated fabric of the old cities of Cyprus is also described as rich in its diversity. The history of Nicosia in particular has been shaped not only by the succession of foreign rulers and armies, but also by the coexistence and interaction of urban dwellers of various origins, speaking many languages and adhering to different religions and customs. Both types of diversity, generated within long-term processes, have come within the purview of the European Union's preservation regimes. Landscapes and cityscapes, with their particular ambient qualities, are now considered part of the patrimony of all Europeans. All over Europe, it has become common among policy makers to talk of natural and cultural heritage as 'resources' to be exploited, but also as 'assets' that need to be managed in a sustainable way so as to benefit future generations. Increasingly, when nature and culture are protected as 'heritage', they are also drawn into market frameworks, and what was once shared by all is then redefined as property. As a consequence, the beauty of a wilderness environment is economically valuated, and the allure of an urban ambience is remade as a commodity. This final section of the book enquires critically into the production of the natural and cultural 'capital' of the Republic of Cyprus. Two of the European Union's programmes that the Republic of Cyprus became eligible for after the 2004 accession, namely, the Natura 2000 network and the European Capitals of Culture programme, figure prominently in what follows.

The Nature of Heritage Making
Environmental Governance

❦

In 1992, the European Union passed the Habitats Directive in order to promote the protection of the European natural heritage. The transposition of the directive resulted in the establishment of Natura 2000, a Europe-wide network of protected sites. When the European Commission updated the Natura 2000 lists of sixteen member states in November 2011, an area of roughly 180 square kilometres on the west coast of the Republic of Cyprus was added. The area, entered on the list under the name Chersonisos Akama, contains natural habitats requiring protection as well as habitats of rare and endangered species – both on the land and in the sea – and is considered essential for conserving the biodiversity of the Mediterranean region. The European Commission's press release stressed that the new conservation area

> includes a marine area covering Posidonia (seagrass) meadows and reefs, but it also hosts very significant terrestrial habitats for the Mediterranean biogeographic region: Brachypodietalia dune grasslands with annuals, Mediterranean temporary ponds and Arborescent matorral with Juniperus spp. Importantly, this site also holds important nesting sites for two marine turtle species: loggerhead sea turtle Caretta caretta and green turtle Chelonia mydas. (European Commission 2011)[1]

Land in designated Natura 2000 sites remains privately owned and can be farmed and even developed, but all land uses, especially development, are monitored, evaluated and, if they threaten the survival of protected species and the integrity of ecosystems, prohibited. Appropriate conservation measures have to be implemented and are monitored every six years on the basis of assessments of the conditions of the site and the protected species. The sustainable development and management of such protected areas can be funded by the EU under the auspices of a number of available programmes. With the EU-wide implementation of Natura 2000, environmentalism has been given politically effective tools based on bioscientific expert knowledge. These take the form of standard selection criteria that are defined in reference lists of habitat types and

species and are applied Europe-wide in accordance with the respective 'biogeographical' traits of nine macroregions within Europe.

However, in many European countries, there are delays in the implementation of the network; quite a few countries have been cited for not designating enough sites or sufficiently large areas of their territory. Also, in many instances, local resistance against the establishment of these EU-monitored conservation areas has been vocal and, in some cases, violent. Cultural anthropologist Meredith Welch-Devine, who conducted a long-term study on the progress of the Habitats Directive in the southwest of France, considers anthropology well-placed as a discipline to enquire into the effects of implementing Natura 2000 sites throughout Europe:

> Examining the implementation of Natura 2000 … from an anthropological perspective is particularly relevant (when it occurs in) an inhabited and contested landscape. What is for some a space for living and working is viewed by others as virtual wilderness, resulting in struggles over the vision for and governance of that space. Anthropology allows a nuanced examination of the engagement of resource users, of the role of 'external' forces, of the interplay between different means of management, and of dynamics of power and authority. (Welch-Devine 2008: 4)

Indeed, in Cyprus, the declaration of part of the Akamas Peninsula as a protected area by the European Commission, requiring the government of the Republic of Cyprus to take adequate conservation measures as quickly as possible – within six years at the most, as the legislation puts it – came after many years of conflict between the government, local landowners, real estate developers and environmentalists. Since the late 1980s, mounting pressure by European agencies to declare the entire peninsula a national park, successive governments dragging their feet in delayed action, futile protests by environmental NGOs, inconclusive negotiations between officials and local stakeholders and suspected behind-closed-doors deals between the government and powerful investors in the tourism economy have marked the saga of Akamas. Again and again over the past decade, angry villagers from the rural communities of the area have mounted demonstrations against the government of the Republic of Cyprus, resisting plans to place the Akamas Peninsula under nature conservation. In 2005, village leaders even made headlines in the press when they went on a short-term hunger strike. To this day, people living in the villages adjoining the Akamas region claim that the future of their children is threatened by establishing Natura 2000 sites here. They assert that the moratorium that froze development activities in the villages as long as there was no decision on the area's designation effectively excluded them from the economic prosperity that tourism and real estate development have made possible in many coastal communities in the same region during the past two decades.

Conversely, local environmental organizations as well as transnational NGOs are not satisfied by the designation of the Chersoniosos Akama site by the European Commission. They insist that the area needs to be protected against development more strictly than under the current Natura 2000 designation to safeguard its value as ecological heritage for future generations and as an outstanding example of the biological diversity of the eastern Mediterranean. They also argue that the terrestrial part of the designated site is too small to fulfil the sufficiency criteria of the Habitats Directive[2] for some of the habitats and species that the declaration of the area as a Natura 2000 site is supposed to help protect.

The implementation of environmental policies such as the EU's Natura 2000 network triggers conflicts that interest anthropologists because they bring complex issues of entitlement and stewardship, property relations and culturally based legitimacy to the fore. In this chapter, I will engage this lengthy and by no means resolved controversy, taking it as an exemplary case that allows us to follow 'a new research trajectory: the social contests and collaborations that are involved in the production of environmental objects, projects, and political positions' (Tsing 2001: 15). Anna Lowenhaupt Tsing coined the concept of 'environmental projects', which combine ideas, policies and practices that are constitutive of what counts as 'nature' or 'environment' in a given situation. According to Tsing (2005), projects are institutionalized discourses that have effects both in the social domain and in the material world. For the purposes of my case study on the Akamas controversy, I contend that the Natura 2000 network – and the more broadly conceived notion of protecting the habitats of rare species and maintaining ecosystemic biodiversity by designating bounded sites, 'parks' and other types of protected areas – constitutes such an environmental project. I am particularly interested in the dimension of transnational agency in its political implementation, or more precisely, in the role of the European Union in the promotion and administration of this environmental project.

This chapter will touch upon some of these aspects by organizing the findings of my long-term research in Cyprus[3] according to the agenda of 'global ethnography' (Burawoy 2000). Global ethnography is an approach that allows the researcher to 'directly examine the negotiation of interconnected social actors across multiple scales' (Gille and O Riain 2002: 279) by addressing three discrete levels of analysis. The first level concerns the ways in which external 'forces', often of great durability, have helped shape local situations; the second deals with newly established translocal and transnational 'connections' that link the local social world with other places, sometimes far beyond; and the third level of analysis entails 'imaginations' that social actors engage in, 'contesting definitions of local, national, and global scale and of the relations among them' (Gille and O Riain 2002: 279).

Forces: Land Ownership, the Postcolonial State
and the Privatization of the Coast

The Akamas region is an area of 230 square kilometres consisting of agricul-
tural land, a smattering of rural communities and an extensive wilderness area
on a peninsula that so far has been largely untouched by development. Akamas
retained its 'natural' condition, which today merits protection, as a late-onset
effect of the colonial history of Cyprus. The terms of the treaty that granted
Cyprus its independence in 1960 gave the British army the right to conduct
military exercises on parts of the peninsula, which for this reason could be used
only for grazing and remained uninhabited to the west and north, respectively,
of the villages of Inia, Drousia, Arodhes and Neo Chorio. The British army
ceased military exercises in the area in 1999, giving in to the protests of envi-
ronmentalists as well as of nationalist pressure groups who had for many years
viewed the continuation of the postcolonial military presence in the area as an
insult to the sovereignty of the country. Because exercises were stopped before
any decision on the establishment of a national park was made, the cessation
of military activity to some extent played into the hands of pro-development
interests (Welz 2006a: 142).

The peninsula contains a number of sensitive coastal ecosystems and im-
portant habitats of rare or endangered species, some endemic to the island.
With its ragged coastline and secluded beaches, Akamas is a landscape of
spectacular natural beauty. For many decades, the peninsula and the adjoining
region of the Paphos district were considered a backwards and somewhat un-
civilized area of little importance. It came into the spotlight of public attention
in the late 1980s, however, when it emerged as one of the very few stretches of
coastline of the Republic of Cyprus that had escaped the impact of tourism
development taking off in the aftermath of the 1974 invasion. More recently,
the Paphos district also experienced a massive expansion of tourism infrastruc-
ture. For many years, the increasing pressure on Akamas came mainly from
the south, where the urban sprawl of Paphos extends northwards, and hotel
complexes and other tourism developments sprang up in rapid succession both
along the coast and in its hinterland. Meanwhile, developers have started to
build villa developments and resorts on the shores of Chrysochou Bay to the
east of Akamas, as well as along the coastline east of the small town of Polis
Chrysochous. These communities, being latecomers to tourism development,
appear particularly eager to transform the area into a look-alike of mass tour-
ism destinations on other Mediterranean shores.

During the 1980s, the first attempts were made by Cypriot conservation-
ists to place the natural environment of the peninsula under conservation. The
then director of the Fisheries Department of the Ministry of Agriculture, a
marine biologist, pushed for the protection of nesting habitats for marine tur-

tles. Since 1989, the Lara-Toxeftra area on the western shore of the peninsula has been protected as a nature reserve by national law, to ensure the protection and maintenance of two species of endangered marine turtles and their nesting beaches. The more far-reaching goal of permanently prohibiting development in the entire area, however, was not achieved. Increasingly vocal environmental groups that had formed to protect the natural landscape and its biodiversity were stalled by pro-development interests. Some investors started acquiring attractive stretches of coastal land and entered into a coalition with local landowners in the villages, who also nurtured hopes of either entering the tourism economy or selling their land at high prices.

In the early 1990s, actors pushing for nature conservation, both within the government as well as in NGOs, enlisted international funding and political backing from European agencies. In 1995, the Mediterranean Environmental Technical Assistance Program received EU funding to complete a study on the Akamas region under the auspices of the World Bank. It proposed a management plan for the area, recommending the establishment of a national park covering the entire peninsula and offering sustainable development alternatives to mass tourism as well as conventional development options to the adjoining local communities within the framework of a zoned biosphere reserve area.[4] However, the World Bank Plan was never implemented in its proposed form. In March 2000, the Council of Ministers of the Republic of Cyprus instead decided to take steps towards opening the peninsula for large-scale tourism development. While placing the local communities under restrictions, this decision privileged the interests of entrepreneurs who planned to construct tourism resorts in the area. Already some years before, a building permit had been granted to erect a luxury hotel on an undeveloped stretch of the northeastern coast of the Akamas Peninsula. Since then, real estate developments have increasingly spread to parts of the area that the 1995 World Bank Plan had intended to be included in a to-be-established Akamas nature reserve, and tourism complexes are springing up close to the ecologically sensitive beaches.

With the March 2000 decision, however, the Cyprus government found itself at odds with the political agenda of environmental protection that the European Union imposed on Cyprus during its course to EU accession in 2004. A revised set of guidelines for the Akamas region, presented by the government in 2002, responded to EU pressure and offered some measure of compromise. While allowing for tourism development in selected sites, it prohibited both villagers and large-scale investors from building hotels or other projects on the as yet unspoiled coastline of the peninsula. Not surprisingly, the villagers immediately came out in protest against this decision, as they did again in the spring of 2005 when, once more, some details of the government's plans to designate part of Akamas as a national park became public. Local community leaders did not want to be restricted to 'soft' options of agro- or ecotourism, as

they felt that they would be left behind in the race for material prosperity that most of their compatriots had had an earlier start in.

Predictably, the government's announcement that the Republic of Cyprus would implement the European Union's Habitats Directive by designating protection zones to be included in the Natura 2000 network caused an uproar in the rural communities of the Akamas Peninsula. After identifying potential sites for inclusion during the run-up period to accession, the Cyprus government submitted a first list of zones to be protected as Natura 2000 sites to the European Commission late in 2004. Akamas, however, was not included. Instead, the authorities were developing a so-called management plan for the area that was supposed to reorganize the land use zoning of the region, in order to accommodate the villages' demands for construction outside of the villages. The extension of some existing areas already zoned for tourism development, the creation of additional infrastructure such as community centres and connecting roads and the earmarking of funds for land exchange packages for local owners affected by zoning restrictions on development in areas within the proposed conservation site were measures intended to pacify the irate villagers. However, the villagers also demanded that a so-called red line beyond their villages, demarcating an area between the rural communities and the coast where construction was prohibited, should be abolished.

It took until 2009 for the government of Cyprus to actually prepare an application to have Akamas acknowledged as a protected site within the Natura 2000 network. The proposal submitted to the European Commission in March 2010, however, covered an area dramatically smaller than the biosphere reserve suggested by the World Bank Plan, and less than half the size of the area originally proposed by a 1999 EU-funded study of Cyprus that had identified those sites and areas that were eligible for protection according to the EU's Habitats Directive.[5] Not surprisingly, much of the land that the government offered up to the European Union's scrutiny as an area to be protected is state forest. This meant that it was already protected under existing national legal frameworks and not within the purview of real estate developers.

Connections: Contested Natures and the Transnational Arena

The struggle over the future of Akamas is by no means over. Yet, the developments that were reported on in the previous section of the chapter attest to the increasing influence that the European Union holds over regional development and land uses in its members states, and the changing role of national governments in this context. In the Akamas case, both the Ministry of the Interior of the Republic of Cyprus, being responsible for centralized land use zoning and regional planning, and the Ministry of Agriculture, Natural Resources

and Environment – where the Environmental Department and the Forestry Department are located – were called upon to apply the pertinent European Union policies. However, the Europeanization of environmental policy implementation ultimately also means that the importance of nation-state authorities is declining. In her study on the establishment of the Natura 2000 network in France, Meredith Welch-Devine observes that state functions are moving 'upwards towards international governance, downwards to regional authorities, and sideways to transnational cooperation' (Welch-Devine 2008: 116). The implementation of the Natura 2000 network is a prime example of the upwards shift of state functions towards the international governance of environmental regulation. In the case of Natura 2000 in Cyprus, we can see that while the actual policies are being decided upon on the supranational level, the 'responsibility for policy *implementation* is shifting downwards' (Welch-Devine 2008: 118; my emphasis), even below the level of the nation-state, towards regional authorities that are in charge of enforcing and supervising the decisions that certain areas fall under the protective regulations of the Habitats Directive or the Birds Directive or both. In Cyprus, due to the small size of the country, many of the responsibilities that in other EU member states are devolved to sub national authorities remain with the central government and the ministries in charge. Yet, even here, 'soft' tools for implementation and monitoring that are already more prevalent in other EU member states are increasingly being deployed. A good example are 'management plans' that are developed to define benchmarks and their subsequent monitoring in order to safeguard the integrity of a Natura 2000 site. Management plan implementation is usually monitored by committees individually set up for each site, consisting of so-called stakeholders. Stakeholders may be local landowners, resource users, politicians, state officials, entrepreneurs, environmental organizations and scientific experts. It is typical for the new governance model of environmental regulation that nonstate actors are included in these processes. However, this does not necessarily mean that environmental NGOs become more influential in the process of the local implementation of nature conservation. Nor do local residents often succeed in making their concerns heard. Typically, such participatory processes are vulnerable to incursions by economic interests or political pressure groups.

Greek Cypriot environmental NGOs, however, have managed to make themselves heard in transnational arenas. In the case of the Akamas conflict, Cypriot environmental organizations not only addressed their complaints and petitions to the European Commission, but were also able to enlist the Bern Convention on the Conservation of Wildlife and Natural Habitats, an international accord dedicated to the protection of endangered species in European countries, in their fight. The Bern Convention is not a European Union instrument, but it was created under the auspices of the Council of Europe. Cyprus

is a signatory, and the convention's membership in recent years has expanded beyond the group of countries that are represented in the Council of Europe. On the transnational level, environmentalism has become a 'mobile policy' that is adopted and monitored within the framework of so-called accords that are in effect interstate contracts that bind the signatory countries to following general rules of conduct. Cypriot environmentalists appealed to the secretariat of the Bern Convention to look into the Akamas case, as the Republic of Cyprus is among the contracting parties of the Bern Convention. After sending a fact-finding mission to the Akamas area in 1996, the Standing Committee of the convention decided in its 1997 annual meeting to open a so-called file against the Republic of Cyprus for its failure to take adequate measures 'to ensure the conservation of the habitats of wild fauna species ... and the conservation of endangered natural habitats'.[6] Since then, at each annual meeting of the Standing Committee, representatives of the Cyprus government have had to testify whether Cyprus in the meantime had taken the necessary measures towards ensuring conservation. At each meeting, counter testimony from local NGOs – in the Akamas case, these are Terra Cypria, Birdlife Cyprus and the Federation of Environmental and Ecological Organizations of Cyprus – is invited and heard as well. Because of the well-documented statements of the NGOs, giving evidence for the government's failure to counteract ongoing and new threats against the environmental integrity of Akamas, so far each year the Standing Committee has voted to keep the file open and continue monitoring the situation. Clearly, the Bern Convention's Standing Committee is no court of law dealing out punishment. It represents 'soft law' that is toothless, as no government will be faced with severe sanctions if it does not comply. The worst that can happen is that the case is made public internationally by transnational NGOs or picked up by the media. But soft law works on the assumption that no state likes being exposed for wrongdoing in front of the international community. Thus, in November 2011, the Cyprus NGOs reporting to the Standing Committee requested the convention's bodies not consider the Akamas case closed after the European Union had declared part of the peninsula a Natura 2000 site. They complained that

> no concrete and/or effective measures have been taken to adequately protect and/or manage the important wildlife of the Akamas Peninsula ... and the current Natura 2000 designations are inadequate.... The area designated as an SCI (Site of Community Interest) for Akamas now ... is so limited as to be catastrophic.... [It leaves] unprotected large areas of habitats listed in the Habitats Directive and species listed in the Appendices of the Bern Convention. Meanwhile, extensive development has been taking place, including the erection of unlicensed, illegal premises, with mostly ineffective and dilatory actions to stop or remove them. (Terra Cypria 2011)

In addition, they also pointed out that the area placed under protection as a Natura 2000 site today is less than half the size of what the study commissioned by the World Bank in 1995 recommended. They also maintained that land use provisions and zoning regulations that apply to areas that are outside the Natura 2000 site do not effectively prevent large-scale construction activities and infrastructure development in the surrounding area. The report concludes that 'contrary to the requirements of the Habitat and Birds Directives, the boundaries for the area designated as a Natura site have been set less on ecological grounds, and more on socio-economic ones, to satisfy local voters'.[7]

At its most recent meeting in December 2014, the Standing Committee of the Bern Convention decided to keep the file against the Republic of Cyprus open, requiring the Cyprus government to submit more detailed information on how they are going to effect the protection of the sites.[8] While the convention's authorities operate independently of the European Union, the convention's secretariat has repeatedly approached the European Commission and enlisted its cooperation (see European Parliament 2009).[9] By the same token, the domestic environmental organizations who made themselves heard by engaging the Bern Convention also bring their concerns to the attention of the European Commission. As environmentalism becomes global, social actors are empowered to create connections that stretch across national boundaries, 'extending across multiple places and spatial scales' (Gille and O Riain 2002: 272). These in turn may help them to overcome obstacles that they are struggling with on a local level.

Imaginations: Local Communities and Moral Economies

The designation of nature as heritage demands that the common good of Europeans be put above the particular interests of national governments or other stakeholders, including individual landowners, who are considered stewards of nature now rather than proprietors of the land. European authorities are holding the national government responsible for adequately safeguarding this legacy. The European ethics of environmentalism has produced a 'moral economy of responsibility' (Herzfeld 2001: 186) towards the environment that brands those who do not comply with it as immoral. In the ongoing struggle over the future of Akamas, it is the local communities who have consistently been the most visible and vocal actors opposing environmental concerns. Early on, upon the publication of the World Bank Plan of 1995, which proposed to make the Akamas area into a biosphere reserve, village leaders angrily stated to the press that they feared 'that the plan condemns the region and its inhabitants to perpetual poverty'.[10] In recent decades, incomes in Inia, Drousia,

Neo Chorio, Kathikas and neighbouring villages have been rising with the employment opportunities that the regional economy of tourism, commerce and construction activities are offering in addition to agriculture. Yet, villagers feel that they been have treated unfairly. 'We have been cheated', they complain, asserting that since the 1980s, successive governments have made promises to them to allow for expanding the building zones of their communities and to lift the ban on construction on their land outside the villages near the sea. Indeed, throughout rural areas of Cyprus, there is a general policy allowing individual buildings to be erected on agricultural land, even if the land is not zoned for residential uses. For the land that the villagers of the Akamas communities own, mostly on the western slopes of Akamas and on the coast, the so-called isolated house policy was suspended by the authorities until recently, allowing for no building activity whatsoever outside the villages – something that was permitted in rural areas throughout Cyprus since colonial times. While other nearby coastal communities of the region during the last decade greatly profited from tourism, these inland villages were excluded. Only if they can build on the land going down towards the sea – or better, sell that land for good prices to developers – do they feel they will be able to adequately provide for the future of their children and grandchildren. A recent study conducted by young Cypriot geographer Stephanie Christou illustrates well the attitudes of the population in those villages who have been unable to profit from the region's boom in tourism and real estate development to the same extent as neighbouring communities outside of the area slated for environmental protection have.[11] In the interviews she conducted, again and again, 'feelings of injustice, discrimination, and lack of information were strongly expressed by many of the locals' (Christou 2009). In 2011, the car of a Cypriot environmentalist who is in charge of the protection and management programme for marine turtles in the area was burned in an arson attack. The suspect's family had opened a business on one of the protected beaches and had been forced by the authorities to close it.

What do we make of this? Environmentalists and scientists condemn the local communities for intransigence in the face of the greater good of nature protection and accuse them of materialistic greed or plain ignorance. Clearly, environmentalism, especially in its scientifically based, political form, is an alien concept to the local population. Environmentalism is not indigenous to Cyprus. Stefanie Christou (2009) points out that the villagers, however, feel that their traditional agricultural activities should also be considered 'ecological', and consequently, they are angry at being branded as not environmentally conscious. Michaelidou and Decker (2003) come to similar conclusions in their study of communities in the Troodos Mountains of Cyprus. In postcolonial Greek Cypriot society, environmental protection has often been seen as an ex-

tension of the symbolic domination of the past colonial rule by the indigenous bourgeois elites (see Argyrou 1996, 2005, 2013) and is therefore rejected outright by rural and working-class populations.

Social anthropologists, however, have also pointed out that land for the rural farming population is considered a resource for securing and increasing the status and material prosperity of their families. Economic anthropologists caution us against trying to separate 'pure' cultural values from 'materialistic' economic motives. Against the backdrop of an ethnography on a comparable conflict on a Greek island, social anthropologist Dimitrios Theodossopoulos (2002) argues that beyond the potential economic value that land acquires once it becomes drawn into the dynamic of the tourism boom, cultural values continue to be attached to property that are closely connected to notions of the integrity and well-being of the family. This attitude to the land and its uses is connected to 'how individuals ally with other individuals to form corporate social entities such as the rural household rather than the mere calculation of material gain or loss' (Theodossopoulos 1997: 264). To abstain from exploiting the economic potential of a piece of land because it merits protection due to its high environmental value is considered immoral – tantamount to not doing one's duty towards one's family.

In the Akamas controversy, villagers also make reference to the preservation of cultural traditions in order to demand that restrictions on building activity beyond the confines of the villages proper be lifted. In this, the so-called dowry house, a building erected by the parents of the bride that constitutes an element of property transfer in the relationship between families established by marriage, has been deployed as an argument. As available land for construction within the villages is limited and rising prosperity has increased the pressure on parents to provide ever larger and more prestigious dowry houses, which may never actually be lived in by the young family but could just as well be used for tourism business, it would be easy to infer that the argument of tradition is used here to cleverly mask more modern objectives. Yet, one would oversimplify the issue by concluding that local populations single-mindedly pursue one goal, namely, material gain. As Michael Herzfeld has pointed out, 'local populations may claim that their cultural heritage entitled them to activities for which environmentalists – for reasons often no less embedded in a particular set of cultural values – would resolutely frown, and the ethics of environmentalism clashes with the ethics of cultural self-determination' (Herzfeld 2001: 186). Yet, Herzfeld cautions us against an uncritical cultural relativism that claims that 'anything goes' as long as it is embedded in a cultural meaning system.

Indeed, while the local villages were the most vocal opponents both of the earlier plans for establishing a national park and the later approach to include part of Akamas in the Natura 2000 network, another interest group was work-

ing quietly behind the scenes. These are entrepreneurs who own hotel chains or are engaged in large-scale real estate projects such as golf resorts, marina developments and similarly profitable economic activities. They have had their eyes on this part of the westernmost coast of Cyprus for many years, waiting for development restrictions to be lifted, or else circumventing them by skilfully wielding political and economic influence. Postcolonial Greek Cypriot society has been called semiclientelistic (Baga 2002); for many decades, a small number of wealthy and influential families maintained close connections to political elites and the church, and today this group still controls much of the services-oriented economy of real estate, trade, financial and corporate services as well as the tourism sector. Increasingly, Cyprus is also attracting foreign direct investment from abroad. In this context, the market for high-end luxury real estate has greatly expanded. The trend towards a 'privatization of the coastline' (Selwyn 2004) that can also be observed elsewhere in the Mediterranean has taken a globalized turn in Cyprus lately. The ability of social actors in the region to slow down this process or influence the course it is taking is severely impeded by the fact that, under the threat of economic downturn and fiscal crisis, the national government is inviting large-scale foreign investment in resort development and infrastructure projects such as marinas and airports.[12]

The local communities of the Akamas area, ultimately, are pawns in a game much larger than the desire for prosperity for their families and villages, as it is the powerful real estate investors, many of them global players, who skilfully make use of local sentiment to further their own goals (Baga 2002). Even though it is doubtful whether this actually is in their own best interest, the decision of villagers to support businessmen and industrialists makes sense against the backdrop of their hopes for getting at least a small share of the profits from tourism and the real estate business as soon as restrictions are lifted. Perhaps more importantly, there is an underpinning of clientelistic relationships cementing the coalition. Also, both local elites and Greek Cypriot investors subscribe to the same cultural values of aggressive economic competition. They act within the framework of a shared moral economy that says that social actors are to be taken seriously only when they are visibly promoting or defending their self-interest, which is often intimately related to family interests such as property rights. By scapegoating the local communities, successive governments of the Republic of Cyprus have actually worked into the hands of the powerful tourism and real estate development industry. Indeed, the long delay in establishing nature protection for even a small portion of the Akamas Peninsula has also been to the benefit of those real estate developers and tourism entrepreneurs who managed to build hotels, villas and resorts just outside, and in some cases within, the no-development zone where construction was prohibited during the decades when the fate of Akamas was still undecided.[13]

Conclusion: The Making of Biodiversity

In her study on the implementation of Natura 2000 in France, Meredith Welch-Devine emphasized that local environmental conflicts 'are not just the result of the proliferation of types and numbers of stakeholders; they also stem from the fact that these groups and individuals have different conceptualizations of the resource' (2008: 160). In this chapter, it has become clear how the real estate sector conceptualized the Akamas Peninsula as a 'resource', namely, as land that promises high returns when invested in and developed. But what kind of a conceptualization of the environment underlies the establishment of a Natura 2000 site, and the actions of experts, activists, civil servants and EU officials who try to implement it? Declaring an area a nature conservation area, as Natura 2000 does, first of all redefines space, both in the discursive and in the material domain. It changes what can be done with an area, placing those land uses under restrictions that are considered detrimental to the maintenance of biodiversity or the survival of specifically identified species. Landowners, for instance, will not be able to receive building permits for hotels or marinas, and they will be prohibited from opening beach bars or seaside restaurants.

The Habitats Directive is still in the process of being transposed into a network of Natura 2000 sites across Europe. The sites operate by way of a territorial regime. Natura 2000 sites take the form of bounded parcels of land. Within their boundaries, prohibitions and interventions geared towards sustaining the survival of specific species are deployed. This is no new governance technology, obviously, but rather is in accordance with the practices and technologies that modern nature preservation has developed and implemented since the nineteenth century. Establishing preservation areas – such as 'sites' or 'parks' – entails setting boundaries, and the boundary of a nature conservation area constitutes an 'ordering device' (Thompson 2002: 185). This ordering device may be coterminous with some man-made border, such as a pre-existent road, or it may be a feature of the landscape, such as a gorge or a river, but often it is an immaterial line mapped invisibly onto the physical landscape.[14] Based on expert studies, this line is produced by evaluating the spatial distribution and frequency of plant and animal species whose protection is the goal of the conservation measure. Only since the advent of Global Positioning System (GPS) technology can the exact location of site boundaries be determined and mapped onto the existing physical environment.

However, biodiversity is not simply 'out there', waiting for scientists to discover, measure, chart and monitor it. Rather, it is 'the discursive and material outcome of a socio-material assemblage of people, practices, technologies and other non-humans' (Lorimer 2006: 540). Sociologists of knowledge and human geographers who observe practices of ecoscientific research assert that it is the 'detectability' of the presence of 'a species, process, or ecological complex'

that makes conservation possible (Lorimer 2006: 549) and, in an important way, 'produces' biodiversity as something to be protected. Technologies of measurement and specific knowledge practices enable scientists to observe and assess ecological processes on the Akamas Peninsula as 'matters of fact'. And it is such 'matters of fact' that policy makers and those charged with implementing the Habitats Directive are using as a basis to develop and deploy measures of biodiversity protection. Sociologist Bruno Latour (2004), however, points out that in order for scientific knowledge to be effective out there in the world, such issues need to be framed not only as 'matters of fact', but also as 'matters of concern'. Rather than from claims of scientific certainty and indisputability, 'matters of concern' derive their authority from how they manage to gather diverse contexts into themselves and are inclusive also of moral considerations, aesthetic judgements, political controversies and cultural concerns. Clearly, this is where future tasks of an anthropology of environmental conflicts lie.

Notes

1. There are two types of Natura 2000 sites. The designated part of the Akamas Peninsula was declared a Site of Community Importance (SCI) according to the 1992 Habitats Directive of the European Union, but was defined as a Special Protection Area (SPA) for various bird species under the 1979 Birds Directive.
2. To propose a 'sufficient' amount of territory for the Natura 2000 network means that for all species and habitats mentioned in the directive, the areas and populations of species proposed should be within 20 to 60 per cent of their national coverage. For so-called priority habitats and species, this should be higher than 60 per cent. Akamas was originally identified as the area that would provide the habitats and species protection so as to reach the adequacy levels needed for Cyprus to fulfil its obligations under the Habitats Directive. However, with the designation of a much smaller area in 2010, it falls short of this target.
3. An earlier version of this chapter was published as Welz (2012b). It builds on and expands earlier work (Welz 2006a) that dealt with the Akamas controversy prior to Cyprus's accession to the EU in 2004. Another book chapter (Welz 2009) included developments up until 2007. My analysis of the Akamas case rests on annual visits to the peninsula and the surrounding areas since 1995 (see also Welz 2012b). Official documents and media reporting were reviewed throughout this period until today. A series of in-depth interviews with government representatives, representatives of NGOs and some local stakeholders was conducted in 1999 and 2000. Research was updated in 2004, 2008 and 2010, with repeat interviews with environmentalists and experts. I am particularly grateful to Christos Charalambous, Andreas Demetropoulos, Martin Hellicar, Dr. Artemis Yiordamli and Nicholas Symons. I am also indebted to Stephanie Christou, who conducted an in-depth study of the attitudes of local stakeholders in 2009 and made her study available to me.
4. The so-called World Bank Plan is the Conservation Management Plan for the Akamas Peninsula (Cyprus) of 1995. An early survey of the biodiversity of the area can be found in Demetropoulos, Leontiades and Pissarides (1986). For a detailed overview of the efforts to protect Akamas, see the online timeline 'Akamas Peninsula: A Brief Historical Background

and Important Milestones', prepared by the NGO Terra Cypria. Retrieved 4 April 2011 from http://www.conservation.org.cy/akamas/background.html

5. In July 2007, the European Commission opened legal infringement procedures against the Republic of Cyprus for its failure to designate a sufficient number of Natura 2000 areas. In response, the government quickly moved to designate twelve additional SPAs – special protection areas for birds – in November 2007. Local and transnational NGOs had been doubtful as to the wisdom of designating parts of Akamas as a Natura 2000 site. In their view, regulations provided under the Habitats Directive guidelines would not suffice to adequately safeguard the biodiversity of the peninsula. In November 2008, two organizations, Terra Cypria and Birdlife Cyprus, lodged a complaint with the European Commission against the Republic of Cyprus for misdesignation of the Natura 2000 site for Akamas.

6. According to Article 4, Paragraphs 1 and 2, and Articles 6 and 7 of the Bern Convention. For an overview of the steps taken by the Standing Committee in the Akamas case from 1997 to 2014, see Convention on the Conservation of European Wildlife and Natural Habitats (2014: 8–11).

7. The boundary setting of a Natura 2000 site is undertaken on scientific grounds only, in accordance with the criteria for the relevant biogeographical region. Consultations with stakeholders do not take place during the boundary setting process, which is supposed to be independent of economic or political considerations and follows objective scientific criteria only.

8. At the 2014 meeting, Terra Cypria appealed to the secretariat to continue putting pressure on the government of the Republic of Cyprus to comply with the convention's regulations. The NGO cited numerous examples of interference by tourist activities and real estate development that continue to pose great risks to wildlife in the area. Subsequently, the Standing Committee of the Bern Convention decided to keep the case against the Republic of Cyprus open.

9. In 2010, following the proposal by the government to have a dramatically 'shrunk' area of Akamas protected under the Natura 2000 provisions, environmental organizations lodged a formal complaint with the European Commission. In May 2011, the European Commission addressed a Letter of Formal Notice to Cyprus 'concerning the insufficient designation of the Akamas peninsula as a SCI. ... On the basis of the awaited reply of the Cypriot authorities the Commission will decide on which further steps to take.' Evidently, the European Commission was satisfied with whatever response they received from the Cypriot government, as they confirmed the site as proposed in November 2011.

10. Reports were published in *Cyprus Weekly*, 26 May–1 June 1995.

11. In a previous report, Xenia Loizidou, a coastal management engineer familiar with the area, contended that the early projects and studies that proposed protection regimes for Akamas 'ignored or underestimated the fact that the coastal zone, especially in the tourist Mediterranean, is an area of high interest and high monetary value. They just asked the locals to sacrifice their future, without being clear and concrete on the reciprocal benefits'. In addition, she claims that local residents 'did not trust the decision-making process and the operability of the legal framework. Corruption, bureaucracy and the very slow process of justice discouraged people' (Loizidou n.d.).

12. For an in-depth discussion of the effects of the economic crisis, see chapter 9.

13. Xenia Loizidou (n.d.) claims that hotels and 'tourist villas' constructed in the Akamas area in the immediate vicinity of what is now protected under Natura 2000 use this position as a

unique selling point. This is also mentioned in successive reports by Terra Cypria submitted to the Standing Committee of the Bern Convention.

14. Spatial data indicating the boundaries of Natura 2000 sites are submitted by countries and integrated into a database maintained by the European Commission. Once they have been validated with a GIS tool, these are linked to descriptions of the sites. Maps of the Cherson-isos Akama Natura 2000 site are also made available online by the Ministry of Agriculture, Natural Resources and the Environment of the Republic of Cyprus.

The Divided City
Europe and the Politics of Culture

❦

To this day, Nicosia is a divided city.[1] Its historic core, the old town encircled by the Venetian walls of the sixteenth century, is dissected from west to east by the barbed wire and sandbag fortifications of the so-called Green Line. The Green Line was initially drawn by the British colonial authorities in the old town to curb hostilities between Greek and Turkish Cypriots in the 1950s. Later, a demilitarized buffer zone was established on both sides of the Green Line, and a United Nations peacekeeping mission was set up to guard it. The buffer zone became completely impassable after the 1974 Turkish invasion. It figures in the Greek Cypriot imagination as a dead zone, heavily infused with fear, hostility and a sense of loss.[2] Today, to the south of the buffer zone, there is Lefkosia, the capital of the Republic of Cyprus and the centre of Greek Cypriot society, a prosperous, modern metropolis with high-rise buildings, shopping malls, highways and rapidly expanding suburbs. The northern part of Nicosia is known by the Turkish Cypriot denomination of Lefkoşa. It is the centre of a polity whose statehood is not internationally recognized, the Turkish Republic of North Cyprus. Its attempts to produce a semblance of legitimacy and sovereignty are, in a paradoxical way, both restricted and bolstered by the continued Turkish military presence.

Over the past forty years, the old town within the Venetian walls has become the focus of heritage preservation and cultural projects that have been working steadily towards subverting the division, with the hope of ultimately overcoming the separation of the island. The first project of this kind was the United Nations–supported Nicosia Master Plan, a jointly developed urban planning instrument of both municipalities that made the restoration of many historic buildings on both sides of the divide possible and continues to create opportunities for Greek Cypriot and Turkish Cypriot urban planners and conservationists to communicate and cooperate. The ongoing political division of Nicosia and the rupture of its urban fabric, both social and material, stand witness to past interethnic violence. Efforts to preserve historical buildings or more general interventions into the built environment of the city inevitably engage with what anthropologist Sharon Macdonald (2009) calls 'difficult heritage',

heritage that calls forth divisive ideologies and painful collective memories. But here also Europe, conceptualized as an area of shared culture and history and as a political framework fostering peace, civility and justice is invoked and celebrated by local actors on both sides of the divide. Since the 1990s, artists' projects and arts events started to play an important role as an instrument for confidence building and conflict resolution between Greek and Turkish Cypriots, mostly within civil society frameworks and nongovernmental organizations. Individual European governments and their cultural organizations were instrumental in making these events happen. Since 2004, much of the funding for historic preservation on both sides of the Green Line in old Nicosia, as well as support for cultural activities, comes from the European Union,[3] and in 2011, the municipality of Lefkosia launched an application to become one of the EU's European Capitals of Culture in 2017.[4] By turning to the EU and, more generally, to organizations in and governments of European countries for funding and for cultural recognition, political actors and cultural entrepreneurs in Nicosia have successfully enlisted the symbolic capital of European agencies and managed to position their projects within a European cultural space. However, Europeanization as a cultural process establishes and reinscribes relations of inequality and hierarchy between societies within and outside of Europe, even as it intends to overcome and discard them.

Dissected Urban Space

Until the 1930s, all of Nicosia was contained within the Venetian walls that had been erected in the years between 1567 and 1570, shortly before the Ottoman army conquered the island. In the 1880s, after the British colonial administration had established Nicosia as the administrative centre of the island, as the Ottomans and previously the Venetians had done, Nicosia had the characteristics of an ordinary Ottoman city. It was a town of mosques and churches, public baths, bazaars, and hans which functioned like present-day hotels' (Hocknell, Calotychos and Papadakis 1998: 147). The British colonial administration considered the old town distasteful and unhygienic. It was a place where the various ethnic and religious groups coexisted in a patchwork pattern of small residential neighbourhoods. This afforded the economic integration of all segments of the population, but throughout the twentieth century, the history of the city may be told 'as one of opposed and interacting forces between Greek nationalism, Turkish nationalism, and British colonialism' (Hocknell, Calotychos and Papadakis 1998: 147). As early as 1956, interethnic violence broke out in Nicosia, set off by the Greek Cypriot struggle against the colonial rulers – the so-called EOKA freedom fighters aiming for a union with Greece – and the British strategy of stifling Greek Cypriot resistance by setting

Turkish Cypriot police on them. This was when the first physical division of Christian and Muslim quarters was established by the British, who separated north and south Nicosia with barbed wire and armed checkpoints.[5] When Cyprus achieved independence in 1960, all of these issues were unresolved, and in December 1963, more armed conflict between Greek and Turkish Cypriots broke out in Nicosia, this time also spreading to other areas of the island. The UN was called in as a peacekeeping force, and the dividing line that had initially been drawn provisionally in 1957 became permanent, with a buffer zone in between that was exclusively UN controlled. The line separated both ethnic groups on a west-east axis, creating a northern Turkish Cypriot and a southern Greek Cypriot part of town (Hocknell, Calotychos and Papadakis 1998). The Turkish invasion of the island in 1974 and the subsequent occupation of the northern part of Cyprus made the Green Line into a boundary between two political entities. Since 2004, it is also de facto one of the outside borders of the European Union.[6]

There is a plethora of studies in political science, history, sociology and anthropology that explore the effects of the 1974 de facto partition and the failed attempts to resolve the situation before and after the EU accession of 2004.[7] In Nicosia, after 1974, both sides inscribed their nationalist discourses on the urban landscape. Patterns of erasure – abolishing street names in the opponents' language, neglect and destruction of historic buildings that symbolize the heritage of the other side – have been prevalent (Papadakis 1998). Monuments to commemorate the idealized greatness of one's ethnic group, but also testifying to its martyrdom and victimization at the hands of the respective 'enemy', were erected at various sites on both sides of the Green Line. Also, the physical structures of the respective army posts at the buffer zone reflect the political stance of both sides. On the south side of the buffer zone, Greek Cypriot military installations are of 'a makeshift and temporary nature, consisting of barbed wire, barrels, and layers of sand-filled bags' (Hocknell, Calotychos and Papadakis 1998: 157). On the north side, much more permanent installations, concrete walls, massive gates and, at the checkpoints, full-scale customs and border control stations indicate clearly that from the Turkish Cypriot point of view, the Green Line constitutes a border between two states. Conversely, on the south of the buffer zone, the insistence on being 'the last divided capital of Europe' still awaiting its reunification also engages symbolic allusions to Berlin and its wall.

The work of social anthropologist Yiannis Papadakis (1993, 1998, 2005, 2006) highlights the emergence of disparate constructions of place, memory and identity in the wake of the division of the city. While the Greek Cypriot official ideology has been one of aiming for reunification, stressing past peaceful coexistence rather than the domination and exclusion of Turkish Cypriots by Greek Cypriot nationalists, for Turkish Cypriots, separation and separate state-

hood – even if not internationally recognized – is celebrated as an achievement in official discourse. For Turkish Cypriots, Lefkoşa is the capital of their republic. A recent study by Yael Navaro-Yashin (2012), enquiring into the emotional and social after-effects of civil war and military intervention for the Turkish Cypriot population of Nicosia, shows that for them as well, the abandoned and ruined parts of the old town close to the UN-controlled buffer zone are rife with a sense of loss and the melancholia that it instils. Navaro-Yashin speaks of northern Cyprus and of the area close to the buffer zone as being 'spectral', haunted by memories and littered with the material relics of war and displacement. Her account ends in 2003, when the Green Line was unilaterally opened in a surprise move by the Turkish Cypriot authorities. Before, only citizens of other countries could acquire a one-day tourist visa to cross on foot from the Greek Cypriot side. In Nicosia, two checkpoints were established in 2003 to allow both Greek Cypriots and Turkish Cypriots to cross the Green Line separating Lefkosia and Lefkoşa. Both were outside the old core of the city. In 2008, a third checkpoint was opened in the very heart of the walled city. This connected Ledras Street in the south with Lokmaci Street in the north, where the Green Line for fifty years had cut a once lively shopping thoroughfare into two separate streets with little traffic or business, each coming to an abrupt halt at the fortifications and walls of the buffer zone. After the checkpoint at Ledras/Lokmaci Street was opened in April 2008, the pedestrianized stretch of Ledras Street and, most particularly, the open space just before the checkpoint have become the site for a number of festivals, fairs and arts events.[8] Here, the municipality of Lefkosia set up an exhibition space devoted to projects that further mutual understanding and reconciliation. Yet, the collective memories of both groups connected with Ledras/Lokmaci Street are also painful and conflictive, and even the opening itself, which happened after long delays, was subject to power struggles between the Turkish Cypriot and the Greek Cypriot political leadership.[9]

The Nicosia Master Plan: Regeneration and Reconciliation

Even before the interethnic violence of the 1950s, the old town of Nicosia had begun its slow downturn. With the separation, a more rapid decline set in, with residential buildings being abandoned and falling into disrepair. Especially the streets close to the buffer zone were no longer used and lived in; entire neighbourhoods were condemned to decay. As early as 1979, the municipal authorities of Lefkoşa and Lefkosia decided to come together, under the auspices of the United Nations and with the assistance of the United Nations Development Programme (UNDP), and take measures to halt and reverse the process of decline affecting the old town. A mere five years after the Turkish invasion,

the mayors of both sides decided to enter into a dialogue about the future of their municipalities and to start working towards a joint framework for urban development that would ensure that once reunification came, the two halves of the city could easily be joined together again. In 1984, the first Nicosia Master Plan was instituted. It provided a general outline of urban planning goals for the entire metropolitan area. It was followed by a second Master Plan that focused on the old town in particular and has been implemented step-by-step since then. Both Master Plans had no European dimension in the sense that we use the term today; rather, they were developed as part of the peacekeeping mission of the United Nations to make provisions for a post conflict reconstruction, should that become possible. Under the provision of the Master Plan, historic monuments – particularly churches, mosques, monasteries and convents – on both sides of the Green Line were restored, and some residential neighbourhood streets were either reconstructed or replaced with new housing units in the style of the old buildings. Also, cultural centres, artists' studios and museums were created. This programme has progressed continuously over the past three decades. With the EU accession of the Republic of Cyprus, the role of the European Union in implementing the Master Plan has become stronger. On the Lefkosia side of the buffer zone, much of the restoration work today is funded by a combination of EU Structural Funds and domestic funding for rehabilitation of areas close to the buffer zone that the Ministry of the Interior of the Republic of Cyprus makes available. U.S. aid extended for individual projects is channelled through the UNDP-ACT, the Action for Cooperation and Trust in Cyprus of the UNDP.[10] The EU-funded programme Partnership for the Future, implemented by the UNDP since 2001, administers European Union funding for the restoration and documentation of heritage sites on both sides of the Green Line.[11]

Today, the success of the Master Plan is evident throughout the streets of the old town. They are studded with restored exemplars of the town's architectural heritage. Because of its tumultuous history, the built environment of the old town has been shaped for many centuries by the interaction of Christians and Muslims of various denominations and diverse ethnic origins. For present-day Greek and Turkish Cypriots, claims to particular buildings as representing one's own group's cultural legacy are not always simple and straightforward. Still, in the early days of the implementation of the Master Plan, preferences in prioritizing certain restoration projects showed an indicative pattern.[12] South of the Green Line, Lusignan and Venetian relics as well as buildings that pay respect to the perseverance of Christian Cypriots under Ottoman rule were among the first restoration projects of the Master Plan. For the cultural universe of Greek Cypriot society, the Ottoman period constitutes the type of dissonant heritage that does not necessarily deserve preservation and invite veneration (Constantinou and Hatay 2010). Conversely, in the north of Nicosia, initially more at-

tention was lavished on buildings that reflect the centuries of Ottoman rule on the island and the Muslim faith (Hatay 2008). More recently, this pattern has disappeared. Instead, buildings and sites that stand witness to the coexistence of ethnic and religious groups have come within the purview of restoration architects working within the framework of the Nicosia Master Plan. A signature monument that embodies this reorientation is the restoration of the *hamam*, the former Turkish bath next to the Omeriye Mosque, in the southern part of the old town.[13] The project was completed in 2003 and received many awards for its exemplary renovation of the sixteenth-century Ottoman structure, which includes some relics from an earlier fourteenth-century Lusignan church.

The Nicosia Master Plan's architects and decision makers are taking pains to highlight the multireligious and multiethnic legacies of Nicosia's old town. In 2002, the Greek Cypriot authorities presented the revitalization efforts of Nicosia's old town in the context of the European Heritage Day (EHD) of that year.[14] The catalogue for the 2002 event was titled 'A Multicultural Dialogue'. The event itself showcased restored monuments on both sides of the Green Line, including many examples of Ottoman architecture. 'Multicultural' in this context did not denote the cultural diversity that results from immigration from other countries. Rather, the term 'multicultural' was meant to be inclusive of both Christian and Muslim residents of historic Nicosia. The promised 'dialogue', however, was difficult at best, because at that point in time the Green Line was impassable for both Greek and Turkish Cypriots. Interestingly enough, the brochure edited for the occasion offered an imaginary walk, complete with pictures and short descriptions, of about forty restored buildings and sites, about a third of them located in the north, many of them examples of Ottoman architecture. There was no map and, beyond the mention of the location, no explicit indication of whether the respective building was in the north or south. This visual and discursive representation of the old town was strongly inclusive of all 'monumental' heritage, no matter what its background, with the notable exception of British colonial architecture, which was omitted completely. The Ministry of the Interior of the Greek Cypriot government had taken on the role of presenting the achievements of the Master Plan on both sides of the Green Line, a stance that some critics would interpret as an attempt by the Greek Cypriot arts and architecture elites to colonize Lefkoşa. More importantly, though, the participation in the annual EHD event series conducted under the auspices of the Council of Europe and the European Commission throughout Europe was intended to show that the Republic of Cyprus had adopted a truly modern and 'European' outlook on cultural heritage. Clearly, this shift away from a narrowly nationalist concept of heritage to a more diverse and inclusionary notion of multiple cultural legacies became more pronounced during the accession process to the European Union. Indeed, the 'reconcilia-

tory dimension of heritage' (Vos 2013) has been promoted by the Council of Europe since the Second World War as an instrument to achieve cross-border transnational cooperation, but also to help with the rapprochement of formerly hostile nations and groups. More recently, the heritage policies put forward by the Council of Europe are based on the expectation that programmed activities[15] 'create spaces in which European citizens could meet and experience a sense of belonging to Europe through a shared interest in the preservation of heritage and the exchange of "European" approaches to heritage management' (Vos 2013: 179). In particular, the European Heritage Days serve as a conduit for the standardization of heritage regimes throughout Europe that was mentioned also in chapter 1.

Crossing the Divide: Transnational Cultural Diplomacy and the Old Town

In a rare case of a joint publication, Greek Cypriot and Turkish Cypriot writers and intellectuals in 1995 gave voice to the shared memory of 'people who had lived in the same neighbourhoods, who had drunk coffee and played backgammon at the same coffee shops, who bought sandwiches and airani from the same vendor, [and] suddenly found themselves on opposite sides of the barbed wire'.[16] In Cyprus, so-called bicommunal projects were initiated in the early 1990s when international political actors saw that the official political channels of high-level diplomacy were not sufficient to urge both sides to agree on a solution to the Cyprus problem. Rather, the United Nations as well as U.S. agencies – such as the United States Agency for International Development (USAID) and the Fulbright Commission – funded conflict resolution training sessions and confidence-building measures, bringing together small groups of volunteers, both Greek Cypriots and Turkish Cypriots. This happened under UN supervision, mostly in selected locales in the buffer zone, but also outside the country. While the European Union had no obvious role in these efforts, individual European governments gave support, mostly through their cultural services. The British Council, the Goethe Institute, the Swedish embassy, the Peace Research Institute of Oslo and others were, and continue to be, instrumental in such projects, which became quite numerous in the early 1990s, hosting events and providing funding. The bicommunal activities were regarded with suspicion by nationalist political elites and power holders on both sides of the Green Line, and participants were often stigmatized as 'traitors'. In 1997, the Turkish Cypriot regime curtailed most bicommunal activity, prohibiting Turkish Cypriot participation (Trigeorgis-Hadjipavlou 1998). The arts had figured prominently in these efforts (Seifarth 2009); a mixed group of Turkish Cypriot and Greek Cypriot artists met regularly for years. Actually, many writ-

ers, filmmakers, musicians, painters and sculptors were involved, even before
the advent of bicommunal projects, in efforts to enter into a dialogue with their
compatriots 'on the other side'.

After 2003, when some measure of freedom of movement was estab-
lished, the new permeability of the Green Line allowed for the staging of local
cross-border arts events focusing on the old town of Nicosia. In 2003, an an-
nual event of almost one month, called Open Studios within the Walls of Nic-
osia, was initiated. Artists from both sides of the Green Line participated. A
map showing the locations of all participating studios and workshops, guiding
the audience to sites on both sides of the Green Line, intentionally omitted the
Green Line to create the impression of a seamless whole. A trilingual catalogue
– in Greek, Turkish and English – was printed and brochures distributed. As
I remember it, it was quite a surprise to pass through the streets of the old
town, which were quiet, dark and deserted on evenings during the rest of the
year, and find lighted doorways, music and the voices of people in conversation
beckoning pedestrians strolling along to come and look at the artwork in vari-
ous studios and small workshops.[17]

In 2006, the European arts biennial Manifesta was supposed to take place
in Nicosia. After the Kassel Documenta and the Venice biennial, Manifesta is
the third-largest arts event in Europe. It is held every two years in a European
city, organized by the Amsterdam-based Manifesta foundation, and receives
some of its funding from the EU.[18] Each Manifesta event is curated by a dif-
ferent team to make it site-specific and to engage with the local culture and
arts scene, communicating Manifesta's vision of cultural exchange within Eu-
rope. The curators for the Nicosia event intended to develop an art school as
the core element of the 2006 series of events in Nicosia. The municipality of
Lefkosia welcomed the project; the government had also promised substantial
funding. However, in May 2006, three months before the biennial was sup-
posed to open, the authorities cancelled the arts festival. Why did this happen?
Evidently, the curators had not taken into account that the Greek Cypriot au-
thorities would strongly oppose their plans to hold some courses and events of
the art school in the north of Nicosia. Greek Cypriots – both the authorities
and quite a few of the artists – objected because participants would be required
to show their passports to Turkish Cypriot officials at the checkpoints, just as
if it was a regular border control station, thereby giving official recognition to
the 'pseudo state' in the north. While the curators insisted that, from the begin-
ning, they had made it perfectly clear that Manifesta would be a bicommunal
event, the authorities would not budge (Seifarth 2009). According to a widely
shared political conviction in Greek Cypriot society, the polity in the north of
the island cannot be acknowledged as an independent Turkish Cypriot state,
but instead has to be regarded as an illegal occupation regime. The Lefkosia
municipal authorities as well as the Cultural Services of the Ministry of the

Interior would rather forgo the advantages of hosting a large-scale European event than compromise on this issue.

Remaking Lefkosia: Artists, Immigrants and World-Class Architecture

More recently, there has been a marked trend towards aestheticizing the rough charm of the old town and its mix of old residents and exotic newcomers. This has become topical in the visual arts especially. Endeavours initiated by artists, arts managers and academics, including conferences, films, publications, exhibits and other public events in Nicosia, but also increasingly websites, digital archives and blogs, take their cue from the political division of the city and the ways in which it manifests itself as an inaccessible no-man's-land that constitutes a stark break in the urban fabric. While during the 1990s most artists' projects focusing on the old town were initiated and conducted by local members of the Greek Cypriot and Turkish Cypriot artistic and intellectual milieu, the ruptured city today serves as an inspiration to artists and cultural scholars from other countries. The old town some years ago started to attract artists who found studios and living quarters in the streets and alleyways within the Venetian walls. Many of the former residents had moved out, creating a vacuum that was increasingly filled not just by artists, but primarily by labour migrants and refugees. Greek Cypriot society, in particular, has increasingly become reliant on immigrants from non-European countries in the service sector and in the building trades since the 1980s. Today, Cyprus is the European Union member state with the highest percentage of foreign-born residents. The old town of Nicosia became home to domestic workers from Sri Lanka, the Philippines and China, many Eastern Europeans, ethnic Greeks from the former Soviet Union, and a large and growing immigrant population from the Arab world and the Muslim countries of South Asia. For many years, private owners had bought up houses in the old town cheaply in order to subdivide and rent them – often at exorbitant prices – to immigrant workers. Some landowners amassed a high quantity of buildings in the old town, waiting for real estate prices to rise again and for new opportunities to revitalize and market the buildings. Some years ago, cultural venues started to spring up in the old town, including the renovation of Famagusta Gate as a cultural centre and the conversion of the former power plant (Ilektriki) near the Municipal Market into a museum of modern art, housing the private Pierides art collection, drawing the middle- and upper-class cultural crowd into the old town for exhibition openings and other events. Formerly inaccessible parts of the city often constitute privileged venues for the staging of arts events when gentrification and urban renewal have begun. While in other cities these may be former industrial areas

or waterfront sites, in Nicosia, it is the old town, especially in the vicinity of the off-limits buffer zone that holds considerable cachet as a site for arts events.

A number of major projects to enhance the cultural infrastructure of the entire city have been underway recently. The National Theatre of Cyprus received a new building that is a top-end venue for the performing arts. Also, the country's most influential cultural sponsor and charity, the Leventis Foundation, erected a new museum just outside the Venetian walls. On the site of the long-abandoned former athletics stadium – one of the few undeveloped open spaces left in the new part of the city – a 'cultural park' is emerging, also to include the National Library. Building activities are underway that will ultimately transform Eleftheria Square, the traffic intersection that connects the old town within the walls with the urban expansions that grew after the Second World War. In 2005, a group of architects headed by Zaha Hadid won the competition to redesign the square, which has important socio-political significance for postcolonial Cyprus (Demetriou 2007). Political elites feel that these changes are necessary in order for Nicosia to be presentable to the European public and to measure up to other European capital cities. The expectation linked to these large-scale architectural projects in the cultural sector is that Cyprus will at last be able to attract important performers of the international classical music circuit as well as host major international arts exhibits.[19] The Republic of Cyprus has been trying hard to make its capital into a European metropolitan centre, hoping to shed its colonial legacy. The British colonial administration regarded Nicosia as a provincial, backwards Levantine town that had little to boast about in the realm of high culture. Local political elites today use European policy frameworks and funding opportunities to this end, intending to prove to the world – and to themselves – the legitimacy of their claim to European modernity. By adhering to a conventional, Western-derived notion of culture and urban life, decision makers responsible for these measures were obviously hoping to make Nicosia appear less 'Oriental'. Governmental officials in the cultural field were also confident that, combined with the 'heritage value' of the old town and the concentration of national as well as municipal museums in Nicosia, the new cultural infrastructure would provide the city with a very advantageous situation in the competition for the title of the European Capital of Culture of 2017.

'Get in the Zone': Competing for the European Title

Cyprus and Denmark are the two EU member states designated by the European Commission to host the European Capitals of Culture (ECOC) programme in 2017. Since its inception in 1985, the ECOC programme's goal has been to strengthen the internal cohesion of the European Union and foster

citizens' identification with the project of European integration. The ECOC initiative, however, also generated conflicts over what understanding of 'culture' is to be deployed and what the ECOC initiative contributes to the 'building of Europe' (Shore 2000). Historian Uta Staiger points out that 'normatively, the linkage of cultural practices and policies with social governance and the encoding of collective identities raise concerns as to the appropriateness and nature of polity building beyond the state and the relation of the Community to its constitutive elements' (2013: 22). In the meantime, the ECOC has grown into one of the most well-known and successful cultural policy initiatives of the European Union, even though the funding that the honoured cities receive from the EU is minuscule. Applying for funding from national and regional governments as well as from private sponsors, the ECOC title enables cities to present themselves in the European arena, with a programme of cultural events that spans an entire year. Increasingly, ECOC events feed into city branding activities and a growing cultural economy of urban festivals and tourism marketing. The capacity of proposed projects and events to enable civic participation across social and ethnic divides, as well as the sustainability of projects to have a lasting effect beyond the ECOC year of events, have become crucial in guiding selection committees when they weigh the applications of competing candidate cities.

Each year, a different pair of member states of the EU – one old and one new – host the ECOC programme. Cities within each host country compete with each other for the title of European Capital of Culture. In Cyprus, this meant that three cities – Nicosia, Limassol and Paphos – submitted initial bids to the European Commission in 2010, competing for the 2017 title. Under the auspices of the Ministry of Education and Culture of the Republic of Cyprus, the selection committee, consisting of Cypriot experts as well as representatives of the EU, examined the applications and rejected the bid submitted by Limassol, leaving Nicosia and Paphos to each prepare a more elaborate application for the second round of selection. The municipality of Lefkosia commissioned ARTos Cultural and Research Foundation, an internationally renowned arts organization based in Nicosia, with preparing the bid. On the occasion of the Cyprus presidency of the Council of the European Union, in November 2012, ARTos created an exhibit entitled 'Does Europe Exist?', which also included a series of long-term projects on the topic of 'Stitching the Buffer Zone', with highly original and imaginative suggestions by artists on how to join the two parts of Nicosia together again.[20] The philosophy of this application for the ECOC title was innovative and future-oriented, inviting the entire population, but especially youth and young adults, to actively contribute to making Nicosia a vibrant, liveable city. An Internet platform ('Get in the Zone') and multiple events publicized the project and motivated people to contribute ideas and activism. It took the present situation of divided Nicosia as a metaphor for

inertness and lack of vision, promising to transform it into a space of playful interaction and creative encounters ('convergence zone').

In the end, however, Nicosia did not win the prestigious award; the title went to Paphos, a smaller town on the seaside, primarily a mass tourist destination but boasting a UNESCO World Heritage site. In spite of the recent upgrading of its cultural infrastructure, the Council of the European Union presidency proving the city's ability to host international events and the application – 'bid' as it is called in the ECOC terminology – highlighting the rich cultural heritage, the lively art scene and the cultural potential of its young residents, Nicosia was not successful. In recent years, selection committees have tended to reward those ECOC bids that convincingly display a 'focus on complex European topics including ethno-religious diversity and socio-economic inequity' (Staiger 2013: 33–34). In the initial application, the Nicosia team had mentioned the multiculturalism of Nicosia, but almost exclusively referring to the historically generated, indigenous religious and ethnic diversity, and not making much reference to the immigrants that are so much in evidence, especially in the old town. Also, the Nicosia team clearly was acting within the narrow constraints set by the official policy line of the Republic of Cyprus's government, considering Lefkoşa's Turkish Cypriot municipality as representatives of an illegal occupation regime with whom no collaboration was to be encouraged. In their final report, the European Commission's selection committee spelled out that three objectives had not been met by Nicosia's bid for the ECOC title, namely, 'urban development for long term sustainable development, a rapprochement between the Greek and Turkish Cypriot communities through shared cultural projects, and an inclusive approach to the "new Cypriots" now increasingly resident in Cyprus from both within the EU and from other countries' (Final Selection Report 2012: 4).[21] The committee felt that by comparison, the projects proposed by Paphos fulfilled these objectives more plausibly (Final Selection Report 2012). The Paphos team had successfully enlisted support and participation from Turkish Cypriots whose families originally lived in Paphos and had left after 1974. In Paphos, the participation of different groups of the population was very evident in the bid itself, as a large group of volunteers had prepared many of the projects and advertised them locally. In particular, labour migrants from outside Europe as well as recent immigrants from northern Europe, many of them retired and choosing Paphos as their second home, were very much part of the Paphos team's concept from the beginning.

What effects has the failed ECOC application had 'on the ground', in Lefkosia? Nicosia 2017, the programme developed as a framework for the greater Nicosia area hosting the European Capital of Culture throughout the year 2017, included a strong commitment to what the European Commission calls 'culture-led urban regeneration' and was billed as part of a 'long-term plan to revitalise the city's core'. The bid made reference to many of the recent efforts

by the Lefkosia municipality, such the Nicosia Master Plan office as well as
the Ministry of the Interior's Department of Town Planning and Housing,
whose funding for the disadvantaged areas close to the buffer zone has also
significantly contributed to urban renewal in the old town. In particular, the
team preparing the application for Nicosia 2017 asserted that they wanted to
'contribute to the cultural and economic rebirth of the old city, help stem and
eventually reverse the flow of citizens and businesses' (*Bidbook 'Nicosia 2017'
Phase 2* 2012: 16). Athena Papadopoulou, the head of the Nicosia Master Plan
office in the Lefkosia municipality, would have welcomed the city becoming
an ECOC in 2017, expecting many beneficial effects for the city and the up-
grading of the built environment of the old town in particular. However, after
the bid failed, the municipality committed itself to taking up the impetus of
revitalizing the old town, in spite of the narrow confines of what can be funded
in crisis-riven Cyprus. In 2012, Athena Papadopoulou saw many signs that
'the middle class that has come back to live in the city', but contended that this
new group will have to be catered to by making the old town 'more liveable'.
Parking spaces and regular garbage collection are considered essential. She also
emphasized that the municipality was trying hard to attract 'the young artistic
scene. ... We will be setting up pilot projects to carry on the momentum of the
ECOC bid process.'[22] When I asked her about the risk for the old town to fall
victim to the detrimental effects of gentrification, with low-income tenants be-
ing pushed out by more prosperous groups as well as by property conversions,
she was hopeful that this would not happen in Lefkosia. Conversely, Achil-
leas Kentonis, the author of the Nicosia bid for ECOC 2017, who had already
witnessed similar processes in other urban centres around the world, was less
confident. In 2012, he already saw many signs that the old town was on its way
to becoming a gentrified urban area, enhanced by the arts scene.

 Similar assessments were voiced by young entrepreneurs I interviewed who
had started to open businesses in the old town, many of them benefitting from
the still low rents. Between 2012 and 2014, close to one hundred new bars,
cafés, restaurants and shops were opened within the old town. Onasagourou
Street, formerly an almost deserted street lined by Armenian fabric merchants'
shops, experienced an unexpected renaissance with the opening of dozens of
open-air cafés, upscale restaurants, fast-food stalls and ice-cream parlours. Le-
dras Street, which was Nicosia's high street until the division and then fell into
oblivion, once again is one of the most popular venues for young people and
families to take a stroll on weekend evenings and Sunday afternoons. Along the
Venetian walls, bars, tavernas and clubs have sprung up, while the area next to
Phaneromeni Church, formerly a very quiet and somewhat overlooked corner
of the old town, draws hundreds of young people on evenings who congregate
in the squares and walkways and populate the outdoor areas of cafés that have
taken over the storefronts that before were occupied by small retail shops and

artisans' workshops. The owners of old buildings have benefitted from subsidies extended by the municipality for renovations and the creation of new businesses. Even along the Green Line, on Ermou Street, where ruined buildings, boarded-up factories and empty lots used to dominate a desolate stretch of land that had remained frozen in time since 1974, the infusion of public funds started to become visible by 2014, with many derelict buildings being spruced up and now housing designers' studios, arts organizations, cultural centres, clubs and bars.

Today, competition for space is rife among the new businesses in the old town. Conflicts also break out, as young people refuse to become paying customers and insist on their right to simply 'hang out' in public spaces, while the police and the owners of the adjacent new businesses attempt to curb unregulated uses.[23] A telltale measure, mirroring the increasing privatization of public spaces in many other cities around the world, has been the removal of public benches from some of the pedestrian areas by the municipality where loitering may interfere with the business of nearby restaurants. The surprisingly rapid renaissance of the old town comes at a time when the avenues of modern Nicosia, outside the Venetian walls, are bearing the brunt of the economic crisis and are in decline, with storefronts and restaurants that used to be the meeting places of the rich and famous standing empty. With rising unemployment, the old town's new economy of cafés and bars benefits from the low-budget entertainment and open-air sociality that it is offering to the adolescents and young adults who do not yet know what the future holds for them.

Conclusion: Ambience for Sale – Nature and Culture as Economic Assets

For the artistic projects that used divided Nicosia as their focus, the scarred urban fabric of the old town is an allegory, metaphorically linking it with separations, evacuations and displacements in other places. In cities around the world, the economic revalorization of decayed urban areas has been utilizing the imagery of borders, unregulated zones or 'rough' areas to make declining neighbourhoods alluring and attract moneyed clienteles. The tendency to artistically explore the divide of Nicosia and to represent it aesthetically goes hand in hand with a 'spectacularization' of the city that feeds into the marketing of urban spaces and the commodification of cultural diversity. Economic processes of reinvestment are often preceded and accompanied by the imposition of a market-oriented visual perspective on urban neighbourhoods. In many other cities in Europe, artists, historians and conservationists who value the authenticity of the historic built environment but, by the same token, often consider contemporary residents and land uses – for instance, sex work, nightlife or immigrant

accommodations – unfitting, distasteful or 'unhygienic' have been instrumental in preparing the ground for gentrification. In Nicosia, the appropriation of the old town by artists and the revaluation of historical architecture by conservationists and cultural historians has primed the old town for consumption and made it attractive for real estate investment and the development of new businesses. The municipality is taking strict measures against property owners who 'act irresponsibly' by allowing houses to become run-down. Derelict buildings are marked 'uninhabitable' so that they can no longer be leased to immigrants and low-income tenants. As a consequence, immigrants from South Asia, the Near East and Africa, who used to make up a substantial part of the population, are being pushed out. The arrival of a new upmarket clientele will eventually also lead to the expulsion of the very pioneers who made the old town attractive: the many artists who rented studio space in its side streets and the journalists, university students, fashion designers and filmmakers who decided to make the old town their home during the past two decades.

The marketing of the cultural heritage of a city, the enhancement of the role of the arts and the new emphasis on attracting real estate investment and tourism all work together to reshape the historical core of the city. These are developments that can be linked to the 'neoliberal' restructuring of cities and the growing importance of cultural production as an asset in interurban competition. Indeed, throughout Europe, the European Capitals of Culture programme also reflects these changes in recent years, with a significant shift from the presentation of high culture towards a reconceptualization of urban everyday life as an economically productive asset. As such, they are not unique to Nicosia and not even to European cities. It is not entirely surprising that the World Bank has been recommending the valuation of heritage as a route to economic revival for many urban centres in developing countries. In a recent publication, it asserts that municipal or state subsidies and other institutional mechanisms that 'facilitate the adaptive reuse of buildings and land with heritage value to meet … new needs' (Licciardi and Amirtahmasebi 2012: xxi) are economically most successful in combining heritage preservation with local development in cities with historic cores. Against this backdrop, the built environment of Lefkosia's old town, produced by its long and variegated history, and the lively atmosphere that its heterogeneous dwellers generated become reconceptualized as a resource and are marketed as products, to be consumed by tourists and well-to-do locals alike.

The European Union–funded programmes that figured prominently in this chapter and the preceding one, the European Capitals of Culture programme and the Natura 2000 network, are targeting very different types of land uses and heritage categories. One is concerned with urban culture, the other with safeguarding biodiversity. Yet, there are similarities in their effects that are not coincidental. As the authors of the World Bank publication quoted above con-

tend, 'interpreting heritage as cultural capital has a clear parallel with the definition of environment as natural capital. Like any other form of capital, both cultural and natural capital have been inherited from the past, might deteriorate or depreciate if not maintained, and impose on the present generation a duty of care' (Licciardi and Amirtahmasebi 2012: xxii). Today, not only land and buildings but also the ambient qualities of landscapes and cityscapes are becoming resources to be exploited. When nature and culture are protected as 'heritage', they are also drawn within the purview of markets and are redefined by property regimes. In the case of Akamas, environmentalists and political actors allied with them are struggling to ward off tourism and real estate projects in order to protect the peninsula from falling victim to economically driven development. However, even the declaration of a Natura 2000 site on part of the peninsula paradoxically appears to feed into the logic of economic valuation. For golf courses, vacation resorts and real estate projects, to be in the close vicinity of a beautiful wilderness area that is certified as unique by the EU serves as an adjacent attraction and is made use of in their advertising and sales strategies. In the old town of Nicosia, it is the allure of an urban ambience that is remade as a commodity. The urban ambience is the product of urban residents' quotidian practices and vernacular knowledge. Even though Nicosia did not win the ECOC title, the application process helped set in motion and legitimize fundamental changes in how urban space is categorized and used. The case of Lefkosia is particularly poignant in that these are the people who are in danger of being pushed out and denied what critical urbanist Henri Lefebvre termed their 'right to the city' (Lefebvre [1967] 1996). Both case studies point to heritage making feeding into the economic valuation of such public goods, often called 'commons', that until recently defied economic valuation and marketization. Ultimately, ambient qualities, no matter whether they are generated in and by people in historic settings and or by the interaction of nature, topography and climate in an ecosystem, are becoming commodities in their own right. The privatization of cultural commons and natural environments is not prevented but, intentionally or unwittingly, aided by the European Union programmes that were singled out for case studies here.

Notes

1. In this chapter, Nicosia denotes the divided city as a whole – inclusive of Lefkosia and Lefkoşa – as well as the many independent municipalities and suburbs that have not been incorporated but form part of the urban agglomeration of greater Nicosia. When I use the name 'Lefkosia' in this chapter, it designates the Greek Cypriot municipality of Lefkosia (in English, Nicosia), which is also the capital of the Republic of Cyprus.
2. Social anthropologist Yiannis Papadakis called his evocative bildungsroman of a Greek Cypriot's ethnographic journey of discovery into the heart of the Cyprus conflict *Echoes*

from the Dead Zone (Papadakis 2005). He takes this title from the Greek denomination of the buffer zone as 'Nekri Zoni'. See also Bryant and Papadakis (2012).

3. Since 1997, I had been visiting Nicosia regularly with my late husband, Stefan Beck. Over the years, we became well acquainted both with the old town and with cultural workers, social scientists, journalists and artists whose work focused on Nicosia. In 1999 and in 2005, I conducted research projects with students and doctoral candidates of cultural anthropology and European ethnology at the Goethe University Frankfurt that involved extended field-work in Nicosia, enquiring, among other things, into historic preservation, cultural policies and the living conditions of immigrants in the old town. Between 2008 and 2014, I came back for half a dozen visits, charting the transformation of the old town and conducting formal interviews with urban planners, conservation architects and social scientists.

4. Part of this chapter builds on an earlier essay that later coalesced into a chapter of a book on the European Union's European Capitals of Culture programme edited by Kiran Klaus Patel (see Welz 2013c).

5. However, more riots and violent confrontations occurred in 1958. After the Second World War, the percentage of Muslim residents, once half of the population, dropped to less than a quarter, and they also started to concentrate in the northern part of the town. The divide-and-rule policy of the British as well as the nationalism fed by the 'parent nations' of Greece and Turkey were bearing fruit. In the wake of the riots, two separate municipal councils were established, while ethnic heterogeneity and economic integration within the neighbourhoods was on the decline (see Papadakis 1998). For an account of Nicosia's history, see also Keshishian (1990).

6. The European Union's Council Regulation (EC) 866/2004, which became effective when the Republic of Cyprus became a member of the European Union in 2004, regulates the mobility of persons, goods and services across the Green Line 'between the areas of the Republic of Cyprus in which the government does not exercise effective control and the areas in which it does'. According to this so-called Green Line Regulation, the Green Line does not constitute an outer boundary of the European Union. However, the police of the Republic of Cyprus are called upon to apprehend 'illegal migrants' at the checkpoints, that is, non-EU nationals without a valid visa for the EU. Because of the unresolved Cyprus problem, the Republic of Cyprus has not been able to join the EU's Schengen accord, which allows for unrestricted movement of EU citizens within the European Union.

7. For anthropologists' perspectives on the post-1974 situation and the likelihood of achieving rapprochement and reunification, see, for instance Papadakis, Peristianis and Welz (2006) and Bryant and Papadakis (2012).

8. Since the opening in 2008 enabling pedestrians to cross the Green Line within the old town, the conveners of the European Heritage Day events in the Republic of Cyprus decided to have 'The Unknown Heritage along the Buffer Zone' as the topic of that year's EHD. In addition to guided tours in the buffer zone, which otherwise is completely inaccessible, a street festival with live music played by bands from both sides of the divide drew a larger audience beyond those immediately interested in preservation issues.

9. For in-depth analyses, see Demetriou (2007) and Navaro-Yashin (2012). On 'heritage anxieties' that came to the fore after the 2003 opening of the checkpoints along the Green Line, see also Constantinou, Demetriou and Hatay (2012). For oral history testimony of collective memories of old Nicosia, see Bakshi (2013). A study of the economic effects of the 2008 opening of the Ledra Street checkpoint for local retail and service businesses was done by Jacobson and colleagues (2009). Stimulated by the global social movement Occupy, a small group of Greek Cypriot and Turkish Cypriot protesters occupied a section of the

UN-controlled buffer zone near the Ledras/Lokmaci crossing for some months in late 2011 and early 2012. A close-up ethnographic study is provided in Erdal (2013).

10. USAID's Cyprus office has for many years provided funding for bicommunal projects involving Greek and Turkish Cypriots. During the 1990s, many confidence-building measures were also made possible by the Fulbright Commission, which to this day organizes and extends funding to bicommunal youth groups and student exchanges. Other activities were supported by the United Nations and their development branch, the UNDP. The UNDP-ACT's most important role is in funding bicommunal activities and projects. For an assessment of the UNDP's role in Cyprus between 1974 and 2000, see Hocknell (2001).

11. Recent renovation projects in the north of Nicosia, funded by the EU via the Partnership for the Future, include the Saint Nicholas Church ruin (Bedestan), the old Municipal Market and an Armenian church and convent. Following the agreement of 2008 to resume talks between Greek and Turkish Cypriots, both sides set up a number of working groups and technical committees of experts to prepare the actual negotiations. Among them, the Technical Committee on Cultural Heritage, charged with identifying and safeguarding sites of cultural heritage across the Green Line, has been particularly active. In 2010, an EU-funded programme was established to conduct restoration projects in the north that were recommended by the committee. For more information, see Partnership for the Future (2013).

12. For a more detailed treatment of the ideological link between Greek Cypriot nationalism, cultural Hellenism and historic preservation, see chapter 2.

13. During the 1990s, the somewhat squalid *hamam* was still in operation, adjoining a small square that formed an important social space for the surrounding neighbourhood. The *hamam* served not only the few Muslim inhabitants left behind in the southern portion of the old town who came to worship in the nearby mosque, but also Greek Cypriots who were living close by. Until the late 1990s, the neighbourhood was a lower-class residential area of questionable repute. Next to many automotive repair and furniture manufacturing workshops, small brothels and prostitutes' walk-in parlours lined some of the side streets. These disappeared in the past decade, and the area became an immigrant quarter. The *hamam* was reopened in 2014 as an expensive wellness-oriented spa capitalizing on its ambience of 'Ottoman decadence'.

14. The Department of Town Planning and Housing of the Ministry of the Interior of the Republic of Cyprus is in charge of the event in Cyprus. Because of the internationally non-recognized status of their polity, the Turkish Cypriot authorities are precluded from mounting their own European Heritage Day.

15. Heritage management programmes are effective even in countries that are not members of the European Union. In the states of ex-Yugoslavia, the Council of Europe has deployed regional heritage progammes that integrate EU candidate states, but also countries that are not going to accede in the foreseeable future, into a joint European framework (Vos 2013).

16. Quoted from a self-published book by artists and writers from both communities (Hadjipieris et al. 1995: 19).

17. A similar project, with parallel events and performances on both sides, the Leaps of Faith festival, was staged in the following year. On the role of artists in the bicommunal movement, see Seifarth (2006).

18. Previously, Manifesta received subsidies under the programme called Culture. In the new funding period starting in 2014, Culture was joined with funding for media under the auspices of a new EU programme, called Creative Europe.

19. The new cultural infrastructure in Nicosia is also being erected with an eye to cultural tourism. Nicosia so far has been underdeveloped for this market (Kaufmann, Gronau and Sak-

kadas 2011). In most of the itineraries of special interest packages for tourists who want to see the archaeological sites and cultural heritage of the island, Nicosia is included only as a one- or two-day stopover.

20. ARTos founder Achilleas Kentonis became artistic director and project curator. He had made a name for himself internationally as a conceptual artist, a curator of many well-received exhibits and an organizer of artistic interventions into public space. For the advisory board, the team preparing the bid recruited prominent representatives of the capital's cultural institutions, among them Yiannis Toumazis of the Nicosia Municipal Arts Centre, who, on the occasion of the Cyprus presidency of the Council of the European Union, curated a contemporary arts exhibition and events programme with the title of *Terra Mediterranea in Crisis*.

21. Already in the preselection report in December 2011, the selection committee had admonished the Nicosia team to prepare a 'clear and precise plan for engaging with both the Turkish-Cypriot community and other ethnic minorities currently residing in Nicosia' (Pre-Selection Report 2011). In the 140-page bid submitted in July 2012, however, actual projects or frameworks for cooperation with Turkish Cypriot initiatives or institutions were not indicated.

22. Another reason why Nicosia missed being awarded the 2017 ECOC title appears to have been the comparatively small number of hotel rooms that are available in Nicosia and its neighbouring communities. Nicosia has about two thousand hotel beds, catering less to tourists than to business travel and conventions, while the mass tourism destination Paphos, by comparison, boasts twenty thousand hotel beds.

23. In April 2014, a Nicosia-based journalist published a lengthy report on the conflicts, writing that 'the teenagers, the hippy, arty types, the immigrants and the original older residents, who for years had made the area no-one else wanted their own, are in danger of being squeezed out of the picturesque narrow streets as newly opened, packed cafés and bars spread in all directions' (Christodoulides 2014). Even the travel section of the *New York Times* waxes rhapsodic about the changes in the old town of Nicosia, claiming that 'emboldened by falling real estate prices, arty cafés, boutiques celebrating home-grown fashion and buzzy restaurants have opened among the Venetian fortifications and Byzantine churches on the Greek side' (Doyle 2013).

Conclusion

Anthropology conceptualizes the political integration of Europe foremost as a cultural process. Anthropologists identify this cultural dimension of the European Union when they observe identity politics, emblematic symbols and the notions of belonging and of collective memory that social actors develop within, below or against European Union governance frameworks.[1] Conversely, I contend that the cultural impact of European Union politics is not limited to the realm of discourses, imaginaries and symbols, but should be investigated by looking at practices, technologies and material objects as well. As a heuristic tool, I coined the term 'European products' (Welz 2005; Welz and Lottermann 2009) to denote a broadly conceived category of things that either would not exist without the European Union, or have been infused with EU-generated qualities to such a degree that something new has come into being. Many 'European products' that I encountered in my research in the Republic of Cyprus were generated by the implementation of European Union directives or regulations. This holds true for an almond-and-sugar confection whose label declares it to be an EU-certified origin product,[2] or for the sheep milk yogurt that has been produced according to the food hygiene protocols demanded by the domestic transposition of the European Union's General Food Law.[3] Others have been mandated under the auspices of EU-funded programmes, such as the sudden appearance of cobblestoned streets and squares in villages that received funding for 'beautification' measures from European Union regional development schemes.[4] Still others radically reshape and indeed invent parts of the natural or built environment in the process of placing them under protection. The protected sites of the EU's Natura 2000 network or the status of a European Capital of Culture each constitute a complex assemblage of landscape or cityscape, human and nonhuman life-forms, expert knowledge and political technologies that would not exist without the impetus given by European Union institutions.

In the first section of this concluding chapter, I will engage with the transposition of European Union regulations within the domestic context of the Republic of Cyprus. On the ground, the European Union is produced – and reproduced – by a whole array of practices, especially since the materiality of states 'resides less in institutions than in the reworking of processes and relations of power so as to create new spaces for the deployment of power'

(Trouillot 2001: 127). Heritage designation and preservation, even though often considered a policy field of little import, illustrates well how European-ization operates as a governance technology. Heightened 'technical intercon-nection' (Dunn 2004) between member states of the European Union, while effecting a subtle process of transformation, does not make technical artefacts and material practices identical across the European Union. Standardization is wrongly perceived as being synonymous with homogenization. However, standards can also be deployed to differentiate products from each other, as I will explain in detail in the second part of the conclusion. There, I also address the fact that material properties of European products are outcomes of the sometimes contradictory interplay of EU standards, national politics and local implementations.

In the third section of this final chapter, I will attempt to make the diverse findings taken from the seven case studies coalesce around my initial assertion that heritage is being made but also unmade in the process of the European-ization of the Republic of Cyprus. What does it mean to 'unmake' heritage and why does this happen? More often than not, exigencies of the market play a role here. That economic concerns take centre stage more recently, of course, is not surprising, as the economic crisis of the Republic of Cyprus, and of southern Europe more generally, has in a paradoxical way become the major driver for the neoliberal Europeanization of Cyprus. The unfolding of the crisis, and also how anthropology tries to make sense of its effects against the backdrop of postcolonial theory, will become topical in the final sections of this conclusion.

Heritagization as a Vector of Europeanization

The 'patrimonial regime' (Hafstein 2007) of transnational heritage designation and protection has proven to be one of the vectors of the Europeanization of Greek Cypriot society – not a very visible vector, but nevertheless a highly ef-fective one. The Republic of Cyprus became a member state of the European Union in 2004. The transposition of European regulations into national leg-islation was a challenge that had to be dealt with within a period of only a few years. During the accession process, the Republic of Cyprus as well as the other nine candidate countries of the 2004 accession round had to change their laws, their administrative procedures, their social and political institutions, their economic and financial policies, their provisions for energy production, their labour legislation, their agricultural production and their practice of admitting immigrants, to name just a few policy areas that were affected. This process was structured by the chapters of the European Union's community contract, the so-called Acquis Communautaire. During the accession negotiations, one chapter after the other was 'opened' and, if the government of the candidate

state could convincingly prove that the necessary changes had been made or would be achieved soon, 'closed' successfully. Of course, the acceding states attempted to keep the required changes to a bearable minimum, to make use of whatever leeway there was, to argue for so-called opt outs, transition periods, extended deadlines and grace periods. This is why European Union discourse labels the process of the transposition of EU legislation into national laws and implementation procedures 'harmonization'. The term is as programmatic as it is euphemistic.[5] Obviously, the better the transposition of European regulations is adapted to local conditions, the more effective it will be. But how does the transfer of Europe-wide standards and their local implementation work?

Knowledge mobility (Ilcan and Phillips 2008), technology transfer (Barry 2002) and mutual learning by knowledge sharing (Bruno, Jacquot and Mandin 2006) are important governance technologies in the European Union context. The heritage field is a good example for how they work. Each one of the policy areas addressed in my case studies – the preservation of vernacular architecture, tourism planning, rural development, food quality, biodiversity and environment policies, and urban upgrading and city branding – generate very lively circuits of mobility and exchange of experts, regulations and expertise throughout Europe. The European Union and other transnational organizations such as the Council of Europe initiate and host Europe-wide networks and meetings where practitioners representing national governments interact with experts and European Union administrators. While some of this mobility predated and actually prepared the ground for the EU accession of the Republic of Cyprus, it markedly intensified after the 2004 accession, and most of my counterparts in fieldwork reported more and more European travel. In the Republic of Cyprus, at no time was this more poignant than between July and December of 2012, when Cyprus rotated into the presidency of the Council of the European Union and was called on to facilitate policy negotiations among European member states, both in Nicosia and in Brussels. As historian Kiran Klaus Patel asserts, 'actors of various types negotiate a broader "field" of European expertise and political action. In this light, experts shape the forms of knowledge and the ways of reasoning that legitimise European policies, and they help to frame the social and communicative strategies that shape this European field' (2013: 72). The transfer of policies between governments and other agencies increasingly proceeds by way of 'competitive emulation' (McCann and Ward 2011: xiv). Policy making itself is changing and is no longer limited to the frameworks of governmental bodies, bureaucracies and other recognizably 'political' forms of agency. Rather, policy models 'travel' across societies – with 'travel' being a euphemism that cloaks the power relations that undergird policy mobilities. Policy making has become a placeless, opportunistic and fleeting practice, conducted by a new category of experts and generating new types of expertise. 'Contemporary policy-making, at all scales, therefore

involves the constant scanning of the policy landscape, via professional pub-
lications and reports, the media, Web sites, blogs, professional contacts, and
word of mouth for ready-made, off-the-shelf policies and best practices that
can be quickly applied locally', write political analysts McCann and Ward in
their study of new policy actors that include 'politicians, policy professionals,
practitioners, activists, and consultants [who] act as transfer agents, shuttling
policies and knowledge about policies around the world through conferences,
fact-finding study trips, consultancy work, and so on' (2011: xix). In fact, many
of the officials, activists and experts I interviewed in the course of fieldwork for
this book qualify as 'policy actors' in this sense. In Cyprus, they gradually began
to replace an older generation of government officials and technocrats who rep-
resented the civic epistemology (Lengwiler and Beck 2008) of the postcolonial
state as a paternalistic provider for its subjects.

Even though the Republic of Cyprus had become a European Union mem-
ber eight years prior to rotating into the presidency of the Council of the Eu-
ropean Union in July 2012, I observed that the presidency provided a major
push for a visible Europeanization of government and state administration. In
2012, the Cyprus government presided over many high-level European policy
meetings and hosted numerous international political events, many of them
in Nicosia. For this reason, impressive new government buildings had been
erected to house ministries and administrative departments that for decades
had been located in the structures left behind by the departing British colonial
administration after Cyprus achieved independence in 1960. Now, however,
the Republic of Cyprus wanted to present itself to fellow Europeans as a truly
modern European nation. The six-month period of the presidency was also
the time when a host of digital information portals went online, including En-
glish-language websites of government agencies that made available a plethora
of English-language documents and reports that before were largely inaccessi-
ble or only available in Greek.

From the 'organizational texts' (Escobar 1995) that government agencies in
Cyprus produced, I had gleaned over the years a substantial amount of the
material that went into the case studies of this book. And increasingly I could
see that most of the people I repeatedly interviewed at their government of-
fices, year after year, became extremely burdened – and sometimes overbur-
dened – with the demand to produce or contribute to such organizational
texts. While before these went into files, disappeared in drawers and had to
be recalled from dusty archives when I asked for them, most of these texts
now freely circulated within the European Union. This also meant that they
had to comply with genre conventions of 'interim reports', 'background papers',
'executive summaries' and 'evaluation documents'. Next to national legislation
harmonized with EU frameworks, these documents are the most important in-
struments in redefining people and places in the Republic of Cyprus according

to European Union classifications. An exemplary case is the client categories of
the European Union that reconceptualize citizens as 'applicants', 'responsibles'
or 'beneficiaries'. For instance, in chapter 3, my analysis of the application of
Structural Funds programmes for agrotourism and regional development in
Cyprus shows how the inclusive notion of European Union citizenship also
creates new types of social division and of graduated rights of ownership and
stewardship.

The findings of my research also contextualize the European Union, while
undisputedly the most powerful driving force of European integration, with
other transnational organizations working towards compliance of member
states with pan-European frameworks of heritage regulation. For instance, the
safeguarding and reconstruction of historical buildings is not legislated by the
European Union, but a standardization of heritage management throughout
Europe has been underway since the 1990s, much of it under the auspices of
the Council of Europe. Interstate conventions signed and ratified by European
countries, transnational programmes offering subsidies for renovation projects
or incentives such as awards and competitions, as well as other instruments
of 'soft law' all contribute to a process of constituting heritage. Examples of
pan-European programmes are the annual European Heritage Days, a joint
initiative of the Council of Europe and the EU, which provide heritage special-
ists and government authorities in the Republic of Cyprus with an opportunity
to present their work, or the Europa Nostra award for outstanding heritage
projects that has repeatedly been awarded to restorations in Nicosia's old town
within the Venetian walls.[6] Incidentally, UNESCO, under the auspices of
which the Nicosia Master Plan was initially created, serves as a case in point for
much of the enquiries conducted by anthropologists into the operation of her-
itage regimes throughout the world (see, e.g., Kuutma 2012; Tauschek 2012;
Kirshenblatt-Gimblett 2006).

Standardization: Sameness or Difference?

One of the most frequent observations on Europeanization, or indeed critiques
of its effects, equates the European Union's policies with standardization.[7] The
European Union does deploy standards to facilitate the circulation of goods
within the common market and to protect their export value in competition
with global production. Within the EU context, standards are understood to
be market devices. They ensure that the quality of commodities that are being
traded across national borders can be correctly assessed and that the prices
accorded reflect these qualities. This is particularly salient in today's global-
ized economy, where producers and consumers are no longer copresent in re-
al-life marketplaces and where commodities travel over great distances from

their place of production to the point of sale. Increasingly, production networks spanning various manufacturing sites result in so-called global value chains.[8] This means that any given commodity we can buy today may have crossed many borders in the process of being assembled. Materials, substances and ingredients are variably sourced, processed and packaged in different places, wherever the cost of labour or the price of ingredients is lowest. Standards are essential to keep global value chains working, to ensure material stability and unchanging quality across individual objects of the same category.

The term 'standardization' carries the semantic load of homogenization and the obliteration of variation and difference. In much of the anthropological literature, things that count as heritage are the antithesis of standardized commodities. Indeed, anthropology and, more generally, the ethnological disciplines have from their very inception as scholarly enterprises been implicated in the divide between what is conceived of as authentic folk traditions and cultural artefacts on the one hand, and the presumed artificiality of standardized mass-produced commodities on the other. When historical artefacts are sold to consumers or cultural traditions staged as an attraction for tourists, the discipline of anthropology has again and again raised its voice to strongly oppose what is seen as the outright commodification of culture. Historians and cultural scholars lamenting the rise of the so-called heritage industry have seconded their claims.[9] Rather than merely affirming the normative assumptions that underlie these critiques, my study has attempted to look at the very process in which artefacts and practices are remade as goods and services. I found that standardization and heritage making are actually not at odds and are more closely connected than I at first had assumed. New economic practices such as flexible specialization, niche marketing, franchising and the localization of global commodities have created an amalgamation of instruments that guarantee stability and homogeneity and those that allow for diversity and accommodate difference. Economist Lawrence Busch has coined the term 'standardized differentiation' for things that are produced to the same standard template as others but somehow manage to stick out – as the same but different.

> Standardized, differentiated products conform to quantity, price, and currency criteria … but they have a different relationship to quality than either commodities, which are standardized but all of the same quality, or craft objects, which are unstandardized and of differing quality. Specifically, they are produced simultaneously to be standard (when compared to each other) and differentiated in space or time (when compared to other products or services), to create a niche targeted at some (larger or smaller) group of persons. (Busch 2011: 165)

Standards, then, do not necessarily obliterate cultural differences, but rather may exploit, amplify and even invent them. Indeed, differentiated standardiza-

tion is proliferating today, as is differentiation on the basis of standards, and the European Union and the economies of its member states are deploying it to get a competitive edge in global markets. This is one of the phenomena that came to the fore in the case studies assembled in this book. They all exhibit a tension, namely, between instruments of regulation that seek to measure and control things, practices and people across time and space, and the need to leave leeway for variance, diversity, local uniqueness or some other type of heterogeneous quality that cannot be brought in line and resists simple homogenization. The EU and its bodies have had to invent, test and apply standards that work to preserve and highlight the nonstandard character of certain products. This becomes evident in Cyprus, where heritage making and the economies of tourism, real estate development and leisure consumption have become closely aligned. The quality labels that the European Commission awards to small-scale rural production of traditional food are a particularly pertinent example of standardized differentiation. But the other case studies as well show that in the age of supply chain capitalism and globalized production networks, for a number of commodities, it is a special asset to not have been brought forth by a global value chain but, on the contrary, be site-specific or have been produced in one circumscribed location. This book argues that increasingly, all sorts of things – and ensembles of things that are place-bound so that they cannot be traded across distance – are becoming subject to marketization. Some of them cannot simply be subsumed under what we as consumers easily recognize as commodities, as places, areas, even atmospheres and experiences emerge as European products.

Unmaking Heritage

When regulations that ensure the heritage status of a building, an ensemble or some other cultural object cease to apply or are revoked, the object or assemblage in question is released from protection and no longer immune against interventions or demolition. In the case of the Akamas Peninsula, for instance, the pressure that real estate developers and tourism entrepreneurs have been exerting on successive governments of the Republic of Cyprus has by and by led to a substantial shrinking of the area protected by preservation measures and is now making the threats against the ecological integrity of this wilderness area posed by tourism and real estate development much more likely than before. While environmentalists have again and again called on European authorities to help them counteract this process of unmaking the natural heritage of Cyprus, the current economic crisis of the Republic of Cyprus is not likely to strengthen their position. It is evident that market pressures, here but most certainly also in other cases, contribute to heritage being unmade.

While it is widely recognized that the heritage status of a thing may disappear or be taken away, the cultural operation of 'unmaking' heritage has hardly been theorized. Material culture studies, however, suggest that objects may indeed migrate 'across different spheres of values and framings of significance' (Skrydstrup 2009: 59). This assumption implies that things may not only circulate in and out of commodity status, but also in and out of heritage status. This may happen both within the life span of a single artefact, or it may apply to categories of objects whose status may change through time and differ between cultures.[10] This ties in with the observation that heritageness is no innate quality of artefacts or relics, but is generated by knowledge practices and governance technologies that identify, designate and valuate them as heritage. This assertion stood at the beginning of my exploration of how heritage making and Europeanization are becoming intertwined in contemporary Greek Cypriot society. Old village houses, the mountainous landscape of inland Cyprus, cheese made of sheep and goat milk, long tables overflowing with different kinds of salads, grilled meats and potatoes are heritage only by virtue of being declared heritage. The ascribed quality of heritage sits well with a long-established social constructionist conviction that has permeated cultural theorizing in anthropology for decades. As social constructionists, we consider traditions to be 'invented', or at least the outcome of sometimes quite arbitrary processes of selection and amplification of singular cultural attributes in the service of identity politics and social boundary making. A constructionist perspective assumes that an object or practice is relabelled as 'heritage' in the process of heritage making, often at the instigation of political elites and state bureaucracies, and today also in accordance with technical and legal specifications. Historic preservationists, architectural historians, folklorists, museologists, regional planners, tourism destination managers and other specialists then proceed to create an interface between the heritagized object and its potential audience by defining and explaining its heritage value. Heritage making implies a movement from 'the unmarked to the marked, from the implicit and embodied to the explicit' (Eriksen 2004: 31).

However, a social constructionist reading of heritage making and unmaking runs the risk of paying scant attention to the materiality of what is designated as heritage. The durability of material – which applies to long-lived artefacts such as buildings – and the continuity of form – of short-lived artefacts such as performances or perishable food – are material features that interact with the declaration of something as heritage. They do so in different, sometimes unpredictable ways (Macdonald 2013: 132). The materiality of heritage artefacts is an enabling or restricting factor for what one can do with an object and which types of preservation it can be submitted to.[11] By the same token, heritage making fundamentally changes the very artefacts that it claims to preserve unchanged by bringing them under its protective umbrella. Rather being

just a process of social ascription in which some artefact is selected and labelled as 'heritage', the heritage declaration sets in motion a process of transformation. Philosopher John Searle's notion of the declaration comes to mind (Searle 2010). He claims that by declarative speech acts, human institutions impose what he calls 'status functions' on objects and also on people. Heritage making is such a declarative act in that it not only represents but also creates heritage. Obviously, in some cases, these transformations are so radical that one can actually consider a new thing to have been brought into the world (Hafstein 2007). But even where this is not the case, typical changes imply the disappearance of irregularities, the erasure of manifest traces of use and a loss of individuality and of depth. For instance, traditional food products that exhibited variety in taste and other organoleptic qualities because of individual producers' recipes, the seasonality of ingredients or other regional differences have been obliterated when heritage standards demand more uniformity between and stability across a class of objects.

In a paradoxical way, then, the valuation and valorization of a cultural good as heritage often contributes to the demise of those practices and the social actors from whom it originates. Historically generated practices are lost because of hygiene standards or marketing concerns, and locally based forms of knowledge become extinct when artisans cannot comply with new rules and have to close down their businesses. In these cases, the heritage regime exerts not only a transformative power, but also is downright destructive. When villages become museums rather than places to be lived in and when government authorities impose standards of conduct, social actors are no longer able to 'reproduce themselves as active subjects of history' (Leitch 2003: 441). They may retain legal ownership of sites and structures, but they are dispossessed of their property in a cultural sense because they are no longer allowed to make use of it according to interests and orientations that stem from the traditional social order.[12]

Heritage regimes also tend to reconfigure the relations of things, people, knowledge and practices in terms of a new ordering of property rights. Critics claim that regulations devised to protect traditional products against global market pressures actually effect a grand-scale disenfranchising of local communities. Heritage making, according to these analyses, plays into the widespread privatization of nonproprietary cultural goods and, more generally, the appropriation of commons. Commons are resources whose use is shared by members of a community. Their privatization is in the interest of national as well as global economic players. In the case of Cyprus, the marketization of 'heritage' occurs within the framework of tourism and other economic sectors that are intimately bound up with it, such as gastronomy, real estate development and construction. Indeed, the rural landscape of inland Cyprus, which was produced by many centuries of human-environment relations, or the unique ambi-

ence of the old town of Nicosia within the Venetian walls, which was created by the patterns of everyday life of its residents in themselves, are not commodities that can be bought or sold. Yet, they have become instrumental assets for tourism destination management and emergent real estate markets. And in order to function as such, they have also been made subject to a multitude of material interventions, in order to make them sit more comfortably with preconceived notions of what tourists may want to see. In the eyes of many anthropological observers, it is the commodification of traditions and other cultural resources that often leads to disenfranchisement, dispossession and sometimes even displacement of social actors whose rights purportedly are being protected by the heritage regime. Much of the discussion about commodification in the heritage arena has focused on intellectual property rights and the regulations pertaining to so-called intangible heritage, often in response to what is seen as the usurpation of indigenous cultural knowledge and practices by Western science and corporate capitalism.[13] In the case of Cyprus, yet another problem space opens up when heritage is reconfigured along the lines of the right to sell and make a profit. Practices and products that historically were shared among the ethnic groups and religious communities inhabiting the island are now claimed as cultural property by one or the other collective exclusively, prohibiting others from producing it for European markets. European Union regulations such as the protected designation of origin awarded to regional food products turn out to be quite conducive to a property-oriented notion of heritage that can be easily aligned with ethnicity and nation.

Neoliberal Europeanization

When I conducted a last round of interviews for this book and concluded my fieldwork in Nicosia in November 2012, the downturn of the economy of the Republic of Cyprus and the rising state debt were already very evident. For instance, some of the government officials and employees of various authorities that I interviewed anticipated problems in regards to the state funding of the very projects and programmes that we were talking about.[14] The Europe-wide recession since 2009 had had a negative impact on the Cyprus economy. More importantly, however, Cypriot banks had accumulated a huge volume of Greek state bonds and suffered severe losses when, in October 2011, Greece was forced to impose a so-called haircut on holders of Greek state bonds as part of an agreement negotiated with the European Commission, the European Central Bank and the International Monetary Found in order to secure a second bailout for Greece from the EU. The Republic of Cyprus soon became unable to borrow money on the international financial market. International rating agencies downgraded Cypriot state bonds to 'junk status', which meant that

they would not be accepted as collateral in lending anymore. The government managed to procure an emergency loan from Russia in January 2012. Yet, in June 2012, it had to request a bailout from the European Union, and entered into negotiations with the representatives of the group of international lenders commonly called the Troika[15] about implementing public sector austerity policies and downsizing the banking sector.

None of the research interlocutors, colleagues and friends whom I met in the course of the final stage of my research in the summer and autumn of 2012, however, could have anticipated what was going to happen a few months later. In the February 2013 presidential elections, a new centre-right government came to power and was saddled with the task of resolving the crisis. Meanwhile, members of European governments, among them the German finance minister Wolfgang Schäuble, repeatedly voiced suspicions that the Cypriot government was allegedly condoning money laundering activities by Cypriot banks that were said to specifically cater to companies and private individuals from non-EU countries, most prominently from Russia. Indeed, since the 1990s, the Republic of Cyprus had grown into an offshore financial services hub, offering high-interest deposit banking, low taxation and a number of services tailor-made for foreign nationals, also from the EU, intent on tax shelter and tax evasion. In a press commentary, the harsh stance of the Troika was called 'a cruel and unusual punishment visited upon ordinary Cypriot citizens who have never been informed of the perpetual risks which have accompanied the tax haven strategy of economic development vigorously promoted by the political elite since the 1980s' (Officer and Taki 2013a). On 16 March 2013, the result of the Troika negotiations was announced. This result differed dramatically from previous deals negotiated between the Troika and other crisis-stricken countries in that it entailed that the assets of ordinary depositors would be seized to refinance the ailing Cypriot banks. At the same time, severe capital controls were put in place, prohibiting transferrals to other countries and minimizing the amount of money bank clients could withdraw, effectively freezing accounts. One of the banks failing because of the Greek state bond fiasco was closed down completely, its staff and infrastructure partially absorbed by a second bank that was refinanced by the so-called bail-in, immediately seizing 47.5 per cent of depositors' assets above the insured level of one hundred thousand euros and freezing another 22.5 per cent. These measures came into effect in July 2013. Private savers, businesses as well as pension funds were hit indiscriminately. Later in the year it emerged that the capital controls had not been particularly effective in preventing capital outflow. Wealthy foreigners who had used Cyprus as an 'asset-protection location' (Kaufmann, Christou and Christophorou 2010) had already moved their funds in 2012 or early 2013, before the controls came into effect, while those depositors who were misinformed or ignorant of the risks were left to bear the brunt of this so-

called bail-in.[16] In many cases, these were ordinary citizens who had saved for their old age, or small businesses now unable to pay salaries and bills. Some of those responsible in the financial sector and in government whose actions had set the disastrous process in motion or who had done nothing to stop it were made accountable, politically and before the law, but much later and with hesitation.

By the end of 2013, limits on cash withdrawals, cheque transactions and transfers of funds were eased, further reduced and finally lifted in 2014. Yet, consumer spending has been dramatically reduced since then. The now empty storefronts of Makariou, formerly the high street of modern Nicosia outside the Venetian walls that had been dominated by fashion designer outlets, chic cafés and expensive shops, is taken by many people as a potent symbol of this downturn. By the end of 2013, experts estimated that one-third of small businesses in the Republic of Cyprus had closed down, much of this also a consequence of the confiscation of private capital and the inability of affected businesses to get loans to stay afloat. The Cypriot middle class was hit dramatically. While before 2008, the Republic of Cyprus had almost full employment, in the summer of 2013, 17.5 per cent of the labour force was registered as unemployed according to Eurostat data (Apostolides 2013) These numbers continued to rise. Throughout 2014, the youth unemployment rate was at 33 per cent while before the crisis, only about 15 per cent of young people were without a job. Families having to rely on charity handouts and the number of households that are classified as living below the poverty line increased. Also, emigration of highly qualified members of the workforce led to many observers fearing a crippling 'brain drain' (Christou, Ioannou and Shekeris 2013). While the private sector made staff redundant and slashed wages, the public sector effected deep spending cuts and lowered salaries and pensions. Semigovernment agencies were threatened with dissolution, and public utilities prepared to be privatized. Bankruptcies of small and medium-sized firms continued to occur at an alarming rate well into 2014. More than fifty food banks passing out food and other necessities to families without income were set up by private initiatives in 2013, and continued to serve the needy throughout 2014. Civic organizations decided to pay for school lunches to be made available for pupils from families where both parents are unemployed. Doctors and nurses as well as pharmacies started to contribute work hours and resources to free-of-charge clinics. At the same time, the Memorandum of Understanding between Cyprus and the Troika stipulated that many government benefits to residents, some of them in place since 1960, were to be discontinued and instead new taxes introduced.[17] The *New York Times* criticized the Troika for pushing the Cyprus economy into a downward spiral: 'Instead of fixing Cyprus's problems, a tough rescue package ... has helped turn what began as a banking fiasco into a deep slump' (Higgins 2013)[18] of the economy.

One Year Later: What Comes after 'the Crusade of Greed'?

When I returned to Cyprus for a visit in the springtime of 2014, it had been exactly one year since the momentous events of March 2013, when the European Union's finance ministers had subjected the Republic of Cyprus to the so-called bail-in, forcing the government to refinance failing banks by seizing the assets of ordinary bank depositors. Some people that I talked to in March 2014 were hopeful that Greek Cypriot society would prove to be resilient and that the economy would revive. Others more realistically pointed out that the worst was still to come, as more companies and businesses would close down and more people would lose their jobs in the coming months. They pointed out that the unemployment rate, at 17 per cent, only incompletely reflected the situation in many sectors, where employees continued working on greatly reduced pay, hoping to keep their employers afloat. Unemployment was highest among the well-educated young adults coming back to Cyprus with university degrees acquired abroad. Some of them had already left Cyprus again, in search of qualified positions elsewhere, but I heard of many who moved in with their parents, keeping busy with unpaid internships and low-paid temporary jobs. The mood was subdued, defiant at times, mostly resigned. 'Dignity and depression' was how a doctor at one of the major hospitals in the country's capital summarized the prevalent attitudes of her fellow citizens when we talked about her patients, her colleagues and her own family facing up to the challenges. Compared to other southern European countries hit by the crisis and subjected to the austerity policies of the Troika, where mass protests, violence and rioting erupted, Greek Cypriots have remained calm, even docile compared to the situation in Athens and other European capitals. Only when the major utility companies as well as the ports, all of them state-owned and operated, announced that they would be privatized did a number of unions successfully organize a series of demonstrations and strikes. Many people appear to be falling back on kinship networks for reciprocal support. In addition, a remarkably large number of charities have been set up, relying on volunteer work, citizens' donations as well as the church and corporate sponsors. The impressive outpouring of goodwill, donations and mutual support that emerged in the spring of 2013 and since to help the needy was compared by many people to the ability of Greek Cypriot society to integrate the refugees displaced by the invasion in 1974. The Greek Cypriot population interprets the challenge of 'the crisis' very much along the lines of the invasion of 1974, as anthropologist Olga Demetriou contends: 'The future of austerity was presented as a collective challenge, where "all of us" will work hard, rebuild the economy, rise up again as "the Cypriot people" have done before' (Demetriou 2013b). The quotation marks in Demetriou's blog post indicate that the widespread no-

tion of Greek Cypriot society as a homogenized collective works well to make economic inequalities and political differences disappear. Even though some media commentaries have blamed the elite of rich Greek Cypriot entrepreneurs and local business dynasties, in particular in the real estate sector, whose unwillingness to repay the multimillion-euro loans was one of the factors contributing to the failure of the banks in 2013, popular sentiment remains muted, although some media have started to lay the blame at the door of the rich and powerful.[19] Yet, in April 2014, Parliament decided against publishing a list of people who had transferred money outside the country in the months before the restrictive measures of financial mobility imposed in March 2013, many presumably acting on 'inside' information. The list contained more than six thousand names.

In the general population, mostly 'Brussels' and the German government are blamed, with people emphasizing that they are well able to differentiate between ordinary German citizens and the political elite. Greek anthropologist Dimitrios Theodossopoulos, who is analyzing the population's indignation with the austerity policy in Greece, claims that 'local rhetorical and interpretive tactics – in Greece and elsewhere – do not merely represent an attempt to evade responsibility (which they often do) but also a desire to reinterpret and renegotiate responsibility and blame, and to assume in this process a small degree of control over a deeply felt sense of political peripheralization' (Theodossopoulos 2013). Also against the backdrop of recent fieldwork in Greece, British social anthropologist Daniel Knight asserts that while 'initial blame is regularly directed toward the authoritarian external Other, such as the European Union, Troika, and the United States', progressively, people 'call for political "elites" to be held responsible for the "crusade of greed" … that provoked the most significant consequences of crisis' (Knight 2013: 151).

Among some of the friends and colleagues I met with in March 2014, there was great concern about the emergence and strengthening of radical right-wing populism in Greek Cypriot society, modelling itself after the Golden Dawn extremists in Greece. A few days before, violent right-wingers had attacked a public event in Limassol where a prominent Turkish Cypriot politician had rallied support for reconciliation between north and south. Also in early 2014, a new round of talks between both communities had been initiated, and both the government and reconciliation-minded civil society actors in the Republic of Cyprus were confident that a window of opportunity existed for a solution. Some of the colleagues I talked to argued that as long as the island was divided, Cyprus would continue to exhibit a particular kind of 'halfway neoliberalization',[20] with the unresolved Cyprus problem acting as a powerful impediment to the complete integration into European and indeed global spheres of capital flows and geopolitical influence.[21]

A Postcolonial Reading of the Crisis

With the exception of Malta and Cyprus, none of the European states that count among the Mediterranean countries have been colonies of European powers in the strict sense of the word. Rather, some of the circum-Mediterranean countries were drivers of the European colonial expansion centuries ago. Those countries that had been under the rule of the Ottomans also do not qualify as 'colonies' in the proper sense of the word in historical discourse. Yet, the theoretical concept of coloniality has become a lever of critique in discussions about the eurozone crisis and also in reflections about the role of the European Union in the Mediterranean region as a whole. Since the mid-1990s, the European Union has expanded its influence in the Mediterranean area by way of supranational accords, financial aid, knowledge transfer, implementation of European standards and the identification and strengthening of cultural heritage (J. Scott 2005). Couched in a language of partnership and neighbourliness, this process is embracing many countries on the southern rim of the Mediterranean[22] as well, who will most likely never become members of the European Union but are called upon to support the border regime of the EU and its restrictive immigration policies.

Throughout the twentieth century, Western scholars and politicians developed a genre of Mediterraneanist discourses that managed to hide the very relations of inequality that they promoted, as geographer Kerem Öktem contends, writing that the Mediterranean is a 'powerful metaphor reflecting the northern gaze towards the southern rim' (2010: 16). 'Mediterraneanism' as an analytical term implies a critique of such discourses similar to that of Edward Said's deconstruction of Western-derived Orientalism. This critique is of particular poignancy for anthropologists working in southern Europe who, decades ago, invented 'the Mediterranean' as a research area of social and cultural anthropology (Goddard, Llobera and Shore 1994). Therefore, anthropologists whose work is informed by postcolonial critiques take issue with the uncritical deployment of the label 'Mediterranean' and argue for its deconstruction (Argyrou 2001).

In recent years, the assertion that the countries of the circum-Mediterranean area are being colonized by the European Union has taken on an additional meaning. As mentioned before, for countries like Portugal, Italy, Greece, Spain and Cyprus, these are the days of the crisis of the banking sector, of governments' rising debt and impending insolvency, of the downturn of the economy and of a stark increase in poverty among the general population, with the rising numbers in unemployment among the young perhaps the most worrisome consequence. The austerity measures that these countries have to submit to when they apply for aid from the European Stability Mechanism (ESM) are

experienced by many as colonial impositions. Postcolonial theory is an apt instrument of critique in these times of crisis. Earlier, Michael Herzfeld repeatedly called Greece a 'crypto-colonial society', a designation that refers to countries that are nominally independent, but their 'independence comes at the price of a sometimes humiliating form of effective dependence' (2002: 899) as a tributary to the West.

The concept of the 'coloniality of power' (Mignolo 2000), initially developed in Latin American subaltern studies, is perhaps more analytically acute when looking at Cyprus because it highlights the fact that in formerly colonized societies, colonial forms of submission to hegemony are reproduced in the contemporary social order. Vassos Argyrou claims that while the country has been independent since 1960 according to conventional understandings of politics, Greek Cypriot society remains a postcolony that inadvertently keeps reproducing the power relations that formed it (2010: 41). By ascribing to modernity and Europeanness, Cypriots – the Greek Cypriot as well as the Turkish Cypriot community[23] – did not free themselves of this legacy, but, as Argyrou claims, affirmed their dependence. Nicosia-based social anthropologist Olga Demetriou posed the hypothetical question of whether the present crisis of the Cypriot economy harbours any potential to effect a 'foundational repositioning of political subjectivity'. She answered this question in the negative and concluded that 'the political subject of the Cypriot crisis is a postcolonial citizen thoroughly embedded in liberal capitalism' (Demetriou 2013b) who will protest against the loss of bank deposits, find ways to make a living in spite of austerity cuts and in some cases blame 'the Turks' as well as non-European immigrants for the hardships experienced.

Other authors have insisted that the specific civic epistemologies that were formed in colonial Cyprus have persisted in independence, producing a kind of 'enlightened paternalism' on the part of the Greek Cypriot state (Lengwiler and Beck 2008). How political elites and ordinary citizens cohere together in Greek Cypriot society[24] even though their interests are actually at odds may well be explained by this postcolonial civic epistemology. One last example from my research will illustrate this. On the coast of Chrysochou Bay, across the water from the Akamas Peninsula, one of the most expensive golf resorts of the Mediterranean is being erected by a highly influential and prosperous group of companies, a domestic enterprise well-known in Cyprus for its engagement in corporate services, commerce, insurance, airport management and real estate development. Two golf courses, designed by international architects, will serve as anchors for up to eight hundred luxury villas to be constructed and marketed at high prices to a clientele of rich foreigners. Shares have been sold for this project since 2010. Only a few days before the end of his presidency in early 2013, the outgoing president of the previous administration laid the founda-

tion stone for this huge real estate development, not heeding that it will place a heavy burden on the existing infrastructure of the neighbouring villages, on the environment of the coastal area and on the water resources of the entire region. The project violates the European Union's Habitats Directive, threatening rare species and sensitive ecosystems on a shore where Natura 2000 sites have been designated by the European Commission. The golf courses and the residential development will utilize the site of a large copper mine that was closed in the 1970s. Local residents and scientific experts have repeatedly voiced concern about polluted soil, seepage into groundwater and unstable slopes. However, both the previous and the present government have made the project a top priority, on the assumption that it will create employment in times of crisis. The year before, the government had installed a so-called fast-track mechanism, for large-scale real estate projects to be issued construction permits and licences swiftly and without any obstruction in order to give 'strategic investments' "the green light" for time-effective implementation'.[25] Rising unemployment figures and the threat of poverty made political decision makers bow to any investor's wishes, rather than heeding prudent warnings and requiring more thorough assessments of all possible impacts and risks. Also, the Memorandum of Understanding between the Republic of Cyprus and the so-called Troika of the European Commission, the European Central Bank and the International Monetary Fund highlighted tourism and real estate development, catering to what is called 'foreign demand in the housing market', as important 'potential drivers of future economic growth' (Memorandum of Understanding 2013). Recently, the European Commission has started an enquiry with the Cyprus government about the integrity of the nature protection sites affected by the golf course development referred to above.[26] Nobody will be surprised, though, if, in the end, economic interests win out against other considerations such as environmental integrity, public health and the sustainable management of natural resources. In Cyprus, the crisis encourages the sellout of the country's assets. Multinational corporations are interested in taking over public utilities and government-owned facilities, natural resources and unique landscapes continue to be 'developed' and sold to foreign investors, and once the banks start to auction off the repossessed houses of homeowners who are unable to pay back their bank loans, representatives of international hedgefonds will queue to buy up whatever properties they can lay their hands on. This is not lost on the population, even though their indignation and protests are aimed against the European Union and the Troika rather than targeting the businessmen, lawyers and bankers who have sold them out. The investors who are waiting in the wings to snatch up Cyprus for a bargain are all too happy that the spotlight is not on them, but on 'Brussels'.

Notes

1. A very good overview of current research in anthropology that addresses Europeanization as a process of identity construction is Wilken (2012). For a critique of this fairly prevalent approach in anthropology, see Welz and Lottermann (2009).
2. Sugared almonds from the village of Geroskipou, called Koufeta Amygdalou Geroskipou, were the first Cypriot product to receive the label of protected geographical indication in 2012.
3. Since the year 2000, the European Union considerably augmented its restrictive regulations to ensure food safety. The most well-known and most widely disseminated food hygiene protocol is HACCP, a quality control concept that is based on hazard analysis and the identification and monitoring of so-called critical control points. In Cyprus, the transposition of EU regulations into national legislation has made an HACCP-type protocol obligatory for any food producing, processing or catering business.
4. For these and similar measures funded under various components of the EU's Structural Funds, see chapter 3 of this book.
5. There are two types of EU legislation – regulations are binding, supranational laws that member states have to comply with to the letter, while directives offer a framework of a guideline-type character that then has to be adopted in and adapted to national legislation. In all EU member states, the national legislature is constantly changing their country's laws to accommodate new directives spawned by the EU.
6. The European Union Prize for Cultural Heritage/Europa Nostra Awards honour excellent examples of cultural heritage conservation. The organization Europa Nostra is an umbrella network of hundreds of heritage associations and governmental bodies in Europe. Among the 2014 award winners is the restoration of the cultural centre Home for Cooperation located in the buffer zone of Nicosia, which hosts the intercommunal organization Association of Historical Dialogue and Research.
7. Anthropology's long-standing interest in classifications as culturally specific types of social constructions that produce certain categories of people but also have material effects in the physical world comes to the fore here (see Bowker and Star 1999).
8. For the role of standards in the governance of global value chains, see Nadvi (2008) and Gibbon, Bair and Ponte (2008).
9. For an exhaustive overview of the normative assumptions undergirding the critiques of commercializing heritage voiced by social scientists and cultural studies scholars, see Frank (2008).
10. Heritage scholar Martin Skrydstrup (2009) adopts Appadurai's notion of the 'tournaments of value' (1986) in order to conceptualize the migration of things in and out of commodity status.
11. Rather than determining how people deal with these things, they afford a whole range of relating to and making use of them. This perspective on the affordances of material artefacts led me to engage with a broad array of social actors such as consumers, property owners, tourists, artisans and administrators in my study. The concept of 'affordance', which was developed in contradistinction to more deterministic notions of human-technology interaction, more recently has been broadened to look at how the material properties of things suggest rather than mandate certain kinds of behaviour. For a discussion, see Beck (1997). For an adaptation of the concept for a discussion of the materiality of heritage objects, see also Macdonald (2013: 83ff.).

12. Herzfeld (1991) conceptualized this movement as the replacement of residents' social time with the monumental time of the state's preservation regime.
13. For a recent case study of food production in Italy, see Mattioli (2013). He also reports on resistance and alternative social movements that protest against the regulatory interventions of the EU's certification of food products.
14. Generally speaking, measures funded by the EU within frameworks such as the Structural Funds require domestic cofinancing by the national government, usually 50 per cent of the cost. The inability of the Cyprus government to contribute its share has resulted in a diminished 'uptake' of European Union funding for projects that had already been approved by the European Commission.
15. 'Troika' was the term used both for the three international bodies who conduct the process, namely, the European Central Bank, the European Commission and the International Monetary Fund, and for the actual negotiating teams of civil servants who represent them and work out the terms of the bailout with the respective government. In the course of 2014, during negotiations with Greece, the name has been changed to 'the Institutions'.
16. The consequences of the so-called bail-in were borne by ordinary depositors while members of the economic elite and the large corporations were left largely unscathed. In particular, the real estate development sector, which is dominated by a handful of powerful domestic entrepreneurs, was not hurt. These companies had never paid back the loans that they had received from the affected banks – in the case of one company alone, this amounted to a volume of nonperforming loans in the order of two hundred million euros. The banks obviously had not made robust moves to reclaim on these loans previously. In some cases, the real estate that served as collateral for the loans they incurred had been sold, with the new owners having no idea of the status of their home and most often still waiting to receive the title deed. The issue of NLPs (non-performing loans) loomed particularly large in the negotiations with the Troika which froze further payments to Cyprus late in 2014, to force the government to legislate foreclosure proceedings which will allow the banks to repossess the real estate of owners who fail to pay back their loans. Without a properly functioning insolvency mechanism in place, this will mean that many ordinary citizens will lose their homes. After many months of controversial debate, the relevant legislation was passed by the parliament of the Republic of Cyprus in May of 2015. A ban proclaimed by parliament against hedge funds buying up real estate that will be auctioned off only extends until June of 2015.
17. The Memorandum of Agreement between the Troika and the government was agreed on in March 2013 and updated again in November 2013. It contains detailed stipulations for policy changes not only in the banking sector and public service spending, but also demands changes in the social security system, the health system and other policy areas. Only when the Cyprus government complies with these prescriptions will successive disbursements of the three-year rescue package be freed (see Memorandum of Understanding 2013).
18. 'In comparison with March 2013, an increase of 8.489 persons or 19,2 per cent was recorded which was mainly observed in the sectors of accommodation and food service activities, financial and insurance activities, public administration, manufacturing, trade, as well as to newcomers in the labour market' (Statistical Service of the Republic of Cyprus 2014). See Christou, Ioannou and Shekeris (2013) for a detailed analysis of which sectors of the economy were hardest hit by the crisis and by the austerity measures.
19. For an analysis of the effect of the crisis on political attitudes, see Charalambous (2014).
20. Olga Demetriou, personal communication, 2014. See also Demetriou (2013a).

21. Hopes were rekindled again in May of 2015, when elections in the North brought the opposition candidate to power who many years ago had been mayor of Lefkoşa, the northern part of Nicosia. His friendship with his Greek Cypriot colleague across the Green Line had made the Nicosia Master Plan possible. As a first goodwill gesture, the new Turkish Cypriot leadership abolished the 'visa policy' at the checkpoints at the Green Line which before had forced visitors to fill out visa applications as if crossing an international state border.

22. The Barcelona Process was initiated in 1995. Another instrument is the Union for the Mediterranean, which grew out of Nicholas Sarkozy's preelection pan-Mediterranean visions in 2007 (Öktem 2010: 15).

23. The encounters with modernity that occurred in the colonial era did bring forth 'conflicting styles of nationalist imagination' between Greek and Turkish Cypriots (Bryant 2004: 2), but both subscribed to the modern notion of nationhood in much the same way as they now seem to subscribe to the European idea.

24. Statement made by social scientist David Officer, University of Nicosia, at a conference in July 2013. See also his study of the role of corruption and the lack of public trust in Greek Cypriot society (Officer and Taki 2013a). For similar observations, see also Faustmann (2010).

25. This is a quotation from the Cyprus Investment Promotion Agency's homepage 'Invest In Cyprus' explaining the 27 June 2012 decision of the Council of Ministers. Retrieved 2 May 2014 from http://www.investcyprus.org.cy/

26. In May of 2015, the European Commission reminded the government of the Republic of Cyprus of its failure to have a proper assessment of the impact of the golf resort on the Natura 2000 site carried out. Indeed, if the government does not repeal their earlier decision to allow the company to build and market beachfront properties, it will be brought before the EU Court of Justice. Ironically, if the Court rules that a hefty fine will have to be paid, it will be the Cypriot taxpayers but not the private company involved that will have to bear this burden. By allowing the project to go ahead, the government had also incurred all the risks connected to this move. See European Commission 2015; Psillides 2015.

Bibliography

Agapiou-Josephides, K. 2005. 'Old and New Patterns of Domestic Politics in the European Perspective: The Debate in the Republic of Cyprus', in S. Lucarelli and C. M. Radaelli (eds), *Mobilizing Politics and Society? The EU Convention's Impact on Southern Europe*. London: Routledge, pp. 152–72.

Albera, D., A. Blok and C. Bromberger (eds). 2001. *Anthropology of the Mediterranean*. Paris: Maisonneuve et Larose.

Algar, A. E. 1991. *Classical Turkish Cooking: Traditional Turkish Food for the American Kitchen*. New York: Harper and Collins.

Amato, F. 2001. 'Nachhaltigkeit als Hoffnung für das zypriotische Hinterland: Neue Konzepte in Denkmalpflege, Regionalentwicklung und Tourismus' [Sustainability as a prospect for the Cypriot hinterlands: New concepts in preservation, regional development and tourism], in G. Welz and P. Ilyes (eds), *Zypern: Gesellschaftliche Öffnung, europäische Integration, Globalisierung*. Frankfurt: Kulturanthropologie Notizen, pp. 173–98.

Amelang, K., S. Beck, V. Anastasiadou-Christophidou, C. Constantinou, A. Johansson and S. Lundin. 2011. 'Learning to eat strawberries in a disciplined way. Normalization practices following organ transplantation', *Ethnologia Europaea*, 41(2): 54–70.

Andilios, N. 1998. 'In Cyprus Traditional Food Makes a Xenos/Visitor a Friend', in P. Lysaght (ed.), *Food and the Traveller: Migration, Immigration, Tourism and Ethnic Food*. Proceedings of the 11th Conference of the International Commission for Ethnological Food Research, Cyprus, 8–14 June 1996. Nicosia: Intercollege Press, pp. 108–14.

Andronicou, A. 1979. 'Tourism in Cyprus', in E. de Kadt (ed.), *Tourism: Passport to Development? Perspectives on the Social and Cultural Effects of Tourism in Developing Countries*. Oxford: Oxford University Press, pp. 237–64.

Apostolides, C. 2013. 'A Detailed Look at Unemployment in Cyprus', *Cyprus Mail*, 4 August. Retrieved 2 May 2014 from http://cyprus-mail.com/2013/08/04/a-detailed-look-at-unemployment-in-Cyprus/

Appadurai, A. (ed.). 1986. *The Social Life of Things: Commodities in Cultural Perspective*. Cambridge: Cambridge University Press.

Argyrou, V. 1996. *Tradition and Modernity in the Mediterranean: The Wedding as Symbolic Struggle*. Cambridge: Cambridge University Press.

———. 2001. 'The Mediterranean? Need One Ask or Reply?', in I. M. Greverus, R. Römhild and G. Welz (eds), 'The Mediterraneans: Reworking the Past, Shaping the Present, Considering the Future', special issue, *Anthropological Journal on European Cultures* 10: 25–38.

———. 2005. *The Logic of Environmentalism: Anthropology, Ecology, and Postcoloniality*. New York: Berghahn Books.

———. 2010. 'Independent Cyprus? Postcoloniality and the Spectre of Europe', in C. Constantinou (ed.), 'The State of Cyprus: Fifty Years After Independence', special issue, *The Cyprus Review* 22(2): 39–47.

———. 2013. *The Gift of European Thought and the Cost of Living*. New York: Berghahn Books.

Attalides, M. 1981. *Social Change and Urbanization in Cyprus: A Study of Nicosia*. Nicosia: Publications of the Social Research Centre.

Azgin, B. and Y. Papadakis. 1998. 'Folklore', in K. D. Grothusen, W. Steffani and P. Zervakis, (eds), *Südosteuropa-Handbuch Bd. 8: Zypern* [Southeast Europe handbook volume 8: Cyprus]. Göttingen: Vandenhoeck & Ruprecht, pp. 703–20.

Baga, E. 2002. 'Civic Involvement and Social Capital Creation: Evidence from the Environmental Sector in the Republic of Cyprus', *The Cyprus Review* 14(1): 55–66.

Bakshi, A. 2013. 'A Shell of Memory: The Cyprus Conflict and Nicosia's Walled City', *Memory Studies* 5(4): 477–94.

Barry, A. 2002. 'In the Middle of the Network', in J. Law and A. Mol (eds), *Complexities: Social Studies of Knowledge*. Durham, N.C.: Duke University Press, pp. 142–65.

Bathelt, H., A. Malmberg and P. Maskell. 2004. 'Clusters and Knowledge: Local Buzz, Global Pipelines and the Process of Knowledge Creation', *Progress in Human Geography* 28(1): 31–56.

Beck, S. 1997. *Umgang mit Technik: Kulturelle Praxen und kulturwissenschaftliche Forschungskonzepte* [The uses of technology: Cultural practices and research paradigms in the humanities]. Berlin: Akademie Verlag.

———. 2005. 'Putting Genetics to Use', *The Cyprus Review* 17(1): 59–78.

———. 2007. 'Medicalizing Culture(s) or Culturalizing Medicine(s)?' in R. V. Burri and J. Dumit (eds.), *Medicine as Culture. Instrumental Practices, Technoscientific Knowledge, and New Modes of Life* (Routledge Studies in Science, Technology and Society, Vol. 6). London: Routledge, pp. 17–33.

———. 2011. 'Staging Bone Marrow Donation as a Ballot: Reconfiguring the Social and the Political Using Biomedicine in Cyprus', *Body & Society* 17(2–3): 93–119.

———. 2012. 'Biomedical Mobilities – Transnational Lab-Benches and Other Space-Effects', in M. Knecht, M. Klotz and S. Beck (eds), *Reproductive Technologies as Global Form. Ethnographies of Knowledge, Practices, and Transnational Encounters*. Frankfurt: Campus, pp. 357–74.

Beck, S. and G. Welz. 1997. 'Naturalisierung von Kultur – Kulturalisierung von Natur: Zur Logik ästhetischer Produktion am Beispiel einer agrotouristischen Region Zyperns' [Naturalization of culture – culturalization of nature: On the logic of aesthetic production. Case study of an agrotourism region in Cyprus], *Tourismus Journal* 1(3–4): 431–48.

Bendix, R. and V. T. Hafstein. 2009. 'Culture and Property: An Introduction', in R. Bendix and V. T. Hafstein (eds), 'Culture and Property', special issue, *Ethnologia Europaea* 39(2): 5–10.

Bérard, L. and P. Marchenay. 2007 'Localized Products in France: Definition, Protection and Value-adding', in V. Amilien and G. Holt (eds), 'From Local Food to Localised Food', special issue, *Anthropology of Food* S2 (March). Retrieved 23 December 2009 from http://aof.revues.org/index415.html

Bidbook 'Nicosia 2017' Phase 2. 2012. Application for European Capital of Culture 2017. Retrieved 21 June 2014 from http://issuu.com/badpixel/docs/nicosia2017phase2english

Borneman, J. and N. Fowler. 1998. 'Europeanization', *Annual Review of Anthropology* 26: 478–514.

Börzel, T. and D. Panke. 2010. 'Europeanization', in M. Cini (ed.), *European Union Politics*, 3rd ed. Oxford: Oxford University Press, pp. 405–17.

Bourdieu, P. 1977. *Outline of a Theory of Practice*. Cambridge: Cambridge University Press.

———. 1984. *Distinction: A Social Critique of the Judgement of Taste*. London: Routledge and Kegan & Paul.

Bowker, G. and S. L. Star. 1999. *Sorting Things Out: Classification and Its Consequences*. Cambridge, M.A.: MIT Press.

Bruno, I., S. Jacquot and L. Mandin. 2006. 'Europeanization through Its Instrumentation: Benchmarking, Mainstreaming and the Open Method of Co-ordination … Toolbox or Pandora's Box?' *Journal of European Public Policy* 13(4): 519–36.

Brunori, G. 2006. 'Post-rural Processes in Wealthy Rural Areas: Hybrid Networks and Symbolic Capital', *Research in Rural Sociology and Development* 12: 121–75.

Bryant, R. 2004. *Imagining the Modern: The Cultures of Nationalism in Cyprus*. London: I. B. Tauris.

———. 2006. 'On the Condition of Postcoloniality in Cyprus', in Y. Papadakis, N. Peristianis and G. Welz (eds), *Divided Cyprus: Modernity And An Island In Conflict*. Bloomington: Indiana University Press, pp. 47–65.

Bryant, R. and Y. Papadakis (eds). 2012. *Cyprus and the Politics of Memory: History, Community and Conflict*. London: I. B. Tauris.

Burawoy, M. 2000. 'Introduction: Reaching for the Global', in M. Burawoy, J. A. Blum, S. George, Z. Gille and M. Thayer (eds), *Global Ethnography: Forces, Connections, and Imaginations in a Postmodern World*. Berkeley: University of California Press, pp. 1–40.

———. 2003. 'Revisits: An Outline of a Theory of Reflexive Ethnography', *American Sociological Review* 68: 64579.

Busch, L. 2011. *Standards: Recipes for Reality*. Cambridge, M.A.: MIT Press.

Cégarra, M. and F. Verdeaux. 2005. 'Introduction', in L. Bérard, M. Cegarra, M. Djama, S. Louafi, P. Marchenay, B. Roussel and F. Verdeaux (eds), *Biodiversity and Local Ecological Knowledge in France*. Paris: INRA and CIRAD, pp. 19–26.

Charalambous, G. 2014. *Political Culture and Behaviour in the Republic of Cyprus during the Crisis*. PCC Report2/2014. Nicosia: PRIO Cyprus Centre.

Christodoulides, Z. 2014. 'Battle of the Benches', *Cyprus Mail*, 6 April. Retrieved 6 April 2014 from http://cyprus-mail.com/2014/04/06/the-battle-of-the-benches/

Christodoulou, D. 1992. *Inside the Cyprus Miracle: The Labours of an Embattled Mini-Economy*. A Modern Greek Studies Yearbook Supplement. Minneapolis: University of Minnesota.

Christou, O., C. Ioannou and A. Shekeris. 2013. *Social Cohesion and the State in Times of Austerity: Cyprus*. Berlin: Friedrich-Ebert-Stiftung. Retrieved 10 January 2014 from http://library.fes.de/pdf-files/id/10424.pdf

Christou, S. 2009. 'The Akamas Conflict: Stakeholders' Environmental Ethics and Their Perspectives on the Proposed Environmental Conservation Plan', master's thesis. London: University College London.

Clerides, S. and N. Pashourtidou. 2007. 'Tourism in Cyprus: Recent Trends and Lessons from the Tourist Satisfaction Survey', *Cyprus Economic Policy Review* 1(2): 51–72.

'Conservation Management Plan for the Akamas Peninsula (Cyprus)'. 1995. Mediterranean Environmental Technical Assistance Program (METAP), World Bank, UNDP, CEC. Prepared by GEOMER, France and IPS, Cyprus, in September 1995.

Constantinou, C., O. Demetriou and M. Hatay. 2012. 'Conflicts and Uses of Cultural Her-
itage in Cyprus', *Journal of Balkan and Near Eastern Studies* 14(2): 177–98.
Constantinou, C. and M. Hatay 2010. 'Cyprus, Ethnic Conflict and Conflicted Heritage',
Ethnic and Racial Studies 33(9): 1600–19.
Convention on the Conservation of European Wildlife and Natural Habitats. 2014. 'Appli-
cation of the Convention – Summary of Case Files and Complaints', Standing Com-
mittee, 34th Meeting, Strasbourg, 2–5 December 2014. Retrieved 14 June 2014 from
https://wcd.coe.int/
Cook, I. and P. Crang. 1996. 'The World on a Plate: Culinary Culture, Displacement and
Geographical Knowledges', *Journal of Material Culture* 1: 131–53.
Creditt, E. 2009. 'Terroir vs. Trademarks: The Debate over Geographical Indications and
Expansions to the TRIPS Agreement', *Vanderbilt Journal of Entertainment and Technol-
ogy Law* 11(2): 425–59.
Crick, M. 1989. 'Representations of International Tourism in the Social Sciences', *Annual
Review of Anthropology* 18: 307–44.
Cyprus Conservation Foundation. 2000. 'A Development Project for the Area of the Ezousa
and Xeros Rivers: Landscape Assessment', typescript of unpublished report, Limassol.
Cyprus Tourism Organisation. 2012. 'Accommodation Industry Capacity Statistics
2010/2011. Retrieved 21 December 2012 from www.visitcyprus.com
Dalsgaard, S. 2013. 'The Field as a Temporal Entity and the Challenges of the Contempo-
rary', *Social Anthropology* 21(2): 213–25.
Demetriou, O. 2007. 'Freedom Square: The Unspoken of a Divided City', *Hagar: Studies
in Culture, Polity and Identities* 7: 55–77.
———. 2012. 'The Militarization of Opulence: Engendering a Conflict Heritage Site', *Inter-
national Feminist Journal of Politics* 14(1): 1–22.
———. 2013a. 'Crisis as a Political Tool in Cyprus: Contextualizing the Politics of Crisis',
Anthropology News. Retrieved 20 July 2014 from http://www.anthropology-news.org/
index.php/2013/06/11/the-order-of-crisis.
———. 2013b. 'A Cultural Reading of the Cyprus Crisis', openDemocracy, 15 April. Re-
trieved 10 January 2014 from http://www.opendemocracy.net
Demetropoulos, A., L. Leontiades and A. Pissarides. 1986. *The Akamas Wilderness: A Re-
port on Akamas with Proposals for Its Conservation*. Nicosia: Ministry of Agriculture
and Natural Resources.
Department of Town Planning and Housing. 2004. *Journey to the Past, Visions for the Fu-
ture*, trans. Sevina Zesimou. European Heritage Days 2004. Nicosia: Ministry of the
Interior.
——— (ed.). 2012. *Preserving the Architectural Heritage of Cyprus*. Nicosia: Ministry of the
Interior.
DeSoucey, M. 2010. 'Gastronationalism: Food Traditions and Authenticity Politics in the
European Union', *American Sociological Review* 75(3): 432–55.
Dikomitis, L. 2012. *Cyprus and Its Places of Desire: Cultures of Displacement among Greek
and Turkish Cypriot Refugees*. London: I. B. Tauris.
Doyle, R. 2013. 'In Cyprus, a New Spirit Animates the Capital', *New York Times*, 28 No-
vember. Retrieved 28 December 2013 from http://www.nytimes.com/2013/12/01/
travel/in-cyprus-a-new-spirit-animates-the-capital/
Drousiotis, M. 2005. 'Our Haunted Country'. English-language translation of an article
published in *Politis* on 25 April. Retrieved 6 March 2014 from http://www.makarios
.eu/cgibin.

Dunn, E. C. 2004. *Privatizing Poland: Baby Food, Big Business, and the Remaking of Labor.* Ithaca, N.Y.: Cornell University Press.

———. 2005. 'Standards and Person-Making in East Central Europe', in A. Ong and S. Collier (eds), *Global Assemblages: Technology, Politics, and Ethics as Anthropological Problems.* Oxford: Blackwell, pp. 173–93.

Eftychiou, E. 2013. 'Power and Tourism: Negotiating Identity in Rural Cyprus', Ph.D. dissertation. Hull, U.K.: University of Hull.

Eliades, G.S. n.d. *An Illustrated Guide to the Ethnographic Museum.* Paphos.

Enotiades, P. 2001. 'Documentation, Interpretation and Presentation of the Architectural Heritage of Cyprus'. Retrieved 8 April 2014 from http://www.eukn.org/Cyprus/cy_en/E_library/Urban_Environment/Cultural_Heritage/

Erdal, M. 2010. 'The Making of Sovereignty through Changing Property/Land Rights and the Contestation of Authority in Cyprus: From the British Colonial Period to the Present', Ph.D. dissertation. Oxford: Oxford University.

———. 2013. 'The Occupy Buffer Zone Movement', in O. Demetriou (ed.), 'Dedicated to the Memory of Peter Loizos', special issue, *The Cyprus Review* 51(1): 55–80.

Eriksen, T. H. 2004. 'Keeping the Recipe: Norwegian Folk Costumes and Cultural Capital', *Focaal: European Journal of Anthropology* 44: 20–34.

Escobar, A. 1995. *Encountering Development: The Making and Unmaking of the Third World.* Princeton, N.J.: Princeton University Press.

European Commission. 2004. *Guide to Community Regulations 2004*, 2nd ed. Working Document of the Commission Services. European Commission, Directorate-General for Agriculture, Food Quality Policy of the European Union. Retrieved 1 January 2010 from http://ec.europa.eu/agriculture/publi/gi/broch_en.pdf

———. 2007. 'General Provisions on the Structural Funds', Summary of Council Regulation (EC) 1260/99 of 21 June 1999. Retrieved 15 March 2013 from http://europa.eu/legislation_summaries/regional_policy/provisions_and_instruments/l60014_en.htm

———. 2011. 'Details on the New Additions to the Union Lists of Natura 2000 Sites', Press Release MEMO/11/806, Brussels, 21 November. Retrieved 5 March 2012 from http://europa.eu/rapid/press ReleasesAction.d?reference=Memo/11/806

———. 2014. 'Halloumi and Hellim: Application for Protected Designation of Origin', Dossier Number CY/PDO/0005/01241. Retrieved 6 August 2014 from http://ec.europa.eu/agriculture/quality/door/.

———. 2015. 'Environment: Commission asks CYPRUS to respect Habitats Directive', Retrieved 3 May 2015 from http://europa.eu/rapid/press-release_MEMO-15-4871_en.htm

European Parliament. 2009. 'Parliamentary Questions 26 January 2009 E-5395/2009 Answer Given by Mr Dimas on Behalf of the Commission'. Retrieved 11 August 2014 from http://www.europarl.europa.eu/sides/getAllAnswers.do?reference=E-2009-5395&language=DE

———. 2012. 'Parliamentary Question of 8 May 2012 E-004686/2012 Subject: Registering Halloumi Cheese as a Protected Designation of Origin Product'. Retrieved 18 July 2012 from http://www.euoparl.europa.eu/sides/getDoc.do?pubRef=-//

Evans, D. 2012. 'Binning, Gifting and Recovery: The Conduits of Disposal in Household Food Consumption', *Environment and Planning D: Society and Space* 30(6): 1123–37.

Evthyvoulos, A. 1997. 'Plea for Akamas', *Cyprus Weekly*, 24–30 January.

Faustmann, H. 2010. 'Rusfeti and Political Patronage in the Republic of Cyprus', in C. Constantinou (ed.), 'The State of Cyprus: Fifty Years After Independence', special issue, *The Cyprus Review* 22(2): 269–89.

Faustmann, H. and N. Peristianis (eds). 2006. *Britain in Cyprus: Colonialism and Post-Colonialism 1878–2006*. Mannheim: Bibliopolis.

Feagan, R. 2007. 'The Place of Food: Mapping Out the "Local" in Local Food Systems', *Progress in Human Geography* 31: 23–42.

Ferguson, J. 1990. *The Anti-Politics Machine: 'Development', Depoliticization, and Bureaucratic Power in Lesotho*. Cambridge: Cambridge University Press.

———. 2005. 'Anthropology and Its Evil Twin: "Development" in the Constitution of a Discipline', in M. Edelman and A. Haugerud (eds), *The Anthropology of Development and Globalization: From Classical Political Economy to Contemporary Neoliberalism*. Oxford: Blackwell, pp. 140–53.

Ferguson, J. and A. Gupta. 2005. 'Spatializing States: Toward an Ethnography of Neoliberal Governmentality', in J. X. Inda (ed.), *Anthropologies of Modernity: Foucault, Governmentality and Life Politics*. Oxford: Blackwell, pp. 105–31.

Figueiredo, E. and A. Raschi. 2011. '"Un' immensa campagna avvolta dal verde": Reinventing Rural Areas in Italy Through Tourism Promotional Images', *European Countryside* 1: 1–20.

Filippucci, P. 2004. 'A French Place without Cheese: Problems with Heritage and Identity in Northeastern France', *Focaal: European Journal of Anthropology* 44: 72–86.

Final Selection Report. 2012. Selection of the European Capital of Culture for 2017 in Cyprus, Selection Panel. Nicosia, 14 September. Retrieved 9 August 2014 from http://ec.europa.eu/culture/tools/actions/documents/ecoc/2017/panel-report-cyprus_en.pdf

Fouilleux, E. 2010. 'The Common Agricultural Policy', in M. Cini (ed.), *European Union Politics*, 3rd ed. Oxford: Oxford University Press, pp. 340–57.

Foundation for the Revival of Laona. 1995. *Final Report Laona Project 1989–1994*. Retrieved 10 July 2009 from http://www.conservation.org.cy/laona/laona.htm

Frank, S. 2008. *Der Mauer um die Wette gedenken: Die Formation einer Heritage-Industrie am Berliner Checkpoint Charlie* [Competing for commerating the wall: The formation of a heritage industry at Berlin's Checkpoint Charlie]. Frankfurt: Campus.

General Court of the European Union. 2012. 'Organismos Kypriakis Galaktokomikis Viomichanias vs. OHIM – Garmo (Hellim) 2012. Judgement of 13 June 2012. Case T-534/10'. Retrieved 7 June 2014 from http://eur-lex.europa.eu/legal-content/EN/

Gibbon, P., J. Bair and S. Ponte. 2008. 'Governing Global Value Chains: An Introduction', *Economy and Society* 37(3): 315–38.

Gibbs, P., R. Morphitou and G. Savva. 2004. 'Halloumi: Exporting to Retain Traditional Food Products', *British Food Journal* 106(7): 569–76.

Gieryn, T. 2002. 'What Buildings Do', *Theory and Society* 31(1): 35–74.

Gille, Z. and S. O Riain. 2002. 'Global Ethnography', *Annual Review of Sociology* 28: 271–95.

Giordano, C. 2012. 'The Anthropology of Mediterranean Societies', in U. Kockel, M. Nic Craith and J. Frykman (eds), *A Companion to the Anthropology of Europe*. Oxford: Wiley-Blackwell, pp. 13–31.

Goddard, V. A., J. R. Llobera and C. Shore. 1994. 'Introduction: The Anthropology of Europe', in V. A. Goddard, J. R. Llobera and C. Shore (eds), *The Anthropology of Europe: Identity and Boundaries in Conflict*. Oxford: Berg, pp. 1–40.

Grasseni, C. 2005. 'Slow Food, Fast Genes: Timescapes of Authenticity and Innovation in the Anthropology of Food', in E. Hirsch and S. Macdonald (eds), 'Creativity or Temporality', special issue, *Cambridge Anthropology* 25(2): 79–94.

Gray, J. 1999. 'Agricultural Policy and the Re-Invention of the Rural in the European Community', *Sociologia Ruralis* 40(1): 30–52.

Gregson N., A. Metcalfe and L. Crewe. 2007. 'Identity, Mobility, and the Throwaway Society', *Environment and Planning D: Society and Space* 25(4): 682–700.

Gronau, W. and R. Kaufmann. 2009. 'Tourism as a Stimulus for Sustainable Development in Rural Areas: A Cypriot Perspective', *Tourismos: An International Multidisciplinary Journal of Tourism* 4(1): 83–95.

Gupta, A. and A. Sharma. 2006. 'Globalization and Postcolonial States', *Current Anthropology* 47(2): 277–307.

Hadjipieris, M., N. Yasin, N. Kizilyurek and G. Kepola. 1995. *Nicosia 1995*. Nicosia.

Hadjisavva, I. 2010. 'National Report Cyprus'. European Heritage Network of the Council of Europe. Retrieved 30 October 2012 from http://www.european-heritage.net/sdx/herein/national_heritage/

Hafstein, V. T. 2007. 'Claiming Culture: Intangible Heritage Inc., Folklore(c), Traditional Knowledge (TM)', in D. Hemme, M. Tauschek and R. Bendix (eds), *Prädikat 'HERITAGE': Wertschöpfungen aus kulturellen Ressourcen*. Berlin: LIT, pp. 75–100.

Halkier, B. and L. Holm. 2006. 'Shifting Responsibilities for Food Safety in Europe: An Introduction', *Appetite* 47: 127–33.

Hannerz, U. 2004. *Foreign News: Exploring the World of Foreign Correspondents*. Chicago: University of Chicago Press.

Hardy, S. 2011. 'Interrogating Archaeological Ethics in Conflict Zones: Cultural Heritage Work in Cyprus', Ph.D. dissertation. Brighton, U.K.: University of Sussex. Retrieved 2 April 2014 from http://sro.sussex.ac.uk/id/eprint/7344

———. 2013. 'Maintained in Very Good Condition or Virtually Rebuilt? Destruction of Cultural Property and Narration of Violent Histories', *Papers from the Institute of Archaeology* 23(1): 1–9.

Hatay, M. 2006. 'The Levantine Legacy of Cypriot Culinary Culture', *The Cyprus Review* 18(2): 129–42.

———. 2008. 'The Problem of Pigeons: Orientalism, Xenophobia and a Rhetoric of the "Local" in North Cyprus', *The Cyprus Review* 20(2): 145–71.

Herzfeld, M. 1985. *The Poetics of Manhood: Contest and Identity in a Cretan Mountain Village*. Princeton, N.J.: Princeton University Press.

———. 1991. *A Place in History: Social and Monumental Time in a Cretan Town*. Princeton, N.J.: Princeton University Press.

———. 2001. *Anthropology: Theoretical Practice in Culture and Society*. Oxford: Blackwell.

———. 2002. 'The Absence Presence: Discourses of Crypto-Colonialism', *The South Atlantic Quarterly* 101(4): 899–926.

———. 2004. *The Body Impolitic: Artisans and Artifice in the Global Hierarchy of Value*. Chicago: University of Chicago Press.

Higgins, A. 2013. 'A Financial Lifesaver Thrown by Creditors Weighs Cyprus Down', *New York Times*, 13 July. Retrieved 2 May 2014 from http://www.nytimes.com/2013/07/14/world/europe/a-financial-lifesaver-thrown-by-creditors-weighs-cyprus-down.html

Hobsbawm, E. 1992. 'Mass-Producing Traditions: Europe, 1870–1914', in E. Hobsbawm

and T. Ranger (eds), *The Invention of Tradition*. Cambridge: Cambridge University Press, pp. 263–307.

Hocknell, P. 2001. 'Contested "Development": A Retrospective of the UN Development Programme in Cyprus', in O. Richmond and J. Ker-Lindsay (eds), *The Work of the UN in Cyprus: Promoting Peace and Development*. New York: Palgrave, pp. 157–91.

Hocknell, P., V. Calotychos and Y. Papadakis. 1998. 'Introduction: Divided Nicosia', *Journal of Mediterreanean Studies* 8(2): 147–68.

Ilcan, S. and L. Phillips. 2008. 'Governing through Global Networks: Knowledge Mobilities and Participatory Development', *Current Sociology* 56: 711–34.

Ioannides, D. 1992. 'Tourism Development Agents: The Cypriot Resort Cycle', *Annals of Tourism Research* 29: 711–31.

Jacobson, D., B. Musyck, S. Orphanides and C. Webster. 2009. *The Opening of Ledra Street/ Lokmaci Crossing: Reactions from Citizens and Shopkeepers*. Nicosia: PRIO Cyprus Centre.

Jannelli, A. 2012. *Wilde Museen: Zur Museologie des Amateurmuseums* [Wild museums: On the museology of amateur museums]. Bielefeld: Transcript Verlag.

Jepson, A. 2006. 'Gardens and the Nature of Rootedness in Cyprus', in Y. Papadakis, N. Peristianis and G. Welz (eds), *Divided Cyprus: Modernity and an Island in Conflict*. Bloomington: Indiana University Press, pp. 158–75.

Kaufmann, H. R., M. Christou and C. Christophorou. 2010. 'Cyprus as EU-Location for Asset-Protection', *The Cyprus Review* 22(1): 107–28.

Kaufmann, R., W. Gronau and S. Sakkadas. 2011. 'Nicosia: Concerted Retailing and Tourism Strategies to Awaken a Neglected and Sleeping Beauty', *Tourismos: An International Multidisciplinary Journal of Tourism* 6(1): 15–29.

Keshishian, K. 1990. *Nicosia: Capital of Cyprus – Then and Now*, 2nd ed. Nicosia: Moufflon Book and Art Centre.

Kirshenblatt-Gimblett, B. 2006. 'World Heritage and Cultural Economics', in I. Karp, C. Kratz and B. Kirshenblatt-Gimblett (eds), *Museum Frictions: Public Cultures/Global Transformations*. Durham, N.C.: Duke University Press, pp. 161–202.

Kirshenblatt-Gimblett, B. and E. M. Bruner. 1989. 'Tourism', in E. Barnouw (ed.), *International Encyclopedia of Communications*. Oxford: Oxford University Press, pp. 249–53.

Kizilyürek, N. 2002. 'Modernity, Nationalism and the Perspectives of a Cypriot Union', *Cahiers d'Études sur la Méditerranée Orientale et le Monde Turco-Iranien* 34: 211–30.

Knight, D. 2013. 'The Greek Economic Crisis as Trope', *Focaal: Journal of Global and Historical Anthropology* 65: 147–59.

Kockel, U., M. Nic Craith and J. Frykman (eds). 2012. *A Companion to the Anthropology of Europe*. Oxford: Wiley-Blackwell.

Köstlin, K. 1998. 'Tourism, Ethnic Food, and Symbolic Values', in P. Lysaght (ed.), *Food and the Traveller: Migration, Immigration, Tourism and Ethnic Food*. Proceedings of the 11th Conference of the International Commission for Ethnological Food Research, Cyprus, 8–14 June 1996. Nicosia: Intercollege Press, pp. 108–14.

Krpata, M. 1997. 'Zypriotische Ethnographica in österreichischen Sammlungen', in *Das Blatt im Meer: Zypern in österreichischen Sammlungen*, Kittseer Schriften zur Volkskunde 8. Kittsee: Selbstverlag des Österreichischen Museums für Volkskunde, pp. 169–252.

Kuutma, K. 2012. 'Between Arbitration and Engineering: Concept and Contingencies in the Shaping of Heritage Regimes', in R. Bendix, A. Eggert and A. Peselmann (eds), *Heritage Regimes and the State*. Göttingen: Universitätsverlag Göttingen, pp. 21–36.

Latour, B. 2004. 'Why Has Critique Run Out of Steam? From Matters of Fact to Matters of Concern', *Critical Inquiry* 30(2): 225–48.

Lefebvre, H. (1967) 1996. 'The Right to the City', in E. Kofman and E. Lebas (eds), *Writings on Cities*. London: Blackwell, pp. 63–184.

Leitch, A. 2003. 'Slow Food and the Politics of Pork Fat: Italian Food and European Identity', *Ethnos* 68(4): 437–62.

Lengwiler, M. and S. Beck. 2008. 'Historizität, Materialität und Hybridität von Wissenspraxen: Die Entwicklung europäischer Präventionsregime im 20. Jahrhundert', *Geschichte und Gesellschaft* 33(4): 489–523.

Lenz, R. 2010. *Mobilitäten in Europa: Migration und Tourismus auf Kreta und Zypern im Kontext des europäischen Grenzregimes*. Wiesbaden: VS Verlag.

Licciardi, G. and R. Amirtahmasebi (eds). 2012. *The Economics of Uniqueness: Investing in Historic City Cores and Cultural Heritage Assets for Sustainable Development*. Washington D.C.: World Bank.

Löfgren, O. 1999. 'The Mediterranean in the Age of the Package Tour', in *On Holiday: A History of Vacationing*. Berkeley: University of California Press, pp. 155–209.

Loizidou, X. n.d. 'High Monetary Land Value and Non-consultation with Locals as Major Problems for Implementing a "Protected Area" Regime in Potential Tourism Destinations, Akamas Area – CY', European Commission: Integrated Coastal Zone Management Database. Retrieved 13 June 2014 from http://ec.europa.eu/ourcoast/

Loizos, P. 1975. *The Greek Gift: Politics in a Cypriot Village*. Oxford: Blackwell.

———. 1981. *The Heart Grown Bitter: A Chronicle of Cypriot War Refugees*. Cambridge: Cambridge University Press.

———. 1998. 'How Might Turkish and Greek Cypriots See Each Other More Clearly?', in V. Calotychos (ed.), *Cyprus and Its People: Nation, Identity, and Experience in an Unimaginable Community, 1955–1997*. Boulder, C.O.: Westview Press, pp. 35–52.

———. 2008. *Iron in the Soul: Displacement, Livelihood, and Health in Cyprus*. Studies in Forced Migration 23. New York: Berghahn Books.

Loizou Hadjigavriel, L. and R. C. Severis 1998. 'Magda Ohnefalsch-Richter', in *In the Footsteps of Women: Peregrinations in Cyprus*. Nicosia: Leventis Municipal Museum and Popular Bank Cultural Centre, pp. 200–4.

Lorimer, J. 2006. 'What About the Nematodes? Taxonomic Partialities on the Scope of UK Biodiversity Conservation', *Social and Cultural Geography* 7: 539–58.

Macdonald, S. 2003. 'Museums, National, Postnational and Transcultural Identities', *Museum and Society* 1(1): 1–16.

———. 2006. 'Collecting Practices', in S. Macdonald (ed.), *Companion to Museum Studies*. Oxford: Blackwell, pp. 81–97.

———. 2009. *Difficult Heritage: Negotiating the Nazi Past in Nuremberg and Beyond*. London: Routledge.

———. 2012. 'Presencing Europe's Pasts', in U. Kockel, M. Nic Craith and J. Frykman (eds), *A Companion to the Anthropology of Europe*. Oxford: Wiley-Blackwell, pp. 233–53.

———. 2013. *Memorylands: Heritage and Identity in Europe Today*. London: Routledge.

Macnaghten, P. and J. Urry. 1998. *Contested Natures*. Thousand Oaks, C.A.: Sage.

Malmberg, A. and P. Maskell 2002. 'The Elusive Concept of Localization Economies: Towards a Knowledge-Based Theory of Spatial Clustering', *Environment and Planning A* 43(3): 429–49.

Marcus, G. 1995. 'Ethnography in/of the World System: The Emergence of Multi-sited Ethnography', *Annual Review of Anthropology* 24: 95–117.

————. 2009. 'Introduction: Notes toward an Ethnographic Memoir of Supervising Graduate Research through Anthropology's Decades of Transformation', in G. Marcus and J. Faubion (eds), *Fieldwork Is Not What It Used to Be: Learning Anthropology's Method in a Time of Transition*. Ithaca, N.Y.: Cornell University Press, pp. 1–34.

Markides, K., E. Nikita and E. Rangou. 1978. *Lysi: Social Change in a Cypriot Village*. Nicosia: Publications of the Social Science Research Centre.

Mattioli, F. 2013. 'The Property of Food: Geographical Indication, Slow Food, Genuino Clandestino and the Politics of Property', in H. Jönsson (ed.), 'Foodways Redux', special issue, *Ethnologia Europaea* 43(2): 47–61.

Mavrommatis, Y. and S. Sokratous (eds). 2007. *Cyprus Yearbook of Rural Development 2007*. Nicosia: Cyprus Institute for Rural and Regional Development.

Mavrou, M., A. Pitta, P. Papantoniou and N. Neophytou. 2012. παραδοσιακά τουριστικά καταλύματα στην ύπαιθρο ΕΠΙΠΛΩΣΗ ΕΞΟΠΛΙΣΜΟΣ. [Traditional Tourist Accommodation in the Countryside: Furnishings and Equipment], Nicosia: Pancyprian Organisation of Architectural Heritage.

May, S. 2013. 'Cheese, Commons and Commerce: On the Politics and Practices of Branding Regional Food', in H. Jönsson (ed.), 'Foodways Redux', special issue, *Ethnologia Europaea* 43(2): 62–77.

McCann, E. and K. Ward. 2011. 'Introduction – Urban Assemblages: Territories, Relations, Practices, and Power', in E. McCann and K. Ward (eds), *Mobile Urbanism: Cities and Policymaking in the Global Age*. Minneapolis: University of Minnesota Press, pp. xiii–xxxv.

Memorandum of Understanding. 2013. MoE on Specific Economic Policy Conditionality. Retrieved 28 April 2014 from http://www.mof.gov.cy/mof/mof.nsf/final%20MOUf.pdf

Meskell, L. 2002. 'Negative Heritage and Past Mastering in Archaeology', *Anthropological Quarterly* 75(3): 557–74.

Michaelidou, M. and D. J. Decker. 2003. 'European Union Policy and Local Perspectives: Nature Conservation and Rural Communities in Cyprus', *The Cyprus Review* 15(2): 121–45.

Mignolo, W. 2000. *Local Histories/Global Designs: Coloniality, Subaltern Knowledges, and Border Thinking*. Princeton, N.J.: Princeton University Press.

Morgan, T. 2010. *Sweet and Bitter Island: A History of the British in Cyprus*. London: I. B. Tauris.

Mowforth, M. and I. Munt. 1998. *Tourism and Sustainability: New Tourism in the Third World*. London: Routledge.

Nadvi, K. 2008. 'Global Standards, Global Governance and the Organization of Global Value Chains.' *Journal of Economic Geography* 8: 323–43.

Navaro-Yashin, Y. 2012. *The Make-Believe Space: Affective Geography in a Postwar Polity*. Durham, N.C.: Duke University Press.

Nicolaou, N. 1980. *Gerichte aus Zypern, der Insel der Aphrodite* [Meals from Cyprus, the island of Aphrodite]. Nicosia.

Niewöhner, J. and S. Beck. 2009. 'Localising Genetic Testing and Screening in Cyprus and Germany: Contingencies, Continuities, Ordering Effects and Bio-cultural Intimacy', in P. Atkinson, P. Glasner and M. Lock (eds), *The Handbook of Genetics and Society: Mapping the New Genomic Era*. London: Routledge, pp. 76–93.

Numan, I. and O. Dincyurek. 2005. 'The Transformation Opportunities of Cypriot Vernacular Houses under the Scope of Tourism', paper presented at the 33rd IAHS

World Congress on Housing, 'Transforming Housing Environments through Design', 27–30 September, Pretoria, South Africa. Retrieved 28 February 2014 from http:// repository.up.ac.za/

Nützenadel, A. and F. Trentmann. 2008. 'Mapping Food and Globalization', in A. Nützenadel and F. Trentmann (eds), *Food and Globalization: Consumption, Markets and Politics in the Modern World*. Oxford: Berg, pp. 1–16.

Officer, D. and Y. Taki. 2013a. *The State We Are In*. Nicosia: University of Nicosia Press.

———. 2013b. 'Troika Shock Therapy Has Killed Our Opportunistic Economic Model', *Cyprus Mail*, 24 March. Retrieved 25 March 2013 from http://cyprus-mail.com/econo mic/troika-shock-therapy-has-killed-our-opportunistic-economic-model/20130324

Ohnefalsch-Richter, M. 1913. *Griechische Sitten und Gebräuche auf Cypern*. Berlin: Dietrich Reimer Verlag.

Öktem, K. 2010. 'The Ambivalent Sea: Regionalizing the Mediterranean Differently', in D. Bechev and K. Nicolaidis (eds), *Mediterranean Frontiers: Borders, Conflict and Memory in a Transnational World*. London: I. B. Tauris, pp. 15–34.

Osam, N. and M. K. Kasapoğlu. 2010. 'Hellim: Kültürel Bir Değerin Kimlik Çözümlemesi', *Milli Folklor Dergisi* [National Folklore Journal]. 87:170–180. Retrieved 13 August 2014 from http://www.millifolklor.com

Pantelides, A. 2011. 'A Boozy Boost to Tourism', *Cyprus Mail*, 29 November. Retrieved 4 August 2014 from http://archives.cyprus-mail.com/2011/11/29/a-boozy-boost-to-tourism/

Papadakis, Y. 1993. 'The Politics of Memory and Forgetting in Cyprus', *Journal of Mediterranean Studies* 3(1): 139–54.

———. 1998. 'Walking in the Hora: "Place" and "Non-Place" in Divided Nicosia', *Journal of Mediterranean Studies* 2: 302–27.

———. 2004. 'Cyprus Delights', in *15 + 10: European Identities*, Kataloge des Österreichischen Museums für Volkskunde 84, Vienna: Österreichisches Museum für Volkskunde, pp. 86–89.

———. 2005. *Echoes from the Dead Zone: Across the Cyprus Divide*. London: I. B. Tauris.

———. 2006. 'Disclosure and Censorship in Divided Cyprus: Towards an Anthropology of Ethnic Autism', in Y. Papadakis, N. Peristianis and G. Welz (eds), *Divided Cyprus: Modernity, History, and an Island in Conflict*. Bloomington: Indiana University Press, pp. 66–83.

Papadakis, Y., N. Peristianis and G. Welz. 2006. 'Introduction', in Y. Papadakis, N. Peristianis and G. Welz (eds), *Divided Cyprus: Modernity, History, and an Island in Conflict*. Bloomington: Indiana University Press, pp. 1–29.

Papademas, P. and R. K. Robinson. 2000. 'A Comparison of the Chemical, Microbiological and Sensory Characteristics of Bovine and Ovine Halloumi Cheese', *International Dairy Journal* 10(11): 761–68.

———. 2001. 'The Sensory Characteristics of Different Types of Halloumi Cheese as Perceived by Tasters of Different Ages', *International Journal of Dairy Technology* 54(3): 94–99.

Partnership for the Future. 2013. 'Support to Cultural Heritage Monuments of Great Importance for Cyprus – Phase 1', UNDP. Retrieved 21 June 2014 from http://www .cy.undp.org/content/cyprus/en/home/operations/projects/partnershipforthefuture/

Patapiou, N. 2006. 'Leonardo Donà in Cyprus: A Future Doge in the Karpass Peninsula (1557)', *Cyprus Today: A Quarterly Cultural Review of the Ministry of Education and*

Culture, April–June, pp. 3–18. Retrieved June 6 2014 from http://www.pio.gov.cy/moi/pio/pio.nsf/

Patel, K. K. (ed.). 2009. *Fertile Ground for Europe? The History of European Integration and the Common Agricultural Policy since 1945*. Baden-Baden: Nomos.

———. 2013. 'Integration through Expertise: Transnational Experts in European Cultural Policies', in K. K. Patel (ed.), *The Cultural Politics of Europe: European Capitals of Culture and European Union since the 1980s*. London: Routledge, pp. 72–92.

Peristiany, J. G. 1965. 'Honour and Shame in a Cypriot Highland Village', in J. G. Peristiany (ed.), *Honour and Shame*. London: Weinfeld & Nicholson, pp. 171–90.

Philokyprou, M. and A. Michael. 2012. 'Evaluation of Environmental Features of Vernacular Architecture: A Case Study of Cyprus', paper presented at the event Progress in Cultural Heritage Preservation EUROMED 2012. Retrieved 28 February 2014 from http://www.cut.ac.cy/euromed2012proceedings/shortPapers/349.pdf

Phocas, C. 1997. 'Case Study: The Pitsilia Integrated Rural Development Project', in A. Nikolaidis, G. Baourakis and E. Stamataki (eds), Development of Mountainous Regions. *Cahiers Options Méditerranéennes* 28: 91–112.

Pott, A. 2007. *Orte des Tourismus: Eine raum- und gesellschaftstheoretische Untersuchung* [Places of tourism: A study in spatial and social theory]. Bielefeld: Transcript Verlag.

Pratt, J. 2007. 'Food Values: The Local and the Authentic', *Critique of Anthropology* 27: 285–300.

Pre-Selection Report. 2011. Designation of the European Capital of Culture 2017 Selection Panel. Nicosia, December. Retrieved 9 August 2014 from http://ec.europa.eu/culture/tools/actions/documents/ecoc/2017/preselection-report-cyprus_en.pdf

Press and Information Office. 1999. 'Agro-tourism in Cyprus', *Cyprus Today*, March. Retrieved 7 October 1999 from www.pio.gov.cy/cyprus_today/jan_mar1999/Agro-tourism.htm

———. 2012. *The Loss of a Civilization*. PIO 378/2012 (English) Republic of Cyprus. Retrieved 28 February 2014 from www.moi.gov.cy/pio

PRIO (Peace Research Institute of Norway). 2011. 'Internal Displacement in Cyprus: Mapping the Consequences of Civil and Military Strife', Peace Research Institute of Norway, Nicosia office. Retrieved 25 February 2014 from http://www.prio-cyprus-displacement.net.

Psillides, C., 'EU takes up the turtle fight', *Cyprus Mail* 10 May 2015. Retrieved 10 May 2015 from http://cyprus-mail.com/2015/05/10/eu-takes-up-the-turtle-fight/.

Radaelli, C. 2004. 'Europanisation: Solution or Problem?', *European Integration Online Papers* 8(16). Retrieved 22 January 2013 from http://eiop.or.at/eiop/texte/2004-016a.htm

Reguant-Aleix, J. and F. Sensat. 2012. 'The Mediterranean Diet, Intangible Cultural Heritage of Humanity', in International Centre for Advanced Mediterranean Agronomic Studies (CIHEAM) (ed.), *Mediterra 2012: The Mediterranean Diet for Sustainable Regional Development*. Paris: Presses de Sciences Po, pp. 465–84.

Riles, A. 2001. *The Network Inside Out*. Ann Arbor: University of Michigan Press.

——— (ed.). 2006. *Documents: Artifacts of Modern Knowledge*. Ann Arbor: University of Michigan Press.

Rizopoulou-Egoumenidou, E. 2002. 'From the Grape to the Vat: Traditional Buildings and Installations for the Production and Storage of Wine in Cyprus (18th–20th c.)', *Douro: Estudos & Documentos* 7(13): 135–42.

———. 2007. 'La table traditionelle chypriote', in J. Bonnet-Carbonell and L. S. Fournier (eds), *Peurs et risque au coeur de la fête*. Paris: L'Harmattan, pp. 59–76.

———. 2008. 'Le petit patrimoine: Un lien de communication et de rapprochement entre Chypriotes grecs et turcs', in L. S. Fournier (ed.), *Le 'petit patrimoine' des Europeens: Objets et valeurs du quotidian*. Paris: L'Harmattan, pp. 101–10.

———. 2012. 'Conclusion', in E. Rizopoulou-Egoumenidou and A. Damdelen (eds), *Turkish Cypriot Dress: The Aziz Damdelen Collection*. Nicosia: Ministry of Education and Culture, Cultural Services.

Römhild, R. 2009. 'Reflexive Europäisierung: Tourismus, Migration und die Mediterranisierung Europas', in G. Welz and A. Lottermann (eds), *Projekte der Europäisierung Kulturanthropologische Forschungsperspektiven*. Frankfurt: Kulturanthropologie Notizen, pp. 261–76.

Sant Cassia, P. 2005. *Bodies of Evidence: Burial, Memory and the Recovery of Missing Persons in Cyprus*. New York: Berghahn Books.

Scott, D. 2006. 'Socialising the Stranger: Hospitality as a Relational Reality', master's thesis. Dunedin, New Zealand: University of Otago.

Scott, J. 2005. 'Imagining the Mediterranean', *Journal of Mediterranean Studies* 15(2): 219–43.

Scott, J. and T. Selwyn (eds). 2011. *Thinking through Tourism*. Oxford: Berg.

Searle, J. R. 2010. *Making the Social World: The Structure of Human Civilization*. Oxford: Oxford University Press.

Seifarth, K. 2006. 'Arts and Politics – A Contradiction? Research Report', Institute of Cultural Anthropology and European Ethnology Johann Wolfgang Goethe University, Frankfurt, Field Research Course 2005–6 'New Europeans: Cyprus after EU Accession'. Retrieved 21 June 2014 from http://luke.uni-frankfurt.de/lehrforschungsprojekte/ neueeuropaeer/wp/wp.html

———. 2009. 'Die gescheiterte "Manifesta 6" in Nicosia: Eine europäische Kunstbiennale im Spannungsfeld zwischen lokalen Konflikten und internationalen Ansprüchen', in G. Welz and A. Lottermann (eds), *Projekte der Europäisierung: Kulturanthropologische Forschungsperspektiven*. Frankfurt: Kulturanthropologie Notizen, pp. 35–52.

Selwyn, T. 2004. 'Privatising the Mediterranean Coastline', in J. Boissevain and T. Selwyn (eds), *Contesting the Foreshore: Tourism, Society, and Politics on the Coast*. MARE Publication Series 2. Amsterdam: Amsterdam University Press, pp. 35–60.

Seremetakis, N. 1994. *The Senses Still: Perception and Memory as Material Culture in Modernity*. Chicago: University of Chicago Press.

Shore, C. 2000. *Building Europe: The Cultural Politics of European Integration*. London: Routledge.

Silva, L. 2011. 'Beneath the Surface of the Heritage Enterprise: Governmentality and Cultural Representation of Rural Architecture', *Ethnologia Europaea* 41(2): 39–53.

Skrydstrup, M. 2009. 'Theorizing Repatriation', in R. Bendix and V. T. Hafstein (eds), 'Culture and Property', special issue, *Ethnologia Europaea* 39(2): 54–66.

Smith, L. 2006. *Uses of Heritage*. London: Routledge.

Staiger, U. 2013. 'The European Capitals of Culture in Context: Cultural Policy and the European Integration Process', in K. K. Patel (ed.), *The Cultural Politics of Europe: European Capitals of Culture and European Union since the 1980s*. London: Routledge, pp. 19–38.

Statistical Service of the Republic of Cyprus. 2013. 'Cyprus External Trade Statistics 2012

– Volume II: Imports/Arrivals by Commodity and Country (Sections X–XV)', *Foreign Trade Statistics*, series 1, report 9. 2013. Retrieved 6 June 2014 from http://www.mof.gov.cy/mof/cystat/statistics.nsf/

———. 2014. 'Latest Figures: Registered Unemployed', March. Retrieved 28 April 2014 from http://www.mof.gov.cy/mof/cystat/statistics.nsf/

Structural Funds Programming Document: Objective 2 Areas 2004–2006. n.d. Nicosia.

Sutton, D. 2001. *Remembrance of Repasts: An Anthropology of Food and Memory*. Oxford: Berg.

Sycallides, G. 2004a. *Flaouna-Pilavuna: A Common Pastry for Greek Cypriots and Turkish Cypriots*. Documentary film prepared for the NGO Eurotoques, Cyprus office. Nicosia: Intercollege Radio and TV Unit.

———. 2004b. *Halloumi-Hellim: The Indigenous Cheese of Cyprus*. Documentary film prepared for the NGO Eurotoques, Cyprus office. Nicosia: Intercollege Radio and TV Unit.

Tauschek, M. 2012. 'The Bureaucratic Texture of National Patrimonial Policies', in R. Bendix, A. Eggert and A. Peselmann (eds), *Heritage Regimes and the State*. Göttingen: Universitätsverlag Göttingen, pp. 195–212.

Terra Cypria. 2011. 'Conservation of the Akamas and Limni Areas in Western Cyprus'. Document prepared by Terra Cypria for the Convention on the Conservation of European Wildlife and Natural Habitats, Standing Committee, 31st Meeting, Strasbourg, 29 November–2 December 2011, T-PVS/Files (2011) 24. Retrieved 14 June 2014 from https://wcd.coe.int/

———. 2013. 'Specific Site – File Open: Akamas Peninsula (Cyprus)'. Document prepared by Terra Cypria for the Convention on the Conservation of European Wildlife and Natural Habitats, Standing Committee, 33rd meeting, Strasbourg, 3–6 December 2013, T-PVS/Files (2013) 48. Retrieved 13 June 2014 from https://wcd.coe.int/

The Steni Museum of Village Life. 2008. Paphos.

Theodossopoulos, D. 1997. 'Turtles, Farmers, and "Ecologists": The Cultural Reason Behind a Community's Resistance to Environmental Conservation', *Journal of Mediterranean Studies* 7(2): 250–67.

———. 2002. *Troubles with Turtles: Cultural Understandings of the Environment on a Greek Island*. New York: Berghahn Books.

———. 2013. 'Infuriated with the Infuriated? Blaming Tactics and Discontent about the Greek Financial Crisis', *Current Anthropology* 54(2): 200–21.

Thompson, C. 2002. 'When Elephants Stand for Competing Philosophies of Nature: Amboseli National Park, Kenya', in J. Law and A. Mol (eds), *Complexities: Social Studies of Knowledge Practices*. Durham, N.C.: Duke University Press, pp. 166–90.

Trigeorgis-Hadjipavlou, M. 1998. 'Different Relationships to the Land: Personal Narratives, Political Implications and Future Possibilities', in V. Calotychos (ed.), *Cyprus and Its People: Nation, Identity, and Experience in an Unimaginable Community, 1955–1997*. Boulder, C.O.: Westview Press, pp. 251–76.

Trimikliniotis, N. and C. Demetriou. 2012. *Legal Framework in the Republic of Cyprus*, report 3, *Displacement in Cyprus*. A research project of the Peace Research Institute of Oslo (PRIO), Nicosia. Retrieved 25 February 2014 from http://www.prio-cyprus-displacement.net

Trouillot, M.-R. 2001. 'The Anthropology of the State in the Age of Globalization: Close Encounters of the Deceptive Kind', *Current Anthropology* 42(1): 125–38.

Tschofen, B. 2008. 'On the Taste of the Regions: Culinary Praxis, European Politics and Spatial Culture – A Research Outline', *Anthropological Journal of European Cultures* 17(1): 24–53.

Tsing, A. L. 2001. 'Nature in the Making', in C. Crumley (ed.) with E. van Deventer and J. Fletcher, *New Directions in Anthropology and Environment: Intersections*. Walnut Creek, C.A.: Altamira Press, pp. 3–23.

———. 2005. *Friction: An Ethnography of Global Connection*. Princeton, N.J.: Princeton University Press.

UNESCO. 2010. *Mediterranean Diet Nomination File No. 00394*. Inscription on the Representative List of the Intangible Cultural Heritage. Retrieved 6 June 2014 from http://www .unesco.org/culture/ich/RL/00394

———. 2013. *Mediterranean Diet Nomination File 00884*. Inscription on the Representative List of the Intangible Cultural Heritage. Retrieved 6 June 2014 from http://www.unesco .org/culture/ich/en/RL/00884

Urry, J. 1990. *The Tourist Gaze: The Tourist Gaze – Leisure and Travel in Contemporary Societies*. Thousand Oaks, C.A.: Sage.

Vos, C. 2013. 'The Ideals and Pragmatics of European Heritage: The Policy and Practice of the Regional Heritage Programme in Serbia', in K. K. Patel (ed.), *The Cultural Politics of Europe: European Capitals of Culture and European Union since the 1980s*. London: Routledge, pp. 179–97.

Welch-Devine, M. 2008. 'From Common Property to Co-management: Implementing Natura 2000 in Soule', Ph.D. dissertation. Athens: University of Georgia.

Welz, G. 1999. 'Beyond Tradition: Anthropology, Social Change, and Tourism in Cyprus', *The Cyprus Review* 11(2): 11–22.

———. 2000. '"Wo sich neun sattessen, werden auch zehn besiegt" – Das Mesedessyndrom: Mutationen einer nahrungskulturellen Praxis' [Where nine are sated, ten can be defeated' – the mesedes syndrome: Mutations of a food cultural practice], in *Volkskultur und Moderne: Europäische Ethnologie zur Jahrtausendwende – Festschrift für Konrad Köstlin zum 60. Geburtstag am 8. Mai 2000*. Vienna: Institut für Europäische Ethnologie der Universität Wien, pp. 169–78.

———. 2001. '"One leg in the past, and one leg in the future". Diskurse einer Übergangsgesellschaft [Discourses of a society in transition] in G. Welz and P. Ilyes (eds), *Zypern: Gesellschaftliche Öffnung, europäische Integration, Globalisierung* [Cyprus: Liberalising society, European integration, globalisation]. Frankfurt: Kulturanthropologie Notizen, pp. 225–43.

———. 2002. 'Siting Ethnography: Some Observations on a Cypriot Highland Village', in I.-M. Greverus, S. Macdonald, R. Römhild, G. Welz and H. Wulff (eds), 'Shifting Grounds: Experiments in Doing Ethnography', special issue, *Anthropological Journal on European Cultures* 11: 137–58.

———. 2004. 'Cyprus Meze: Transformations of a Local Culinary Practice in the Context of Tourism', in Cyprus Tourism Organisation (ed.), *Local Food & Tourism International Conference*. Nicosia and Madrid: World Tourism Organization, pp. 39–48.

———. 2005. 'Ethnografien europäischer Modernen' [Ethnographies of European modernities], in B. Binder, S. Göttsch, W. Kaschuba and K. Vanja (eds), *Ort – Arbeit – Körper: Ethnografie Europäischer Modernen*. Münster: Waxmann, pp. 19–31.

———. 2006a. '"Contested Natures": An Anthropological Perspective on Environmental Conflicts', in Y. Papadakis, N. Peristianis and G. Welz (eds), *Divided Cyprus: Modernity, History and an Island in Conflict*. Bloomington: Indiana University Press, pp. 140–57.

————. 2006b. 'Lokale Tradition, globale Wertschöpfungsketten: Der Agrotourismus-Unternehmer' [Local traditions, global value chains: The agrotourism entrepreneur], in B.-J. Warneken (ed.), *Volksfreunde: Historische Varianten sozialen Engagements*. Tübingen: TVV, pp. 339–48.

————. 2009. 'Eine Chronik des Scheiterns europäischer Umweltpolitik: Der Konflikt um die Halbinsel Akamas in der Republik Zypern' [A chronicle of the demise of European environmental policy: The conflict over the Akamas Peninsula in the Republic of Cyprus], in G. Welz and A. Lottermann (eds), *Projekte der Europäisierung: Kulturanthropologische Fallstudien*. Frankfurt: Kulturanthropologie Notizen, pp. 143–62.

————. 2010. 'Die Herstellung agrotouristischer Tourismusräume: Eine Fallstudie in der Republik Zypern' [The production of tourist spaces in agrotourism: A case study from Cyprus], in K.-H. Wöhler, A. Pott and V. Denzer (eds), *Tourismusräume: Zur soziokulturellen Konstruktion eines globalen Phänomens*. Bielefeld: Transcript Verlag, pp. 143–56.

————. 2012a. 'The Diversity of European Food Cultures', in U. Kockel, M. Nic Craith and J. Frykman (eds), *A Companion to the Anthropology of Europe*. Oxford: Wiley-Blackwell, pp. 355–71.

————. 2012b. 'Regimes of Environmental Governance: A Case Study from Cyprus', in G. Welz, F. Sperling and E. M. Blum (eds), *Negotiating Environmental Conflicts: Local Communities, Global Policies*. Frankfurt: Kulturanthropologie Notizen, pp. 179–202.

————. 2013a. 'Contested Origins: Food Heritage and the European Union's Quality Label Programme', in *Food Culture and Society* 16(2): 265–79.

————. 2013b. 'Halloumi/Hellim: Global Markets, European Union Regulation, and Ethnicized Cultural Property', in O. Demetriou (ed.), 'Dedicated to the Memory of Peter Loizos', special issue, *The Cyprus Review* 51(1): 37–54.

————. 2013c. 'Lefkosia/Lefkoşa: Europeanisation and the Politics of Culture in a Divided City', in K. K. Patel (ed.), *The Cultural Politics of Europe: European Capitals of Culture and European Union since the 1980s*. London: Routledge, pp. 198–216.

Welz, G. and N. Andilios. 2004. 'Modern Methods for Producing the Traditional: The Case of Making Halloumi Cheese in Cyprus', in P. Lysaght and Ch. Burckhardt-Seebass (eds), *Changing Tastes: Food Culture and the Processes of Industrialization*. Basel: Schweizerische Gesellschaft für Volkskunde; Dublin: Department of Irish Folklore, University College Dublin, pp. 217–30.

Welz, G. and P. Ilyes (eds). 2001. *Zypern: Gesellschaftliche Öffnung, europäische Integration, Globalisierung* [Cyprus: Liberalising society, European integration, globalisation]. Frankfurt: Kulturanthropologie Notizen.

Welz, G. and A. Lottermann (eds). 2009. *Projekte der Europäisierung: Kulturanthropologische Forschungsperspektiven* [Projects of Europeanization: Anthropological research perspectives]. Frankfurt: Kulturanthropologie Notizen

Wilk, R. 2011. 'Reflections on Orderly and Disorderly Ethnography', in T. O'Dell and R. Willim (eds), 'Irregular Ethnographies', special issue, *Ethnologia Europaea* 41(1): 15–26.

Wilken, L. 2012. 'Anthropological Studies of European Identity Construction', in U. Kockel, M. Nic Craith and J. Frykman (eds), *A Companion to the Anthropology of Europe*. Oxford: Wiley-Blackwell, pp. 125–44.

Wöhler, K.-H., A. Pott and V. Denzer (eds). 2010. *Tourismusräume: Zur soziokulturellen Konstruktion eines globalen Phänomens*. Bielefeld: Transcript Verlag.

Wulff, H. 2002. 'Yo-Yo Fieldwork: Mobility and Time in a Multi-Local Study of Dance in Ireland', in I.-M. Greverus, S. Macdonald, R. Römhild, G. Welz and H. Wulff (eds), 'Shifting Grounds: Experiments in Doing Ethnography', special issue, *Anthropological Journal on European Cultures* 11: 117–36.

Zarkia, C. 1996. 'Philoxenia: Receiving Tourists – But Not Guests – on a Greek Island', in J. Boissevain (ed.), *Coping with Tourists: European Reactions to Mass Tourism*. Oxford: Berg, pp. 143–73.

Index

A

Acquis Communautaire, 7, 151
agriculture, 49, 60–4, 68, 82, 98, 104–5, 118, 120, 124, 130n14
agrotourism, 14, 17n10, 26, 29, 38–56, 64–6, 70, 72n6, 154
Agros (village), 66, 91n9
Akamas (peninsula), 15, 72n6, 115–130, 146, 156, 165
Alona (village), 57–60, 67, 71n2, 71n4, 73n14
Andilios, N., 84, 91n3, 94, 97, 99, 110n7
Appadurai, A., 167n10
archaeology, 11, 34n2, 68
Argyrou, V., 9, 16n4, 83, 88, 125, 164, 165

B

Beck, S., 10, 17, 27, 34, 91, 147, 153, 165, 167
bicommunal, 10, 17n6, 17n8, 35n5, 97, 137, 138, 148n10, 148n17
British colonial administration, 23, 72n8, 79, 132, 140, 153. See also colonial (Cyprus)
Bryant, R., 17n6, 17n11, 58, 147n2, 147n7, 169n23
Burawoy, M., 12, 117

C

Chersonisos Akama (Natura 2000 site), 115, 130n14
Clerides, K., 9, 6n4
colonial (Cyprus), 6–9, 21–23, 55n10, 58, 69, 72n8, 79, 81, 84, 87, 97, 103, 118, 124–25, 131–32, 136, 140, 153, 164–65, 169n23. See also British colonial administration

Common Agricultural Policy (of the European Union), 60–65, 72n6, 98. See also CAP
Council of Europe, 33–4, 36n10, 121–2, 136–7, 148n15, 152, 154
Council of Ministers (Republic of Cyprus), 119, 169n25
crisis (economic, of Cyprus), 89–90, 159–66
CTO, 39–44, 46, 55n4, 55n5, 55n9, 71n3. See also Cyprus Tourism Organisation
Cyprus conflict, 13, 15, 17n11, 24, 35n5–7, 52–4, 56n12, 95, 102, 104, 121, 132–4, 137, 146n2, 149n23, 169n23. See also Cyprus problem
Cyprus Conservation Foundation, 22, 30, 36n12
Cyprus problem, 7, 9, 13, 17, 36, 106, |137, 147n6, 163. See also Cyprus conflict
 solution (of the Cyprus problem), 8–9, 36n9, 106, 137
Cyprus Tourism Organisation, 39–44, 54n1, 55n2, 56n12, 65, 72n4, 72n7, 78–79. See also CTO
CAP, 60–65. See also Common Agricultural Policy (of the European Union)

D

Demetriou, O., 9, 17n11, 35n7, 88, 140, 147n9, 162, 165, 168n20
Department of Town Planning and Housing, 25, 30–2, 35n3, 36n15, 41, 44–5, 65, 72n4, 72n6, 143, 148n14
Dikomitis, L., 17n6, 35n6, 36n9, 97

division
of Cyprus, 6–7, 13–4, 23, 43, 54,
83, 97, 106–7, 131–3, 143
of Nicosia, 12, 15, 131, 141, 144,
146n1

E
ECOC 140–4, 146, 149n22. *See also*
European Capital of Culture
EU accession, 3, 6, 8, 9, 14, 44–5, 63, 79,
94, 98–9, 119, 133, 135, 152
of Cyprus, 9, 13, 33, 44, 45, 79, 94,
98, 113, 128n3, 136, 151
European Parliament, 5, 59, 104, 106,
111n15, 123
European product, 4–6, 13, 15, 19, 34, 69,
71, 150–1, 156
European Commission, 5, 9, 14, 33, 58,
59, 62, 66, 70, 72n8, 72n10, 99–101,
103–6, 108–10, 111n9, 111n10,
111n11, 115–7, 120–3, 129n5, 129n9,
130n14, 136, 140–2, 156, 159, 166,
168n14, 168n15, 169n26
European Capital of Culture, 140–3, 150.
See also ECOC
Europeanization, 2, 4–6, 9, 13–4, 16, 59,
98, 121, 132, 151–4, 157, 159, 167n1

F
Faustmann, H., 6, 169n24
FAO, 61. *See also* Food and Agriculture
Organization (of the United Nations)
Food and Agriculture Organization (of
the United Nations), 61. *See also* FAO
Ferguson, J., 13, 61

G
Green Line, 7, 10, 15, 23, 97–8, 106,
131–38, 144, 147n6, 147n8, 147n9,
148n11, 169n21

H
Hatay, M., 17n11, 83, 97–8, 106, 135–6,
147n9
Hellenism, 7, 148n12
heritage, 1–4, 107–10, 156–59
cultural heritage, 3, 8, 14, 15,
17n11, 23, 33, 64, 67, 71, 72n6,

89, 106, 113, 125, 136, 142,
145, 148n11, 149n19, 164,
167n6
heritage regime, 19, 29, 33, 38, 71
natural heritage, 2, 115, 156
difficult heritage, 3, 52–4, 135
heritagization, 16, 22, 39, 75, 108, 151
Herzfeld, M., 1–2, 29, 61, 73n12, 84–86,
123–25, 165, 168n12
historic preservation, 14, 21–37, 41, 60,
71, 132, 147n3, 148n12, 157

I
immigrants, 8, 17n10, 25, 42, 55n1, 55n7,
94, 139, 142, 144–45, 147n3, 148n13,
149n23
immigration to Cyprus, 16n1,
17n8, 136, 164
independence (of Cyprus), 7–8, 21, 58,
103, 118, 133, 153, 165
post independence Cyprus, 79,
87–88
pre independence Cyprus, 69
invasion (of Cyprus by Turkish troops in
1974) 7, 8, 23–25, 35n7, 35n8, 36n9,
53, 78–80, 97, 118, 131–34, 162
International Bank for Reconstruction
and Development, 61, 72n7

K
Kirshenblatt-Gimblett, B., 1, 33, 51, 77,
90n1, 107, 154
Kritou Tera (village), 21–6, 28, 30, 34n1,
35n6, 36n11

L
Laona (region), 22–24, 26–31, 33, 34n2,
34n3, 36n11, 36n15, 43, 71, 72n6,
90n3
Lefkoşa (Turkish denomination of
Nicosia), 131, 134, 136, 142, 146n1,
169n21
Lefkosia (Greek denomination of
Nicosia), 131–5, 138–9, 141–3,
145–6, 146n1
Limassol, 16n3, 28, 48, 53, 56–8, 72n7,
141, 163
Löfgren, O., 80–81

Loizos, P., 10, 16n2, 16n5, 84, 96–7, 110n5
loukoumi, 97, 110n2

M

Macdonald, S., 3–4, 33, 52–54, 55n8, 68–9, 107, 110n4, 131, 157, 167n11
Manifesta, 138, 148n18
Marcus, G., 11
Master Plan (for the reconstruction of Nicosia), 131, 134–6, 143, 154, 169n21
materiality, 3, 33, 50–1, 54, 70, 77–, 89, 107, 150, 157, 167n11
Ministry of Agriculture (Republic of Cyprus), 104–5, 118, 120, 130n14
Ministry of the Interior (Republic of Cyprus), 30, 32–3, 35n3, 36n14, 41, 72n6, 120, 135–6, 148 n14
modernity, 1, 2, 5, 11, 58, 61, 77, 87, 88, 140, 165, 169n23
modernization, 1, 8, 10, 29, 31, 59, 61, 71, 87, 94, 100

N

nationalism, 22, 84, 93, 132, 147n5, 148n12
Natura 2000 network (of the European Union), 113, 117, 120–1, 125, 128n12, 145, 150. *See also* Natura 2000 site *or* sites.
Natura 2000 site *or* sites, 4, 115–7, 120–3, 127, 128n1, 129n5, 129n7, 130n14, 146, 166, 169n26. *See also* Natura 2000 network.
nature conservation, 3, 4, 11, 15, 62–3, 115–30
Navaro-Yashin, Y., 17, 35–6, 52, 107, 134, 147n9
Nicosia, 7, 10, 12, 15, 17, 21, 28, 31, 35, 44, 55, 57–9, 66, 72, 79, 88, 91, 110, 113, 131–49, 152–4, 159, 161, 165, 167n6

O

OECD, 72n8. *See also* Organisation for Economic Co-operation and Development

Office of Harmonization in the Internal Market (European Union), 93. *See also* OHIM
OHIM 93, 95, 110n1. *See also* Office of Harmonization in the Internal Market (European Union)
Ohnefalsch-Richter, M., 83–4, 91n6, 91n7, 96
old town (of Nicosia), 15, 91n5, 131–49, 154, 159
Organisation for Economic Co-operation and Development, 72n8. *See also* OECD
Ottoman empire, 6, 34n1, 136

P

Papadakis, Y., 14, 17n6, 17n11, 23, 53–4, 97, 98, 110n5, 132–3, 146n2, 147n5, 147n7
Paphos (district), 10, 12, 27, 30, 36n12, 48, 54n1, 72n6, 78, 85, 91n3, 97, 103, 118
Paphos (town), 21, 30, 35n4, 73n11, 80, 82, 118, 141, 142, 149n22
Parliament (Republic of Cyprus), 9, 163, 168n16
past presencing, 3–4, 6, 33, 110n4
Patel, K.P., 72n9, 147n4, 152
PDO, 101–9. *See also* protected designation of origin
Peristianis, N., 6, 14, 91n3, 147n7
PGI 101–8. *See also* protected geographical indication
philoxenia, 42–6, 84–6
Pitsilia (region), 57–60, 62–4, 66, 72n6, 73n14, 91n9
Polis Chrysochous (town), 12, 54n1, 78, 118
postcolonial (Cyprus), 6, 9, 15, 17n7, 22, 34n1, 43, 59, 62, 87, 118, 124, 126, 140, 151–3, 164–5
PRIO, 17n11, 35n6, 56n11. *See also* Peace Research Institute of Oslo
Peace Research Institute of Oslo, 17n11, 35n6, 137. *See also* PRIO
protected designation of origin, 101–109, 159. *See also* PDO
protected geographical indication 101–8, 167n2. *See also* PGI

R

refugees, 7, 16n2, 16n5, 24–5, 35n6, 35n7, 52, 139, 162

Rizopoulou-Egoumenidou, E., 91n3, 91n4, 110n5

rural development, 14, 54n1, 57–73, 152
 Rural Development Programme, 60, 67
 rurality, invention of 14, 64, 70, 71

S

Sant Cassia, P., 53

Second World War, 22, 63, 137, 140, 147n5

Shore, C., 5, 90n2, 141, 164

standardization, 2, 34, 37n17, 71, 82, 137, 151, 154–6

standards, 1, 4, 6, 8, 12, 14, 19, 28, 29, 32–3, 42–3, 47, 55n2, 70, 71, 87, 99, 106, 115, 151–2, 154–6, 158, 164, 167n8

T

Tera (village), 24, 25

Terra Cypria, 122, 129n4, 129n5, 129n8, 130n13

Theodossopoulos, D., 125, 163

Tochni (village), 38, 44, 46–50, 52–3, 54n1, 56n11, 56n14, 66

tourism, 8, 11, 14, 15, 17n10, 22, 26, 38–43, 45–53, 54n1, 55n2, 55n3, 55n7, 56n12, 58–72, 77–92, 113, 116, 118–20, 125–6, 141, 145, 146, 148n19, 149n22, 152, 156–9, 166

Troika, 9, 15, 58, 90, 160–6, 168n15, 168n16, 168n17

Troodos, 17n10, 29, 35n4, 35n12, 48, 57–8, 64, 67, 71n3, 72n6, 73n14, 124

Turkey, 7, 78, 83, 94, 95, 106, 147n5

Turkish Republic of North Cyprus, 14, 17n6, 131

Turkish Cypriot village, 149n21, 25, 36n9, 142, 165

U

UN, 7, 24, 35n5, 35n6, 133–37, 148n9. *See also* United Nations

United Nations Education Science and Culture Organization, 23. *See also* UNESCO

United Nations 7, 21–23, 51, 53, 61, 131, 134, 135, 137, 148n10. *See also* UN

University of Nicosia, Endnote 17n7, 55n1, 91n3, 169n24

Urry, J., 4, 67, 69, 70

USAID 137, 148n10. *See also* United States Agency for International Development

United States Agency for International Development, 137. *See also* USAID

UNESCO 23, 35n4, 51, 89, 91n9, 142, 154. *See also* United Nations Education Science and Culture Organization

V

Venetian walls, 15, 131–2, 139–40, 143–4, 154, 159, 161

vernacular architecture, 14, 21–2, 25–7, 31–2, 35n3, 36n11, 36n15

Vos, C., 137, 148n15

W

Welch-Devine, M., 116, 121, 127

World Bank Plan (for the Akamas peninsula), 119–20, 123, 128n4

World Bank, 59–62, 145

World Heritage (UNESCO designation), 23, 35n4, 89, 93n9, 142

World Intellectual Property Organization, 101. *See also* WIPO

WTO, 101. *See also* World Trade Organization

World Trade Organization, 101. *See also* WTO.

WIPO, 101. *See also* World Intellectual Property Organization